Beyond Marginal Gains

Showcasing the Optimal, Maximal, Incremental, and Threshold (OMIT) and Accelerate The Curve (ATC) models, this book offers a solid understanding of high performance and how to improve it.

The concept of marginal gains is well known – make small improvements and increase performance. What happens when these gains are harder to find? This book answers all your performance-related questions including: How can I continue to improve, even if I am better than I have ever been, and better than everyone else? How can I use my time, energy and resources better, so that I can improve more, with less? The book begins by introducing two concepts for high performance – OMIT and ATC. Using high-profile case studies, it maps the performance of business and sporting organisations, as well as individuals, against these models and offers practical advice for those looking to understand and improve their own performance using these concepts. Beyond marginal gains, towards threshold gains.

Combining the theoretical understanding of each model with suggestions for how to apply them in practice, this is the ideal resource for those looking to increase individual, team, or organisational performance across a range of domains.

Rob Mugglestone is based in West Sussex, UK. He has over 20 years of experience working with global client organisations in the field of organisational psychology, consulting on organisation and leadership development, recruitment, influence, and high performance for teams and individuals.

Beyond Marginal Gains

The Search for High Performance and 'High-Hanging' Fruit

ROB MUGGLESTONE

Routledge
Taylor & Francis Group

LONDON AND NEW YORK

Cover: shomos Uddin via Getty Images

First published 2025
by Routledge
4 Park Square, Milton Park, Abingdon, Oxon OX14 4RN

and by Routledge
605 Third Avenue, New York, NY 10158

Routledge is an imprint of the Taylor & Francis Group, an informa business

British Library Cataloguing-in-Publication Data
A catalogue record for this book is available from the British Library

ISBN: 978-1-032-63148-6 (hbk)
ISBN: 978-1-032-61385-7 (pbk)
ISBN: 978-1-032-63153-0 (ebk)

DOI: 10.4324/9781032631530

Typeset in Dante and Avenir
by KnowledgeWorks Global Ltd.

Illustrations designed by Andy McAlister

To Cathy. The work leading up to the book, and the writing of the book were only possible because I'm at my best when I'm with you.

Contents

Preface

This book has been 10 years in the making; writing only started recently, but the ideas, particularly Accelerate The Curve (ATC) have been incubating for a while. ATC led to the Optimal, Maximal, Incremental, and Threshold (OMIT) model and I then started researching and collecting examples. I noticed how major organisations, sports teams, and high-performing individuals often talked about the reasons, processes, thinking, and actions behind their success, and how these often resonated with the ATC and OMIT models. The idea of the book was born.

The idea that marginal gains are worthwhile is now a well-understood philosophy, since Team Sky rider Sir Bradley Wiggins won the Tour De France General Classification in 2012 and then GB Cycling won eight gold medals at the 2012 Olympics.

The book builds on marginal gains and explains how marginal gains fit into a larger and more complete model of improving high performance.

Two new models are illustrated with examples from sport and industry, examples of people, teams, organisations, and products that these models can show why and how success can be built.

Acknowledgements

The catalyst for the book is Roger Clark and his work on ATC; I hope he'll be inspired to write the second book. His help on this book has been amazing.

There are many other people who have helped along the way, providing opportunity, support, challenge, advice, and plenty of tea.

These include Jayne Mugglestone, Simon New, Andrew Walsh, Sarah Davies, Clare Watts, Jonty Leicester, all my Chartwell colleagues, Mike Clark, Mark Dunsford, and Cathy Henderson.

Introduction ... 1

Beyond marginal gains

Are you interested in high performance? Many of us think that only elite athletes are really interested, but the reality is that we all are in many ways.

Let's take "motivation" as an example. Individuals and organisations alike seem to all want to increase motivation. Why? Because there's an understanding that motivation leads to higher performance. If it led to decreased performance would anyone want to be motivated?

How well we do things in life – from raising our children to getting promoted at work or earning more money – these are all things where higher performance is seen as better. This book looks to explain how we can improve performance, and not just in small ways.

The idea that marginal gains are worthwhile is now a well-understood philosophy, since Team Sky rider Sir Bradley Wiggins won the Tour De France in 2012 and then GB Cycling won 8 gold medals at the 2012 Olympics. Sir Dave Brailsford became the spokesperson for marginal gains, advocating the aggregation of "1% margin of improvement in everything you do".

In 2012, this gave a clear advantage to Team Sky and GB Cycling, but their competitors soon caught up. What happens when everyone else does the same? The playing field levels again.

Whilst I didn't start out to research the psychology and effectiveness of marginal gains, we carried out research which led to the development of the two new models in this book; what we then discovered was that marginal

DOI: 10.4324/9781032631530-1

gains fit into one, or maybe two of the four quadrants of our model, and as such shines a light on why marginal gains are not the answer to all perform-ance improvements, and what you, or anyone, can do to develop further.

The first obvious issue with marginal gains is that **not everything can be improved marginally** (or incrementally, to use the language of our model). Team Sky famously took rider's own pillows with them on tour to improve their sleep. But can you continue to improve a pillow? And as I said above, once every other team has also improved their pillows, the advantage has gone.

The second issue with marginal gains is that sometimes there is **no advan-tage from a marginal gain**. You may be able to continue to improve pillows, but is there a point where cycling performance is no longer improved?

The third issue with marginal gains is that **not all gains are equal**. So what if you're doing the less effective ones? Is a better pillow more or less beneficial than nutritional gains, or mindset improvements? It matters less if you can work on ALL possible gains simultaneously, but what if you can't and you have to choose which gains to work on?

The fourth issue with marginal gains is that the **cost of the gain might be disproportionately high**. Pillows are relatively cheap, but where does the cost/benefit curve get disproportionate?

The fifth aspect is the **timing and sequence of gains**. Some gains have a knock-on effect on other gains, in which case maybe they should be done first. Some aspects are less noticeable, masked perhaps by over-performance in another area. Treating all gains as equal and isolated means that you cannot benefit from any multiplier effects.

This book looks at the timing and therefore the sequence of development, and maps the differences between incremental gains and threshold gains (bigger jumps), and also between optimal and maximal aspects (where good enough is good enough, or where every single improvement must be found).

We provide plenty of examples from high-performance sports and business, aiming to show how it's possible to get some of these aspects right without knowing how or why. Our focus then is to show that when looked at proactively and methodically, unlocking the next stages of performance is possible.

So, had this book been available in 2010 when Dave Brailsford took over Team Sky cycling could an outcome from following the OMIT and ATC models been better pillows? Yes, absolutely. And instead of then being focussed on one quadrant (the Maximal/Incremental quadrant), attention and effort could have highlighted other areas too for development, and importantly, from a timing and sequence perspective, focus could have been placed on aspects that fit our "urgent" Optimal Threshold quadrant.

There are plenty of books of the "this is how we did it" variety, but they all tend to be written with the benefit of and the perspective of hindsight. Psychologists call this the Texas Sharpshooter fallacy – the act of drawing the bull's eye around where the bullet struck. Our book is intended to draw the target before you start and show you how to get more of the bullets to the bull's eye, more of the time.

This book then, in many ways, is not about marginal gains – or rather it is not only about marginal gains. The two new models that the book introduces – Accelerate The Curve (ATC) and Optimal, Maximal, Incremental, and Threshold (OMIT) – are both linked to marginal gains and high performance, and I hope will be of interest to anyone looking to improve performance. In some ways, they will be most useful to those who might consider their performance already as elite, and certainly for those who spend the majority of their time on high-performance development.

ATC is the "what" of performance; OMIT looks at prioritising.

ATC

At the start of developing a skill, we can be on quite a steep learning curve. ATC is a deliberate effort to spend more of your time on the accelerated part of a development curve than on a plateau. This is achieved by understanding that performance in any discipline is a culmination of tens, if not hundreds, of skills as subsets, and ATC is about firstly mapping all these aspects, which gives greater depth and breadth to understanding the components of skilful activity in that discipline. Then to deliberately choose the individual skills to develop that offer the steepest learning curve. It is possible therefore to always be on several steep development curves at any one time.

I have not yet carried out any research on childhood development, but we see differences in performance much more starkly with children as they tend to all be at the early stages of learning, and the ones who are slightly ahead of the others tend to stand out. We can see this performance advantage as "talent", or we could wonder if instead, this advantage is a result of being on a greater number of steeper learning curves. Imagine as an example a 6-year-old footballer playing as well as 7- or 8-year-old footballers.

This model initially came from a colleague, Roger Clark, when we worked together at ApplianSys, from his passion for development and improvement. In very brief terms, the essence of it is this.

Imagine I am learning to play the piano, and I practice for an hour a week to prepare for an exam. Closer to the exam, I increase my practice in the hope that I do well enough to pass. What would be the outcome if instead,

I did the intense practice at the start? Then, later on when I'm still practicing for an hour a week, all this subsequent practice is at a higher level. Would the overall outcome at the point of the exam change as a result of this? I did some research, and although only a small research project, the results were statistically significant and showed that the accelerated development curve gave up to 18% performance gain (for the front-loaded pattern) despite the total time spent on development being the same as for the linear (no peak at the start or at the end) and back-loaded development patterns.

I've included the research in Chapter 4 and in more detail in Appendix. This was a small research project and one of the desired outcomes for this book is that others may be inspired to do further research.

ATC then breaks down any "activity" into its component parts and maps these onto a "tree" diagram which helps to categorise and group them, and then looks to accelerate the development curve for any of the individual component aspects in order for the performer to always be on a steep development curve, or multiple steep curves simultaneously.

We're aiming for multiple 18% gains over several aspects that all point to high performance and without the total time spent on development changing.

Our assertion then is that if you can break down your performance into tens or hundreds of micro components, and look to develop those in an accelerated way, you'll develop further and faster (or at an accelerated rate).

Out of the initial thoughts and research came the focus on how it might work for anyone looking to improve. This is where the book will focus.

OMIT

This model came after ATC and very much as a result of ATC.

ATC breaks down the many components of performance, OMIT looks at how they relate to each other, and how you might see their relative importance. Not all gains are equal. As such, OMIT can help with prioritising or the order in which to tackle the individual components and also when you might want to stop developing one aspect.

I was working in a client organisation with their marketing team that had for months been working on the new company website. The team leader said to me that the website project was "90% complete". To the outside world, the new website was 0% complete because the old website was still there, and this sparked the notion of threshold (the T in OMIT).

In software development, it is referred to as MVP – the minimum viable product. And it is a critical aspect because until it has reached

MVP stage there is no product. The MVP threshold is important because at that point there is something that can be monetised. It can also still be improved further.

This idea of reaching a threshold is key – and if we look at this in conjunction with the ATC model, we can see that the drive to MVP is similar to the accelerated curve that ATC promotes.

Imagine two software companies each spending 1000 man-days on the development of identical products that will compete. What is the value of one company reaching MVP earlier? If we assume there is a value in reaching MVP earlier, the question then is how?

Before we answer this in the book, let's just look at the rest of OMIT.

O – Optimal and M – Maximal. This is one axis of the OMIT model. We look to classify development areas as one or the other. This is a separate axis to I – Incremental and T – Threshold, so we need only to consider how much development is required and where to stop. With Maximal, there is no stopping point, because you can never have enough. Think of fundraising for a charity, or top speed for a sprinter. Now, I'm not saying that to keep increasing these is easy (that's the Incremental/Threshold piece), but it is clear that more charity revenue, or sprinting speed are beneficial. With Optimal, we recognise that there's a sweet spot beyond which there would be very little point continuing to develop. The performer's time would be better invested elsewhere. This is a very important factor, for our limited research would suggest that even elite performers spend valuable development time on aspects which they are no longer required to develop further.

I – Incremental and T – Threshold. The other axis of the OMIT model. As mentioned above, threshold is a critically important factor because if you're below a key threshold, your performance in that area is close to zero. Any sense of qualifying criteria would be a threshold. You can't compete at all if you can't qualify. You can't start to sell your product if you've not yet got a product to sell even if it's very much the minimum viable. If you have a team member that's underperforming, then look to see if there's a particular area where they are below threshold. Do whatever you can to bring them above that threshold as soon as possible, for all the whilst they are below, they will continue to underperform.

Incremental – in our model, we do distinguish between incremental and threshold, but I also recognise that some of the factors below threshold may well be developed incrementally. However, the sense of Incremental for OMIT is that it is something that can be developed literally in small increments. I can lose weight incrementally. I can generate sales incrementally and reach my sales target incrementally. I can sell one copy of this book at a time.

Both models – ATC and OMIT – are to be seen as live models, where iterations are possible and meaningful. For ATC, the map of performance aspects changes and develops over time. If a new piece of equipment or software is introduced, then it would not previously have been on the map, and now needs consideration. For OMIT, something that is initially Incremental and Threshold may no longer be, once the threshold has been reached. I may need to spend time every day learning a new skill (Incremental) to become competent, but once competent (threshold reached), further development of that skill could be in any of the quadrants, depending on subjective and objective analysis of the future desired competence.

Finally, a note on the book's subtitle – "the search for high performance and the high-hanging fruit".

Some of the aspects of the book will make most sense to those who have already achieved high performance and who dedicate their time and effort to achievement. My hope is still that anybody looking to increase their performance in any given field can look to the concepts in the book to help them. For others, all of their time and effort is focussed on high performance and the low-hanging fruit is already harvested. I don't want people to think that the book is difficult to use to achieve development – in fact the opposite is the case. But if you have already exhausted the supply of the low-hanging fruit, all that is left is the high-hanging. This book helps with that too.

Structure and flow of this book

Chapter 1 – This is a brief introduction. Beyond this, the book is structured as follows.

Chapter 2 – The Accelerate The Curve (ATC) model is explained – from the origins of the model, to initial explanations of mapping, execution, multiple victory cycles, and momentum.

Chapter 3 – The OMIT model is unpacked and explained, firstly each aspect individually, and then each quadrant "Optimal/Incremental", and so on.

Chapter 4 – Research and data. A brief look at the findings from the initial research. Appendix has this research in greater detail.

Chapter 5 – Key theories and psychologists. Much like cooking, I am merely bringing together existing ingredients and recipes, looking to show how these ingredients and recipes can work together. I spent a long time with the strong belief that I would discover that someone else had published

these ideas years ago. I still haven't seen any, but there are of course plenty of great ideas and theories already published, and my intention is that I show how they link with ATC and OMIT. I hope that through publication of the book, other linked theories and ideas also come to my attention that I have until now overlooked. This book is not a definitive summary of the theory; if anything, it is the thin end of the wedge with much more to be discovered.

Chapter 6 – Case studies. These are mostly retrospective. What I mean by that is that over the years, I have collected examples of people, teams, and organisations across industry and sport, where they have talked about their success. What I started to notice was how I could transpose aspects of their success onto the ATC or OMIT models. That could be seen as the Texas Sharpshooters fallacy where bull's eye targets are drawn after the bullets have already hit. Whilst that isn't my intention, there is of course a possibility that this is precisely the case, but I also believe that in doing so, the models highlight the areas that all these performers MISSED. So the purpose of showing the case studies is almost to show how without any knowledge of these models, it is of course possible to achieve elite performance, but WITH knowledge of these models, it is possible to notice and develop in the areas that would otherwise be missed. What we're highlighting therefore is that their use and understanding of the models is only partial, and as such they have not been able to reap all of the potential rewards, nor have they been able to iterate effectively … so in many cases their success is relatively short lived (e.g. team sky (although to say that Sky/Ineos are not successful would be a challenge!) how do you iterate "better pillows" – ATC may have put pillows on a branch called "sleep, rest and recovery" which itself would be on the bough of physical and a branch that's not directly related to cycling dynamics).

Chapter 7 – Practical applications. The most important part of the book. The other chapters serve mainly to convince you, the reader, that the ideas are worthy of consideration. Chapter 7 therefore is as practical as I can currently make it, in the hope that you will try and put some of the ideas into practice for you, your team or your organisation. In many ways, some of the ideas and models can be applied so simply, because the ideas and learnings are memorable. I often look to see where I am below a threshold and look to address it quickly. I cycled Land's End to John O'Groats in 2022, and my training was much better once I'd got over the 100-miles-a-day threshold. Once I'd done that in training, I knew that the ride itself (980 miles over 9 days) would be achievable. The training after this became more incremental. For an ATC personal

example, I can look to injury. It's easy to think that when injured you're off plan and somewhat doomed! But it is a practical help and motivational to switch to another ATC "leaf" as shown by Figure 2.4 and focus on what CAN be done, not what CANNOT. Injury may mean that some aspects of physical training (or even all aspects) must be put on hold temporarily, but there are other aspects of development that you could argue normally get squeezed out through lack of time – spending time reading, researching, developing your knowledge and understanding. Roger Clark has the phrase "tough bone" that he refers to as being developed when experiencing any kind of difficulty or relative failure. Tough bone is synonymous with resilience and mental toughness and treats these as aspects that can be developed. Need to go and train in appalling weather? Good ... you'll be able to develop your tough bone too. Tight deadline looming? Treat it as an opportunity to develop resilience and stamina. In short, there's always SOMETHING that you can focus on developing.

Citations and bibliography. I have included these at the end of each chapter. I hope to have included everyone and everything that I needed to, but should that not be the case, I apologise for the omissions and hope that you can let me know. This book has been "easy" in one regard as the concepts are my own, to talk about however I wish. But it has also been "difficult" in other respects because my knowledge and understanding of psychology is only partial. There are likely to be theories, ideas, publications, and authors that I am unaware of and whose toes I may have trodden on. My hope is that this book uncovers those and allows us to work together to see how these ideas fit in the broader world.

High performance – definition

Before going much further with this book, I need to define high performance. I've always been fascinated by the concept, and generally see that the most important differentiator and definition is that of the measure of performance. *Objective* high performance is easy to measure, and therefore easy to see where you are in relation to the "highest" performer. If you're a marathon runner, then there are "good for age" measures and of course world records – and the idea of these multiple measures is that you select the one that's most relevant for you. Whether you're old, young, professional, or amateur athlete, able bodied or in some way less able. The next set of objective measures are in the form of competition – any kind of sporting knockout tournament is designed to have an objective winner – the

individual or team who objectively beat every other competitor. You can literally be objectively the best in the world.

Then you have the subjective measures. A business owner, or founder who sells the business for tens of millions of dollars. Yes, objectively "successful" but how do they compare with other successful business owners? They may have done well, but could someone else have done better? This leads us down the path of "being the best that you can be" – your version of high performance, and hence the very definition of subjective.

So, which definition or measure does this book refer to? Which is more difficult to achieve?

This is where it gets interesting … there may be world record holders who are actually below their own subjective best. Maybe they will continue to break their own world record in the future, so even their performance now is below their own ultimate high-performance level. As an example, Michael Phelps broke 39 world records in his swimming career.[1] In three events (200M Butterfly, 200M Individual Medley, and 400M Individual Medley), he broke the world record for each of these events eight times. At any point, his then world record would have been sufficient as a measure of high performance, yet he went on to beat the record repeatedly. His 200M Butterfly first world record in 2001 was 1:54.92, his eighth world record at that distance was 1:51.51. In 2001, would we have described Michael Phelps as a high performer? Of course. And of course from this end of the timeline, I'm sure we can document retrospectively all the different aspects of his overall performance that contributed to the continued development, but the intention of this book is to be able to design and develop strategies to proactively develop.

Then there may be people who are subjectively outstanding performers but who are well below an objective level of high performance, or they operate in a discipline where there is no easy objective measure of high performance. As an organisational psychologist, how is my performance measured?

Why do these definitions matter? Because "high" performance is different from performance. And my assertion with this book is that it matters not how you measure or calibrate your current level of performance, there are aspects of your performance that could increase your total performance further. And of you think that's not possible because you're already at the top, then refer above to Michael Phelps' 39 world records.

If we've defined "high", then we should go on to define performance. Your performance goal could be to relax more, or to travel the world. It could be to make better coffee. Or be a better parent, or spouse. There are plenty of aspects of one's life that are open to improvement.

Hierarchy of performance

The examples given throughout the book are often for individual performers, but also teams or organisations. For any "performer", development can be achieved at several levels.

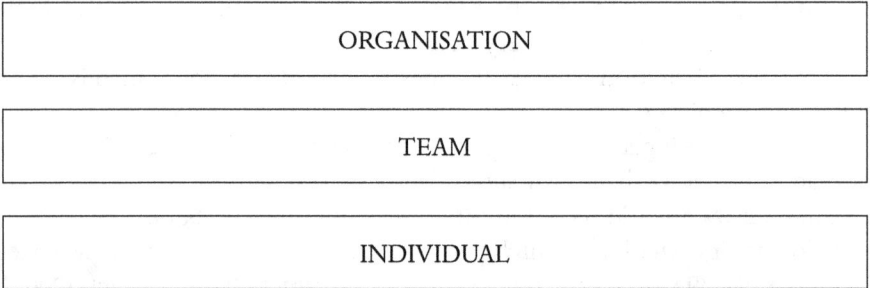

ORGANISATION

TEAM

INDIVIDUAL

Whilst a team is a collection of individuals, it is not the case that performance development comes only from the development of the individuals; there will be aspects of performance that exist only at the team level and to which the individuals will certainly contribute. A team is not just a group of say 10 people each doing 1/10th of the overall task. I see it as almost the opposite, where a task cannot be broken down and requires those 10 people to work together. Think of a group of cyclists together lifting an Audi and moving it to free a cyclist trapped underneath. I was in this very situation a few years ago when a cyclist slid on loose gravel and into the path of an oncoming car. The first 8-12 cyclists that arrived on the scene, including me and my son Charlie, lifted the car out of the way. This was teamwork, for we could only lift the entire car by working together. Whilst individually we each only lifted 100kg, together, as a team we lifted an entire car.

The same applies to organisations which are not just collections of individuals or teams.

For your own personal performance then, you are likely to also be affected by the performance of the team and organisation that you perform within.

If you are interested in the performance of an entire organisation, then mapping the performance factors is exponentially greater.

My assumption is that organisations do not want high performance to be something that is determined by individuals; they require high performance as an output from strategy and the organisation's processes, etc. That means there is a gap for organisations that are serious about high performance to achieve this through the mapping, prioritisation and focus of all performance aspects at all levels.

Who is this book for?

> Anyone who is interested in performance.
> Your own, or the performance of others. Manager, coach, parent, etc.
> Teams, or multiple individual performers.
> Work, sport, leisure individuals and teams.
> Anyone interested in improving something.

I'm also keen for this book to be used by people interested in learning from elite teams and individuals, and who may even have reached a peak or plateau, where performance would be difficult to increase further. This is where I see the book having most value. Traditionally, looking at marginal gains would suggest finding any area, however small, to improve will increase performance. I hope that from this book they can be more selective about the areas to improve, and also find a wider spread of components.

I would also love this book to be used by students of and researchers in psychology. My research is thin at best, is limited and although generated a statistically significant result, I would encourage anyone to research it further. Particularly if you disagree or are sceptical. The doors are open to further research to find if and how these models work.

Finally, if you are a professional high-performer or team of high performers, then I'd like to hear from you. Especially if you're in a competitive environment where there are huge financial implications to your performance. I'd like to see how this can work to help you beat your competitors.

How to use the book

My intention is that it will pique your interest. I hope to encourage you to explore how you define high performance, and to break down your performance into as many discrete components as possible. I don't mind if you dip in and out of the book, reading the sections that appeal. It's not necessary to read it cover to cover, but it is written with a logic that allows for this, finishing with the practical guides to help unpack your own performance.

The book predominantly explores two models of high performance – ATC and OMIT.

The two models can be used independently or in conjunction with each other. One (ATC) looks at how you can change the shape of your learning curve to be developing a little faster and earlier. The other model (OMIT) helps you prioritise – how do you know which aspects should be developed

first, or with greater intensity. Both models help you unpack all the different elements that contribute to overall performance.

The book explains the models in detail and gives examples throughout.

The real-world examples are my personal collection from newspapers, TV, media, interviews, etc., where I've noticed that these high performers are essentially making reference to the ideas in this book. The analogy is an example being someone talking about how they mixed water, flour, salt and yeast and then baked the resulting mixture. I can then reference in my book how I call this mixture "bread".

I haven't invented bread, nor am I saying that bread only exists when created in the way I suggest – no – what I'm saying is that I've found a way of unifying many aspects of high performance in a way that allows performers to look for gaps.

Note

1. https://www.worldaquatics.com/athletes/1001621/michael-phelps

Accelerate the curve **2**
ATC

Introduction to ATC

This book appears to be a book about high performance, but it didn't
start there – and it's more accurate to describe the book as being about
"improvement", as continuous improvement will lead to increased per-
formance. As the research and writing developed, it became clear that
improvement is important at every stage of development, but in the early
stages it's relatively easy to improve, because the size of the development
gap is so large (the gap between where we are now and the peak). The
received wisdom is that it becomes more difficult to improve as you get
closer to the top, and to some degree this explains the focus on marginal
gains as maybe all that remains are marginal gains.

What my research led to was an understanding that there is always
(there's a risky word to use!) aspects of the performance that are further
away from the peak, and as such offer steeper development curves. I would
also propose that often, even for peak performers, there is a degree of com-
pensation for poor performance in some areas with peak performance in
other areas.

Acceleration can be defined as "the rate of change of velocity" and so
defines this model well – becoming good at something takes time, and if
your improvement benefits from a greater acceleration, your rate of change,
or rate of improvement, is greater.

DOI: 10.4324/9781032631530-2

Roger Clark, who came up with the accelerate the curve (ATC) concept initially posed it as a simple question:

If, instead of practising (developing a skill) at an even rate of say a few hours a week with then an intense period of compressed practice ahead of an exam, for example, what would happen if you moved the compressed period to the early stage of development? Would this mean that all subsequent practice is at a higher level and therefore much more beneficial?

Imagine learning to play the guitar. Your fingers need to be able to reach all the positions to be able to play scales. After this point, the range of what you can play expands and you unlock the next level of development.

With typing speed and accuracy, both improve if you are able to touch type. Touch typing has a threshold where all keys can be located without looking; even though you may be slow and make mistakes at first, your development accelerates. It may take a great deal of effort to transition from two-finger typing to touch typing. In fact your advanced two-finger typing may even be faster and more accurate than your novice touch typing. But once you're over the threshold of touch typing, very little practice is then required to maintain, and a little more practice leads to greater speed and accuracy.

Figures 2.1–2.3 show the time/practice curves as described.

Figure 2.1 plots elapsed time on the X-axis and cumulative time on the Y-axis.

If the elapsed time stays consistent – for example, 2 hours per week, then the curve is a straight line.

Figure 2.2 shows that the elapsed time is now less to begin with and then increases towards the end – think of this as cramming for an exam.

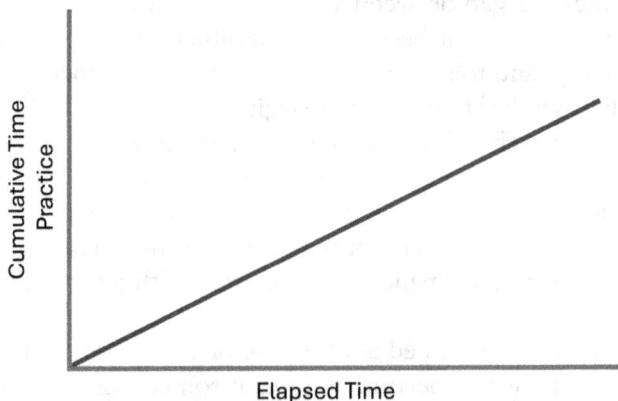

Figure 2.1 Chart showing elapsed time (x-axis) and cumulative practice time (y-axis) where there is a linear increase in both.

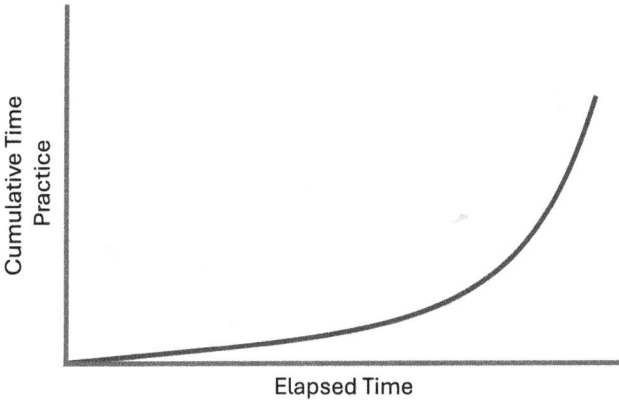

Figure 2.2 Chart showing elapsed time (x-axis) and cumulative practice time (y-axis) where the cumulative time increases are very small initially, and then much larger later.

Figure 2.3 shows elapsed time being greater at the start and then lessening – cramming at the start if you like.

Figure 2.4 shows all three-time curves overlayed, and with a little artistic licence you can see why we then refer to this as the leaf.

Roger's question about the different ways that time could be spent gives us in simple terms three shapes of time curve.

Our research question then was to investigate if the shape of the time curve had any correlation with the development curve.

Figure 2.4 shows all three time curves converging at the same point – this means the cumulative time spent for each shape curve is the same. The area

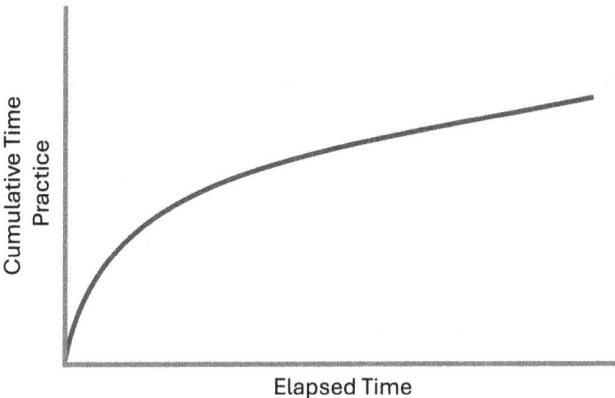

Figure 2.3 Chart showing elapsed time (x-axis) and cumulative practice time (y-axis) where the cumulative time increase is very large initially, and much less later.

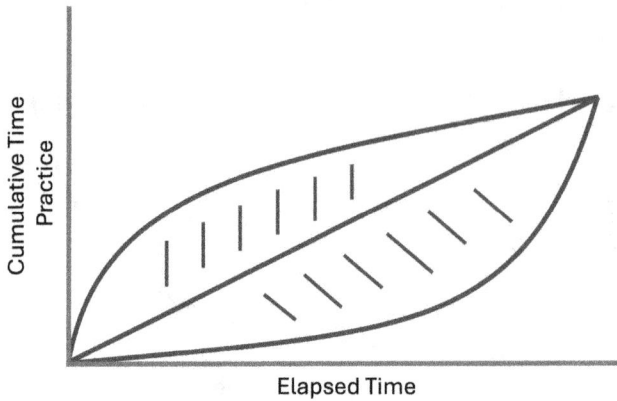

Figure 2.4 Chart showing elapsed time (x-axis) and cumulative practice time (y-axis) with three time curves plotted; the resulting curves resemble a leaf.

under the curve, however, is noticeable different, and Roger (Clark) and I wondered if the area under the curve correlated with the development – that is to say, if the area under the curve is greater, does that mean that the person developing the skill has received a performance benefit without any time cost (because the cumulative time is the same).

Figures 2.5–2.7 show the same curves as Figures 2.1–2.3 with the area beneath each curve shaded.

The detailed research is in a later chapter, but the research question was "Do quantifiable differences in the spacing of practice (front-loading,

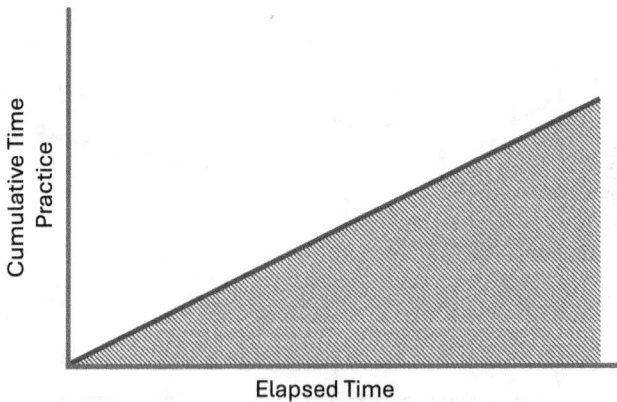

Figure 2.5 Chart showing elapsed time (x-axis) and cumulative practice time (y-axis) with a linear increase in cumulative time, with the area under the curve highlighted by shading.

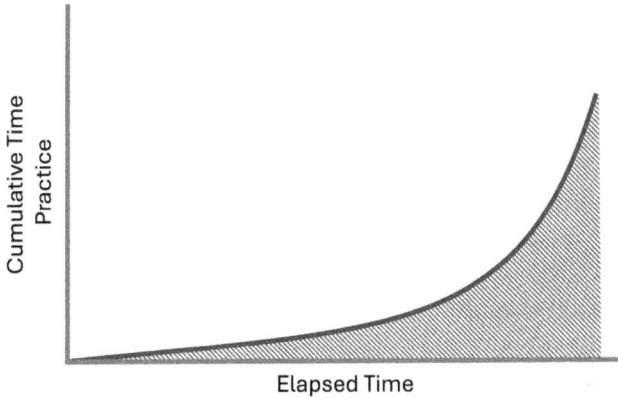

Figure 2.6 Chart showing elapsed time (x-axis) and cumulative practice time (y-axis) with a small increase in cumulative time initially, increasing later, with the area under the curve highlighted by shading.

end-loading or linear) correlate with objective and subjective performance measures and allow for a cumulative advantage?"

> ... the hypothesis was supported by the data and the group with the front-loaded practice pattern (Figure 2.7) objectively reported a significantly greater increase in performance over the duration of the research ...

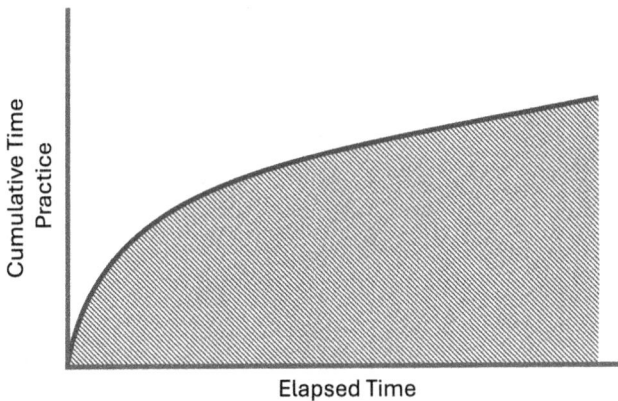

Figure 2.7 Chart showing elapsed time (x-axis) and cumulative practice time (y-axis) with a large increase in cumulative time initially, decreasing later, with the area under the curve highlighted by shading.

This is now our starting point for the book.

> Front-load your practice and you'll get a net positive effect for the same total time spent practising.

The next step then is to see how we can overlay practice so that instead of practising one aspect, we're developing multiple aspects simultaneously, with each one benefitting from this positive effect.

The overall development curve is therefore steeper as a result of multiple steep development curves. Of course, they are probably not sequential per the diagram below, and can be simultaneous. The aim is to be on as many steep development curves as possible.

Figures 2.8 and 2.9 show the compound effect of multiple steep learning curves.

Figure 2.8 depicts seven consecutive learning cycles, each continuing to a plateau before the next begins. In Figure 2.9, the next learning cycle starts before the plateau, and the overall effect is a steeper whole learning curve.

Both figures depict identical individual learning curves; it is the exit point and the start of each iteration that creates the steeper overall picture.

Note 1. As the overall shape of the curve is steeper, this also correlates to a shorter overall time.

Note 2. Even though each iteration starts sooner in Figure 2.9, the total height of the final curve is not much different from Figure 2.8.

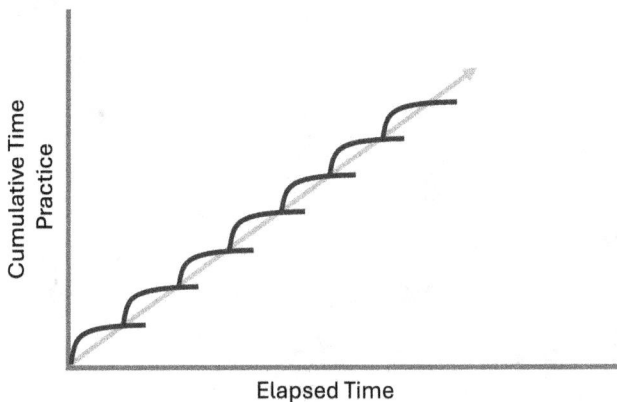

Figure 2.8 Chart showing elapsed time (x-axis) and cumulative practice time (y-axis) with 7 sequential time curves plotted, illustrating the overall relatively shallow development curve.

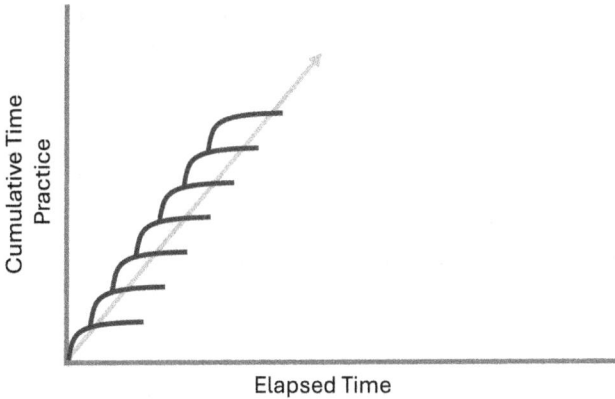

Figure 2.9 Chart showing elapsed time (x-axis) and cumulative practice time (y-axis) with 7 sequential time curves plotted, illustrating the relatively steeper overall development curve.

Tip 1.

Front-load your development time.

Front load, stay steep and then when progress tails off, reduce to the minimum to maintain your new level, but also switch to another steep curve.

Be aware of what you're doing that's MAINTAINING as opposed to DEVELOPING.

As an example, we can spend hours a day typing but we generally do not improve; The time needs to be intentionally focussed on development, not just 'doing'.

Tip 2.

Keep looking for steep development opportunities.

We look at mapping and implementation later on, but effective mapping of all the possible components of high performance is an important step so that you know what can be worked on. OMIT (Optimal, Maximal, Incremental, and Threshold) looks at helping with prioritising and selection of development activities. If each individual aspect of development can be seen as a Leaf (Figure 2.4), then the leaves can all be mapped onto branches, boughs, and trees to show the whole development picture. The mental imagery of a Leaf is an important part of the simplicity of ATC.

Tip 3.

Be flexible and adaptable if you can't work on what you want to.

As an example, I have previously mentioned the metaphor for resilience, the "tough bone". Athletes often get injured, and the frustration

is that this restricts physical practice. But there is always something else that can be a useful development opportunity, even if it is "just" developing your tough bone (resilience, motivation, mental strength).

So, back to the idea simply of improvement, irrespective of relative development. ATC is about accelerating the overall development curve by always looking for and focussing on steeper development curves for aspects of the overall goal. And breaking down development and key aspects of performance with greater granularity so that even tiny aspects of performance can be considered for development. It is the "what" of performance. Whilst the overall performance measure is likely to be the key measurable difference between performers, it is my assertion that in breaking down that overall performance into tens or hundreds of component parts, every one of those components can then be measured and therefore developed.

ATC has two parts – mapping and implementing, and both aspects work in conjunction with the OMIT model.

Physics and psychology

Figure 2.10 Is a line-drawing cross-section of marble tracks – imagine a marble being rolled starting at one end and under its own momentum,

Figure 2.10 Two marble tracks.

finishing at the other end. Both tracks start and finish at the same point. The first track represents a "normal" shortest distance between two points

The second track is steeper, bumpier and further than the lower track, a ball rolled along would have much further to travel than a ball on the upper track. However, it may surprise you to know that, in the lower track, a ball would reach the end in less time than the upper track.

This is down to inertia, acceleration and momentum, and it is well worth watching the YouTube videos of Bruce Yeany (or reading his book[1]) as he has made physical models of these tracks to roll snooker balls along and show the results.

Whilst this is not a physics book, I wanted to include this in part because of the counter-intuitive nature and also because the shape of the curve – or rather the resulting acceleration – makes a real difference to the outcome.

Whilst the shortest route between two fixed may be a straight line, the quickest route between two fixed points may not be the shortest route. I am not trying to say that the ATC curve is in any way counter-intuitive, in fact to me it seems entirely intuitive. Getting an early head start, accelerating faster, and building momentum is exactly the principle of ATC.

The psychological and performance equivalent of rolling balls along a track is that we achieve more, in less time.

We know how to deliver the "faster" track, by implementing multiple accelerated short developmental bursts.

These developmental bursts could be focussed on developing any aspect of performance, but ideally developing the aspects that have the greatest potential positive impact, and one of the first principles of ATC is to map the whole domain of performance. We refer to this as the Success Tree, because of the analogy with leaves (the shapes of the three curves) and branches of development.

When there are multiple development activities, either potentially to choose from or even concurrently, it's important to find the optimum route. If the analogy continues for ATC, what we are aiming for is to always be on the steepest part of the curve, with maximum acceleration and momentum, and when that starts to slow, to switch to another development area. It would be like driving along a motorway and if conditions (traffic, number of lanes etc) meant that your speed dropped, to be able to switch to a different motorway where your speed would again increase.

The first step then is to map the entire network and all the potential areas for development – mapping every detail. In practice, we keep adding to this map over time as more aspects become apparent or new items appear. This is the ATC map – the Success Tree – upon which are the various ATC leaves for each performance area.

Then we select the aspects which will deliver the most impact (the OMIT model is the key here). This delivers part of the overall gains – simply choosing the right things to work on.

Focussing on the way in which each is developed – with particular (and different) focus on accelerated bursts, which we know delivers greater short and long-term results – switching to other aspects once a significant portion of the development potential of each single aspect has been achieved. This delivers both objective performance improvements, and we believe that this also brings subjective, psychological gains.

Essentially, we replicate the second track – but not just in the way it is drawn in Figure 2.10.

Imagine zooming in on one of the "bumps" to find that the curve itself is comprised of multiple smaller bumps, and zooming in again reveals that these smaller bumps are also comprised of even smaller bumps.

In Formula 1, as in many high-performing organisations, some teams seem to achieve more in the same time frame. Even with capped budgets, some teams are consistently better than others. Some people are seen as having more "talent" – but what if these differences in performance or talent are simply the net result of having been on the faster track (marble track or race track!) for longer, or having been able to keep switching to fast tracks.

What's more, the second, faster track, can be lengthened – it does not need an end stop if we keep the accelerated bumps going, so that way more is achieved in the same elapsed time. The longer you are on the bumpier track, the more the gains accumulate. This also links to concepts such as Cumulative Advantage that are covered elsewhere in this book.

Most organisations and individuals, however, do not have the time or inclination to keep switching between development activities. It is probably for simplicity that organisations like to organise learning and development (L&D) in very structured, linear ways, settling for administrative, and scheduling ease over absolute performance. And that is absolutely correct if absolute performance is not the goal.

Let's imagine an organisation that identifies a key skill that many people across the organisation need to learn, and that the benefit is linear – the more they learn the more they can apply what they've learned and the more benefit to the organisation. (The OMIT model would classify this as Maximal/Incremental.)

If, in this scenario, everyone needs to spend 20 hours learning the new skill, then they spend an hour a week it will take them 20 weeks in total – the elapsed time. The organisation will probably look to schedule this quite gently over the next year or more so as to not overload the organisation or its L&D function, for they probably have other skills to also help develop.

A few people each week start their 20 hours of development, but it's pretty strung out and 2 years later almost everyone has completed the training. The organisation has benefitted, most people have done all the training and L&D scheduled their time effectively. All of this is absolutely fine and normal, and probably describes L&D functions the world over.

However, it is not the most effective from a high-performance perspective. The most effective way would be to accelerate not just individual learning (by front-loading development time) but by accelerating the entire organisational benefit as a result of everyone being trained in a much shorter time-frame.

The situation is even more contrast if the benefit of the training, instead of being Maximal/Incremental, is Optimal/Threshold (or even Maximal/Threshold). This means that the benefits of the training may not be realised individually until all training has been completed. Imagine if there was a test or licence required at the end. This means that neither the individual nor the organisation gets any benefit at all until the threshold has been met.

The purpose of this book is to explore and understand the differences in these various approaches. For organisations that are focussed on high performance, understanding the different approaches, and outcomes will give huge advantages.

The resulting performance differential over other teams and individuals may be only a tiny percentage difference, but as with financial investments, a tiny percentage improvement creates huge differences over time. Think of ATC as compound interest on your development capital.

Whilst ATC promotes deliberate development focus, it is of course not always the case that individuals and teams have been deliberate or proactive. We know that is the case because we see success everywhere. What we see in some teams is what I like to think of as accidental discovery of some elements of this approach but critically it is accidental, and as such is difficult to replicate in future iterations.

The underlying principle of ATC, the front-loading of development time has been researched on a small scale and has shown up to 18% gains in performance over identical cumulative and elapsed time periods.

My assumption therefore is that the concepts work; they have counterparts in physics and could explain or underpin much of the high performance that we see in the world. But the likelihood is that for those organisations and individuals who are looking for competitive advantage, even small percentage improvements would make a valuable and measurable difference.

What is a 1% improvement worth, relative to what you otherwise would have achieved?

What's a 1% improvement worth, relative to the next highest-performing team?

The next step then is to start with ATC mapping to determine the extent of every component that contributes to performance – either for a discrete skill, an individual, a project, a team, or an organisation.

Mapping

In my experience, people, teams, and organisations rarely look to map every component of their performance. Any mapping done tends to focus on building on existing strengths, rather than mapping from a more holistic perspective. Also, existing teams tend to notice what's not working, so the focus can be drawn towards fixing negative aspects rather than developing positive ones. The analogy could be of injury prevention rather than cure.

I've included a few examples below. They are not exhaustive, and it may be possible to still add more to any of the examples. That's a good thing and something that isn't necessarily omitted initially through carelessness; it could also be omitted because it didn't exist before or wasn't relevant before. Years ago, before personal computers, most people did not spend time typing, and therefore typing speed and accuracy would not have been relevant. Now, most people spend some of their time typing and as a result, typing speed and accuracy at some level is a performance factor.

Example 1. Running

I've initially broken running down into seven sections – physical, mental, technical, nutrition, racing, lifestyle, and coaching. There's always some cross-over between aspects but generally I look to find discrete high-level aspects. I know I've missed plenty – if I were writing a running map, I would continue to add to the map indefinitely, so if you have other aspects that spring to mind, add them to the map (Figure 2.11).

As an example, it would be easy to add to the "mental" aspects of running, shown on Figure 2.11 by adding the various psychological aspects found in Chapter 5, such as motivation, self-efficacy, augmented feedback, optimism, etc.

Example 2. Software development

As an example of negative mapping, I'm going to use Steve McConnell's Rapid Development book – specifically from the chapter on Classic Mistakes which states 36 mistakes in 4 categories, each of which may even be able to be broken down further (Figure 2.12).

How many people running software teams today are aware of this and have mapped their team's performance against these mistakes? Nearly all of the people-related aspects I would see as being applicable to any team, not just a software team and again, how many people leading teams are aware of or have mapped these?

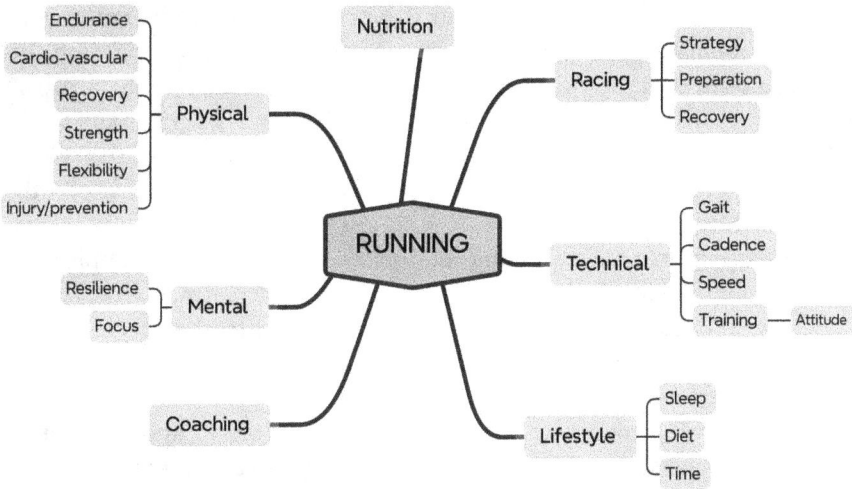

Figure 2.11 A map for running.

Figure 2.12 A map of classic mistakes for software development teams.

Mapping therefore is a non-exhaustive process of awareness of any and all components of your performance (or your team, or organisation). It's important not to try to prioritise at this point, but instead to note all aspects irrespective of how small. It is helpful to think of other performers so that you don't overlook aspects that they may have as strengths but that you do not. In my discussions with teams, I often ask the question "what do other teams do better than you?"

It is important to also include peripheral aspects – for example, your home and family life as these will also impact performance.

As the ATC model has developed, it has become increasingly clear that at an individual level, there are some fields that appear consistently on every map – the various psychological/mental factors.

They vary in importance from one person or role to another, but the consistent aspects are ones such as resilience, motivation, optimism, conscientiousness, reliability, etc.

Execution

Implementing ATC is about action. Having created the map what you then are looking to do is to accelerate your development and to stay in accelerated phases of development indefinitely.

Let's ignore for now the issue of prioritisation and selection of aspects to develop and simply look at how you would implement your development irrespective of which attributes you're looking to develop.

It's worth noting at this point that there is some overlap with the OMIT model in the book. It is almost impossible to talk about implementation without talking about things such as threshold or increments but as far as it is possible to do I will look to separate ATC and OMIT.

As an example, I have put together an ATC map for Tour de France cycling. Given that Dave Brailsford's approach of the aggregation of marginal gains is well known I thought it would be useful to see what would happen if I took a step back and without the knowledge of some of the quoted examples of those marginal gains, see whether or not they would emerge through ATC methodology and what else might emerge. It also serves as an example of how we might look at the map from an implementation perspective.

Figure 2.13 is the first level map; there may be more in the outer ring of the diagram, or you may even group/name them differently, but I think that in the RECOVERY section, sleep and massage would both be performance aspects that would be in the next tier of the diagram.

I have created this map from my perspective of an organisational psychologist, so it is easy for me to include the MENTAL section (I have referred

Figure 2.13 A possible map for a Tour De France cyclist.

to this as mental to differentiate from physical, and as distinct from psychological), but I noticed when watching the Brawn F1 documentary series how Jenson Button talked about the mental side of F1 in the 2009 season – he mentioned how long it took him to mentally recover from a bad race result, and later in the season how it felt to be losing ground to his teammate and the feeling of the championship slipping away. He also commented that the night before the race where he finally won the championship, his father took him back to their hotel, bought him a beer, and it sounded like the conversation they had really helped Jenson go into the race the next day in the right frame of mind. This was as recent as 2009 and it is apparent to me like Jenson could have benefitted from spending more time with a sports psychologist throughout the season.

Back to implementing the map.

The aggregation of marginal gains is described as making 1000 things a tiny bit better, and the prioritisation of those is also looked at in the sections on OMIT, but it would be fair to assume that not all gains are equal in either benefit or implementation.

Pillows – help sleep and therefore recovery – easy to implement – cost effective.

Bike – small performance gains in aero and weight (within UCI's [Union Cycliste Internationale] rules) – difficult to implement (rules and development time, brand determined by sponsor) – less cost effective than pillows.

Aside from the scale of the benefit or implementation difficulty comes the next differentiator which is iteration. Some of the gains can come from a single iteration – such as pillows. Change them once, get the benefit. Leave them alone.

Other gains are on a continuum that needs reiterating. Physically, athletes need to deliver peak (compared with their peers) metrics – power to weight for a cyclist, for example, or $\dot{V}O_2$ max. The likelihood is that if you're in the professional cycling team your stats are already high, so how do you decide whether to seek to improve, and by how much. Do you work on this time and again, or only once (like pillows)?

From the implementation perspective, there is a danger that everything so far sounds like a lot of data and record-keeping, which for some may feel like anathema. It is an important aspect of ATC, particularly when we look at the psychological benefits of perceiving success and progress, but it could be that someone else does the mapping, measuring and planning for you or the team.

Relationships and resources

This brings us to the question of resources, or constraints brought about by limited resources. The two key limiting resources are time and money. Does everything else track back to these? The size of a team is a resource constraint, but often this is driven by the budget (money) that is available for paying a team.

The models in this book are important because time and money are finite. If they were infinite, or even less restricted, then development would be easier. Every client I work with has a L&D budget. Every team member is more focussed on spending their (limited, say 40 hours per week) work time on delivering results. Time spent on improving reduces the time available for performing.

Abraham Lincoln is reputed to have said "give me 6 hours to cut down a tree and I will spend the first 4 sharpening the axe". If I have a 40-hour working week, how many hours should I spend "sharpening my axe"?

I had a client some years ago, Head of Learning and Development for a London property company, who said that as a result of asking people what they wanted from L&D, that they wanted "just in time" development. If they had to, for example, negotiate with a key customer, they wanted negotiation skills training just beforehand, available in very short chunks from the organisation's intranet. This is a reflection that time is limited – a precious resource and as such must be spent wisely. Whilst this is what the customer wanted, the Learning & Development approach is to recognise that skill development takes time and cannot all be delivered at the point of

need, and to apply their specific expertise to curating a development programme that delivers the clients needs, but in a way that is achievable.

There is a question therefore about how much time and money to allocate to development. Once that question has been answered, the next question is how to make best use of that time and budget.

These models are then created to make good use of limited resources. However, much or little time is spent on development to make sure that the area under the development curve is maximised.

One of the key underpinning concepts within ATC is that of key relationships, those who can help you achieve your goals. These allies are critical and need to be identified and recruited to your cause.

Multiple victory cycles

One of the research questions that I had was around the subjective measures of performance. The research study results were positive. Simply put, progress feels good.

ATC has at its core a desire to ride a wave of multiple small wins – victory cycles – because noticing and measuring progress feels good.

When I was a teenager, I swam competitively. Freestyle and butterfly mainly, 100 m to 400 m. The main performance measure I had available was a stopwatch and a record of PBs (personal best times for a given event). Winning was also a good performance measure but a little too binary and not entirely within one's own control. You could set a new PB and come second for example.

So wins and PBs were important, but could be fairly hard to achieve, especially as one nears the peak of their own performance. This can absolutely be demotivating. Even taking a week off on holiday could feel negative because of the short-term impact on times – because I had no more sophisticated ways of measuring my performance – or rather I was unsophisticated.

ATC allows for measurement of ANY of the performance factors, irrespective of how small. Rather it encourages measurement.

When we link ATC to personal change, we know from models such as Dannemiller's change equation (Cady et al., 2014; Dannemiller & Jacobs, 1992) that dissatisfaction with how things currently are and a positive vision of the future are important to overcome resistance (to change). In the world of developing high performance, change is the goal – you are specifically looking for the future performance to be different from how it is today. Multiple victory cycles allow for the psychological positives to be

realised through an increasingly positive view of the future (progress) and through managing dissatisfaction. Dissatisfaction has to be high enough to help overcome inertia, and having so many measures allows for many more opportunities to notice and be dissatisfied with much smaller aspects of performance.

For Multiple Victory Cycles, there is still dissatisfaction present, but for smaller aspects – and this is both easier to manage because much smaller steps of progress are possible and less psychologically negative because it's only small aspects of performance that are negative, not the entire performance.

Multiple Victory Cycles also allow for positives to be sought even when the bigger picture is negative. Imagine injury or times in organisations where something else becomes priority and prevents progress. Traditionally, these periods of "injury" (I'm referring to all aspects whether personal, physical, or team/organisational as injury) are fallow where the main task is to hurry up and wait to get back on with it.

ATC simply shifts focus to measures that ARE possible to work on.

Injured and training not possible? Use the time to read or developmental skills that are relevant (they should be on the ATC map already). Find another ATC leaf that you CAN work on, instead of worrying about one that you cannot. My summer holiday break from swimming could have been seen as time to work on nutrition, strength and flexibility, honing my motivation by reading about Mark Spitz or VO_2 max by doing another sport. So many things were possible.

Momentum

The next aspect of ATC to look at is momentum – and this is a different definition from the Multiple Victory Cycles in the previous chapter.

Momentum in this case is more the macro momentum than the micro of the Victory Cycles.

Momentum feels like something that can be harnessed by the best, or else be defeated by it:

Why does the last race/match of the season feel more important than any other if it's neck and neck at that point? How many football championships are won for example by teams that started well and maintained their lead, versus teams that (scored the same) but came from behind to win? Theoretically, no single game is any more important than any other if they all score the same points.

Do competitors give up early if someone has a strong lead?

Teams who win with very fine points margin over other teams – how often does the team with the early momentum win? If it's late momentum is that also important?

What can be done to maximise any positive effects of momentum, or to minimise any negative effects?

If we assume that there is a positive effect from being ahead, then the ATC methodology works not just on an individual level (front-loading development time means you make good early progress) but could also have a corresponding negative impact on competitors, as they see you move ahead of them early on.

To boost the feeling of momentum therefore, it is suggested to follow ATC front-loading principles, and also (as we will show later) the OMIT principles – specifically to work as a priority on sub-threshold aspects.

Note

1. Yeany, Bruce. (2006). *If you build it, they will learn: 17 devices for demonstrating physical science.* NSTA Press.

References

Cady, S., Jacobs, J., Koller, R., & Spalding, J. (2014). The change formula: Myth, legend, or lore? *OD Practitioner, 46*(3), 32–39.

Dannemiller, K. D., & Jacobs, R. W. (1992). Changing the way organizations change: A revolution of common sense. *The Journal of Applied Behavioral Science, 28*(4), 480–498.

OMIT

3

OMIT overview

OMIT is an acronym for Optimal, Maximal, Incremental, and Threshold. The four aspects of performance components in relation to how they can be developed. The idea formed after thinking about Incremental and seeing that there are many aspects of performance that cannot be improved incrementally.

The model has two axes (Optimal/Maximal and Incremental/Threshold), which create four quadrants (Figure 3.1):

Optimal/Incremental
Optimal/Threshold
Maximal/Incremental
Maximal/Threshold

There are four quadrants, but performance aspects may not be easily categorised. I have come to appreciate this as a positive aspect of OMIT. Not only is specific placement open to interpretation and opinion, but placement can change over time and as a result of development.

As will become clearer as the quadrants are explained in more detail, once a threshold has been met for example, the attribute may move to one of the incremental quadrants unless there is a new threshold to focus on.

As such, noticing these developmental milestones would help to identify when to stop focusing on development of an attribute.

DOI: 10.4324/9781032631530-3

INCREMENTAL

Keep improving until
reach optimal

Always keep improving –
every increment helps

OPTIMAL —————————————————————— MAXIMAL

ABOVE threshold –
STOP! Maintain only

As much as possible,
up to the threshold

BELOW threshold –
Reach ASAP!

THRESHOLD

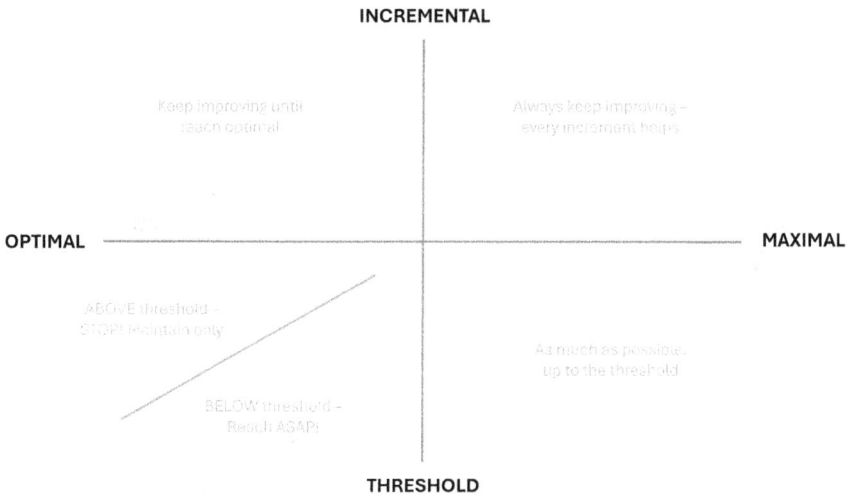

Figure 3.1 The OMIT grid.

For example – typing. What I mean is "using a keyboard". We all use keyboards, on our phones and computers. Physical, with actual keys or touch screen. In the Western world, we use a QWERTY layout, where the first six letters in the left of the top row are QWERTY.

Let's look at a typical user who types with two fingers at say 40 words per minute at 97% accuracy. This user COULD see development as Incremental and look to develop either speed, accuracy, or both through deliberate practice. They may well improve both. But this does not necessarily mean that typing/use of a keyboard fits in one of the Incremental quadrants. This is because there is ALSO a threshold in typing which is the technique known as touch typing. This is NOT an incremental development from two-finger typing. It is a completely different technique. So it could be a recipe for high performance to STOP incremental development of two-finger typing and look to achieve the threshold of touch-typing. Then, once proficient at touch typing, it may again be developed incrementally – but up to a much greater level of speed and accuracy.

What to do? Incrementally develop two-finger typing to 45 words per minute, or achieve the threshold of touch typing, and then incrementally develop to over 100 words per minute? It seems obvious doesn't it? Yet why do so few people touch type? (See also Chapter 5 for the change equation.)

When defining Incremental, it's important to compare with Marginal Gains (Hall et al., 2012; Smith, 2018) as a relatively well-known concept, linked in many ways to Sir David Brailsford and the sport of cycling.[1]

It's easy to see how marginal gains are beneficial. Simply put, make 1,000 things a tiny bit better rather than trying to make 1 thing 1,000 times better.

It also has more than a passing resemblance to the well-known Japanese production philosophies of Kaizen, continuous improvement.

But not everything can be improved incrementally, and even when they can, if you're below a certain level then achieving the level is more important that improving incrementally. If I can only run software on version 10 of an operating system, and I'm currently on version 7, then if doesn't matter even if I upgrade to version 8 (the next increment) because I still can't run the software. I my organisations budget allocation for marketing is insufficient to get us noticed (the threshold) then is it worth spending any of it? Could that budget be better allocated elsewhere to help achieve a different threshold?

The risk of only improving small things that can be improved incrementally, is that you end up only improving small things by a small amount. So we need a better approach, with a wider vocabulary and scope than just "incremental" (or marginal). This is where OMIT comes in.

The aim of the OMIT model is to allow for better use of development time, to help inform better development choices, to help find blocks to increased performance, and to highlight "problem" areas.

The model can be looked at from multiple levels – such as whole organisation, through to individuals and right down to individual projects or issues.

First, let's introduce the OMIT model. The flow for the introduction is first a high-level overview, then each of the two axes and, then the four quadrants.

The OMIT model (Optimal, Maximal, Incremental, Threshold)

X-axis: Optimal and Maximal.
Y-axis: Incremental and Threshold.

The axes of the model relate firstly to the degree of improvement sought – either Optimal or Maximal. There's a point that's good enough, or else more is better.

The second axis looks at whether development can be gradual (Incremental) or not (Threshold).

Throughout, we'll refer to anything that requires improvement. It might be tiny. It might be huge, but key is that it's an aspect of performance that can improve. And by performance, we mean any measure that you're applying to your outputs. At a later stage in the book, we look at how

to develop these aspects in a structured way (see Accelerate The Curve – ACT).

Optimal

Optimal attributes are elements that do not conform to "more is always better", so that there is a point that is seen as optimally good. Good enough. There's nothing to gain by developing this further, or even that it could be detrimental to develop further. There are many personal attributes or psychological traits which are curvilinear.

In behavioural terms, we could look at self-confidence. More is better, to a point. Too much and we see unhelpful or unwanted traits, such as narcissism or over-confidence.

For professional sport it might be weight – in many sports there's an optimum weight that delivers good performance (maybe power to weight is a consideration). So anyone overweight would want to get to the optimum, but not beyond.

The general sense of Optimal is not that there's no point at all in developing further (there may be the next threshold after all) but that your effort is better diverted elsewhere.

Some examples of Optimal aspects of work performance at an organisational level:

Office space: Or physical storage space. Below Optimal life is just more difficult.

Staffing levels: Being short-staffed is difficult for everyone else as there's a degree of stretch that is not present when there are simply sufficient people to cover all the key roles.

Meeting deadlines: A level of reliability that does not need to be exceeded, but makes a difference when met.

Knowledge and skills: If a licence or qualification is required, then even if I am close to achieving the threshold, I am still unable to be useful until I meet, in the first instance, the Optimal level of the licence or qualification. It may then shift to become Maximal, but it is important to recognise where there is initially an Optimal aspect.

Common across all Optimal aspects is the critically negative impact of being below the optimum.

Often overlooked is the negative impact of being above optimum and yet still developing further when there is arguably little or no benefit (as would be

the case for Maximal aspects). Perfectionism is a possible symptom of treating Optimal as Maximal – treating everything as Maximal.

Maximal

More is better. Keep going for more.

Sales, for example. There may be a target but exceeding the target is better!

Nutrition and diet – yes, however good it is, keep improving.

Knowledge and understanding – more!

There is another aspect to Optimal and Maximal that is worth considering, and that is that for some aspects, the relationship between the attribute and performance may be curvilinear – that is more may actually be worse. In psychology, we know that there are some personal attributes, such as self-confidence that is desired, and the relationship between self-confidence and performance is a positive one, but only to a point. Beyond that point, the relationship turns negative.

Some examples of organisational Maximal aspects:

Knowledge and skills: These may at some point have been Optimal (e.g. a licence or qualification) but could then go on to be Maximal.

Trust: In my experience of working with organisations, I have not yet come across an organisation where trust is not Maximal. For both transactional trust (people deliver on their commitments) and vulnerability trust (depth of relationships and for example the ability to admit mistakes), trust appears to be Maximal.

YouTube subscribers: Or customers as we would have traditionally called them. The difference with YouTube or other media is that the cost of production does not change directly, but revenue does. Beyond the key threshold (to be able to monetise your YouTube channel) YouTube subscribers are then Maximal.

Incremental

Incremental may appear to be an obvious inclusion, thanks to marginal gains, or Kaizen – these are the small steps that are discreet and where positive results are manageable, and deliverable at each small step.

Sales revenues are Incremental, even if sales targets or bonus levels are not (see Threshold – which could explain why sometimes sales targets fail to motivate if there's too much of a gap to the next bonus level).

I can lose weight incrementally. I can recruit new customers incrementally. I can develop my running pace incrementally.

However, **not everything can be improved incrementally**, sometimes there is **no advantage from an incremental gain, not all gains are equal, or** the **cost of the gain might be disproportionately high**

Examples of Incremental:

Knowledge and skills: Such as continuing professional development (CPD), where the increments are counted in hours.

Customers: Can be added one at a time.

Sales (value): Could also apply to profit. Increments can be small here, as small as a cent/penny.

Threshold

You can't be a little bit pregnant.

Threshold in our model refers to those things that can either be binary, or the increments are so large as to be seen realistically as a threshold – even if there is another threshold after, the gaps are too big to be seen as incremental.

Imagine a marketing team launching a new company website. At the latest meeting to discuss, they announced that they're "95% of the way there". This sounds good, but the site hasn't launched. They have been treating the project as Incremental, creeping near the finish line.

Except it isn't Incremental. Whilst it's true that they can develop in small steps, the key aspect that matters – the site being live – is Threshold. It is either launched or it isn't.

Examples of Threshold:

Equipment specifications: The hardware is either up to the job or not, and if it is below the required threshold then it will be unable to operate, either partially or totally.

YouTube subscribers. Below a given threshold, YouTube will not monetise the channel. Currently this threshold is 1,000 subscribers and 4,000 hours viewed over 12 months.

Product: Software developers refer to this as minimum viable product (MVP). The threshold here is whether the product can be sold to customers.

Sales targets: Whilst sales are achieved incrementally, targets are often a threshold, either because there is a defined hit or miss, or because there is a large jump between levels of target.

Note that for Threshold, I have not explored here the differences between Optimal and Maximal, instead just focussing on the definition and examples of Threshold.

For these, as with the other dichotomy pair, the performance aspects can move depending on time and iteration. For example, a product may initially be considered Threshold, but once it is above the Threshold of MVP, it could then be developed incrementally.

OMIT quadrants

Why do these resulting quadrants matter? Why not just keep going with incremental gains?

Simply, they have very limited success – noticeable success for sure, but not long-lasting success (Figure 3.2).

What's wrong with incremental gains?

1. Not everything can be developed incrementally.
2. Sometimes there's no overall performance advantage from an incremental gain.
3. Not all increments are equal with a resulting failure to prioritise.

Figure 3.2 The OMIT grid.

4. Difficult to iterate. To quote Team Sky, once you've taken your rider's own pillows on tour, what do you do next?
5. The cost of the gain might be disproportionately high. Pillows are cheap, but where does the cost/benefit curve become untenable?
6. Easy for competitors to copy (see pillows, above).
7. Difficult to remain motivated – do the best gains tend to be made early on when you're making larger gains, or more of them?
8. The timing and sequence of the incremental gains is important. As an overly simple example, there's no point buying all the new (incremental performance-enhancing) kit if you're also going to be losing weight and it won't fit once you've lost the weight!

Rather than viewing incremental gains as wrong, OMIT is more selective, offers alternatives, and a more granular approach. If something cannot be developed incrementally, then maybe it belongs in the Threshold quadrants; if it's difficult to iterate then maybe it fits within Optimal. OMIT specifically includes marginal gains (Incremental) and then is selective between Optimal and Maximal. The purpose of being selective is that it helps with prioritisation of development activities.

OMIT is also easy to remember. This is key to any successful model as the ease makes it portable, lightweight and accessible. Anyone can use it, at any time.

Introduction to the quadrants using a simple example

Having defined our terms, we next need to look at the resulting quadrants, as none of the terms exists independently. As an example, there is a great difference between Incremental/Optimal and Incremental/Maximal. As we will show, simply dealing with these as "incremental" is at the root of why incremental gains are not the complete answer to performance improvement.

Consider this crude example that expands on all aspects of OMIT:

50 kg of coal is required to fuel a furnace for 1 day.

If 50 kg is "Optimal", then there would be no benefit to go beyond
If 50 kg is "Maximal" then there would be a benefit to go beyond
If 50 kg is in a single 50 kg indivisible block, then 50 kg is a Threshold (as is multiples of 50 kg)
If 50 kg is in smaller, say 1 kg blocks, then 50 kg can be developed Incrementally.

Let's unpack each of these possibilities.

"Optimal/Incremental"

If the individual has to deliver 50 kg of coal to fuel the fire, but can deliver these in 1 kg increments. The requirement can be reached incrementally. There is no point in over-delivering (because 50 kg is Optimal), so once this 50kg threshold has been reached, the individual can stop. Personal (or performance) development is in the form of increasing the capability to more than 1 kg at a time, or in moving the 1 kg more quickly or over a shorter distance, thus improving efficiency.

Optimal – 50 kg
Increments – 1 kg
Focus – Incremental gains all help, but only up to 50 kg (optimum).

"Optimal/Threshold"

If the same 50 kg has to be delivered in one 50 kg bag that cannot be divided, this changes things compared with the Optimal/Incremental example. The Threshold is 50 kg so if the individual can only lift 45 kg, they will be unable to deliver ANY coal. Personal (or performance) development therefore is in the form of increasing capability to the point where 50 kg is possible. Until this is reached, no fuel is being delivered and this is a huge performance block, and much worse than "only" 45 kg of 50 kg increments. About 50 kg is still the Optimal amount so, no over-delivery is required.

In our work, it's important to seek the Threshold/Optimal first – as any under-performance is critical, and any over-performance is wasted.

Optimal – 50 kg
Threshold – 50 kg
Focus – reach threshold asap, as until then performance could be as low as zero.

"Maximal/Incremental"

As with the other examples, 50 kg is required daily, and in 1 kg increments. With this example though, there is a benefit to over-delivering beyond 50 kg because performance is now Maximal and not Optimal.

About 50 kg could therefore be seen as the minimum, and any additional coal can be used to fuel other furnaces and enhance efficiency. Personal

development is in the form of "going faster", which may be carrying multiples of 1 kg at a time, or reducing the time/distance to carry, etc. Even 51 kg is "better" than 50 kg, so this should be a priority area for development.

Maximal – beyond 50 kg brings benefits
Incremental – 1 kg increments so performance can be raised in small chunks
Focus – get to minimum asap, then continue to develop.

"Maximal/Threshold"

As this is again Threshold, the coal is in 50 kg bags that cannot be subdivided. Maximal means that there is an advantage to over-delivery, but this would only be noticeable at 100 kg (2 × 50 kg). Therefore, there is no performance benefit until the individual can carry 100 kg (2 bags) at a time. Until the NEXT threshold is reached, any small increases in performance have no effect. Personal development then need to be tactically effective – working in a way that will deliver the next threshold as soon as possible.

Maximal – beyond 50 kg brings benefits
Threshold – 50 kg
Focus – Performance cannot be noticeably developed until the next
 threshold – so get to 50 kg is the focus, or see of 100 kg is possible.

In Chapter 7, I will look at the practical implications for using this model, but for now I want to explore each of the quadrants in more detail. It is my assertion that any aspect of performance can be put into one of the quadrants, and that each quadrant suggests a slightly different focus and approach for development – so it is important to be able to determine which quadrant any aspect sits within.

It is important to consider that the OMIT quadrants I see as being subjective, not objective. It can be really useful for a team to discuss, and determine for themselves each performance factor sits.

Performance aspects can move around quadrants as they develop, and this is one of the key realisations for this model. Something that is initially Optimal/Threshold may, once the threshold is reached, then move into the Optimal/Incremental or any other quadrant. As an example of this, Leicester City Football Club (see Chapter 6) reported that beetroot juice had a positive performance effect. So initially, this could sit in the Optimal/Threshold quadrant (Threshold because the shift is from none to some – and Optimal because it's unlikely to be Maximal in my view).

Once the players start taking beetroot juice, it may move into the Optimal/Incremental quadrant as they experiment with how much juice, and of course it can be increased or decreased in small quantities.

Recognising the shift to a different quadrant is therefore important, and reinforces the purpose of iterating the mapping of performance aspects.

The next section looks at each of the four quadrants.

"Optimal/Incremental"

Optimal – enough is enough
Incremental – gains are small enough to be developed in small steps.

Identifying Optimal aspects is important, and often solely to make sure that development focus is switched elsewhere – either to a sub-optimal aspect, or a Maximal aspect.

If performance is below optimal then the focus for development is on reaching optimal as soon as possible and in the Optimal/Incremental quadrant this will be through incremental gains.

Once the optimal level has been reached, focus on development can stop, and any performance activity is focussed on maintaining this level. This is an important step that is not often recognised.

Instead, people and organisations tend to continue with the same level of development activity as a habit/routine. The level of intensity required to get to the optimal point is greater than the intensity required to maintain that point, so the ideal is to achieve optimum, then determine how little is required to maintain. This leaves time to shift the intensity elsewhere, so a steeper learning curve (ATC) and where greater gains can be made.

Examples of Optimal/Incremental:

Onboarding. New hires have a steep learning curve to get on board with the new organisation. Sufficient competence is required in many areas before the recruit is able to contribute well. These basic requirements are multiple, and can be developed incrementally, and only need developing to the point of sufficiency. Beyond this, time would be spent that could otherwise be better spent on deliverables. Most organisations know the cost, and the value of onboarding and to accomplish this to an optimal level as quickly as possible. **Typing speed and accuracy**. Most people do not continue to develop their competence and skill beyond what's required to do their job well enough. My own typing speed and accuracy could be considered poor, but it is sufficient for me to write this book as I can generally type at a speed that gives me time to think. Or rather I can think slowly enough to be able to type at the same speed! (you can check your own speed and accuracy here:

https://www.keyhero.com/free-typing-test/). I type at about 40 words per minute at 97.85% accuracy.

So here's a question. Why do I not develop my typing speed and accuracy? This is something easily measured, easily developable and improved and with a clear link to improved performance (speed of working). Why don't any of us? Why does every organisation not develop the typing speed and accuracy of every employee? A quick Google search suggests 40 wpm is average, with 60 wpm as "productive".

Typing then is an example of Optimal/Incremental – I would say that 60 wpm is optimal, and worth the effort to develop to that point. It's also clear that once at 60 wpm, no further time is required to continue to develop, as the time we spend typing is continued practice. It could also, however, be an example of Optimal/Threshold, because with typing there is a definite point to get beyond, and that is touch typing. Below the threshold (e.g. two-finger typing) your speed and accuracy are limited. To improve beyond this you probably need to shift to touch typing, and this is a completely different technique from below the threshold.

Weight loss. This is not an organisational performance measure of course – this refers to people who personally want to lose some weight. It is Optimal because it could only be considered Maximal if weight loss could continue indefinitely with positive benefits at all stages.

Induction/onboarding activities. Getting new hires up to speed with any software/knowledge, etc. that will help them get them able to start performing well is important, as there will be gaps in their performance until they know sufficient to be able to perform adequately. Most organisations carry out onboarding activities in a focussed way at the start of employment, which absolutely fits with the OMIT model of speed and focus on sub-optimal factors.

From your own world … what is something that can be developed incrementally, but where there's a point where you don't need to keep developing further?

"Optimal/Threshold"

Optimal – enough is enough
Threshold – gains are only realised once over a key threshold – either a binary threshold or a much larger step than an increment.

This quadrant is the domian for essential requirements, and for recognising where the current level is below that required. If attending a conference is important, then a ticket to get in is an Optimal/Threshold requirement.

If you are launching a new product, then developing to the point where it is marketable might be the minimum acceptable level in the short term.

Focus is the keyword for development within this quadrant.

This is one of the most important quadrants to identify performance aspects. Anything that is below the optimal threshold needs to be developed with the utmost importance and priority. Anything that is above the optimal threshold that is still being developed should cease further development.

Optimal/Threshold is where there is an optimal level of performance, and also where there is a key threshold to be above. Easy examples are key qualifications. A driver's licence unlocks a threshold, and once over it there is no need to continue to develop the skill (no need maybe, but plenty of reasons to!). In a work context, it may be a qualification that unlocks not just performance but promotion or salary too. In a sporting context, it could be promotion to the next league, or to a "finals" event (e.g. World Cup).

If I continue the typing speed and accuracy example from Optimal/Incremental, I mentioned above that it was also an example of Optimal/Threshold because of the Touch Typing threshold. What this means is that if I am currently below the threshold and below optimum, then I really need to focus and develop this as soon as possible to at least achieve the threshold. Whilst touch typing is an example of a threshold, it's not necessarily the best example because it is still possible to type even below the touch-typing threshold. It's just that a different level of performance is unlocked above this threshold.

Where threshold really has meaning is because performance below the threshold is effectively zero. If I need to lift 50 kg and I can only lift 49 kg, then I cannot lift 50 kg **at all**. If the next threshold is 100 kg then the optimal level is arguably 50 kg, for there is also no discernible benefit from being able to lift 55 kg or above, unless 100 kg is achievable.

This is easily tested by the notion of "next level". What is the next level in something that you do? I was at an amateur triathlon event recently and noticed that not all competitors did a "flying dismount" from their bike. This is where at the end of the cycle part, the competitor does not come to a standstill before getting off their bike. It's faster to get off the bike and continue running as you cross the transition line, but it's definitely a next-level skill, and many triathletes stop their bike before dismounting. My guess is that all of those athletes would happily cut a few seconds from their run personal best (PB) and probably specifically train to do that. The threshold of a flying dismount is figuratively a barrier that is beyond them.

For your work, or chosen sport, there is probably something that is "worth doing" but also feels like a barrier that requires too much effort to overcome. Finding these Optimal/Threshold areas is really important – think of them as gold dust! They have the potential to unlock a greater leap in performance

than any other gain because they move performance from zero. Back to typing ... as a two-finger typist the maximum speed is probably 50 wpm, but once over the touch-typing threshold, the maximum is more like 200 wpm.

The other noticeable and important aspect of thresholds, is that they often unlock something else – another key performance factor, so there is a multiplier effect. The ability to touch type gives the ability to maintain eye contact whilst typing – so you can make notes whilst on a team's call and continue to give attention to what's happening on screen.

Optimal/Threshold examples:

Touch typing, a qualification or licence, promotion. Anything that is seen as an essential requirement. An entry ticket – each person only needs one, so Optimal not Maximal.

Any performance aspect that is currently at zero – something that is missing individually or as a team, and could be something that you see as being compensated for elsewhere.

"Maximal/Incremental"

Maximal – more is better
Incremental – gains are small enough to be developed in small steps.

Momentum here is the keyword for developing within this quadrant. Knowledge and skills sit very well generally in this quadrant. Different from qualifications or licences (which are Threshold), knowledge and skills can be developed (usually) incrementally, and also Maxmally – more is better.

My company runs a nine-month leadership development programme annually called ASPIRE. We can run with as many delegates as we want; 12–18 for each cohort and whilst 12 would be a threshold, it's more accurate to see this as Maximal as we can run as many cohorts as required. It's also incremental as we can sign up people one at a time.

I compete in triathlons and do long-distance cycle events. I know that any training ride I do contributes to my overall performance, and I can do training rides one at a time. Training rides are therefore Maximal/Incremental.

At an organisational level, revenue/sales may not be Maximal/Incremental, or it may be for some revenue streams and not for others. In other words, some sales are better than others. Margins need to be protected. The expression "busy fools" applies to organisations as well as individuals. You need to develop the right sales, the right customers. Are the organisation's systems and processes, reward systems, etc., aligned to create the conditions where the right mix of sales is developed?

Aspects that fall in the Maximal/Incremental quadrant do not have the same urgency necessarily as the sub-Optimal/Threshold quadrant. Conversely, they can be developed constantly, rather than as a short-term focus. Development activities therefore would most often be regular, impactful, repeatable activities that bring incremental results. A weekly LinkedIn post to generate discussion for example. Regular marketing activities.

Key here is to be deliberately selective and differentiate between Incremental and Threshold. Sales may well certainly be Maximal, but whether they are treated as Incremental or Threshold will determine where targets are set for example. Aligning organisational and personal goals is also important. The organisation may treat sales as Incremental, but if the individual sees sales as a threshold (there's a sales target to hit and no clear benefit individually beyond this target), then the mismatch may be noticeable in sales results.

Examples of Maximal/Incremental:

YouTube subscribers, once the monetisation threshold has been reached; or well before the next threshold, subscribers can be recruited one at a time, and more is definitely better

Knowledge and skills: Learning a second language would be a good example here; regular activity designed to maintain momentum for learning.

"Maximal/Threshold"

Maximal – more is better.

Threshold – gains are only realised once over a key threshold – often a much larger step than an increment.

Qualifications or licences that have a material performance impact sit in this quadrant. Not every qualification or licence is maximal though, and many are Optimal – but almost all will be Threshold. You either have the qualification or you don't.

From an organisational perspective, then commercial products can fit in this quadrant. The first example that came to mind for this section was that of Microsoft developing Word.

Maximal – of course, it was to be a world-beating software.

Threshold – until it was launched, it did not exist as a product that could be bought or used, and therefore generate revenue. WinWord originally had a one-year schedule, expecting to be released in September 1985. It was actually released in November 1989. (From the excellent book Rapid Development by Steve McConnell.)

The second example is that of learning to play a musical instrument. When learning to play guitar, an example of a key threshold is knowing scales. Up until that point, you could play many songs on the guitar, but once you know the scales, you can play the instrument. But you would not stop there, so although there is a threshold, it is also Maximal in that now you can continue to learn and develop. If "Optimal/Threshold" is a door to be opened, then "Maximal/Threshold" is a doorway to a staircase.

Examples of Maximal/Threshold:

Sales – easy to consider as Maximal, but instead of Incremental, there may be a production Threshold that requires consideration, for example, or any other resource that may struggle above a Threshold

Qualifications. There are plenty of industries and occupations where qualifications are helpful, important, and necessary. They are Maximal and are also Thresholds because whilst the learning may be Incremental, the qualification is achieved as a Threshold.

As with Optimal/Threshold, it is important to consider whether you are below or above threshold. If a licence or qualification is required, then until that threshold is met, the performer is unable to do their job at the required level. A driving licence is a simple example; I may be learning to drive and increasing skill incrementally, but until the licence is granted, I cannot legally drive. Being below the threshold (passing the driving test) may only be a tiny increment away, but the effect is magnified because of the threshold. It is clear then that if it takes, say, 20 hours to learn to drive, those 20 hours are compressed into the shortest elapsed timescale.

If I am studying for 2 licences, both will take 20 hours to attain proficiency to be able to pass the test, should I study simultaneously or sequentially? The elapsed time for both will be the same, but sequentially allows me to pass one test at the halfway point, and of that test unlocks a useful advantage, then it is worth taking the sequential route.

This gives another level to the OMIT prioritisation – it's not just important to look for below-threshold aspects but to then consider the timing and sequence of multiple thresholds.

OMIT moderators

ATC and OMIT work on the basis that time and other resources available for development are scarce, and maximising the effect of any development activity is therefore beneficial.

However, this works on a rather general principle of scarcity, rather than a specific scarcity, such as budget or indeed time.

Let's use as an example an organisation that runs a fleet of trucks and employs drivers. At an organisational level, the better qualified and more experienced drivers perform at a higher level. Not just the day-to-day performance but at a higher level too; accident rates are lower, wear and tear on vehicles is lower, maybe even customer satisfaction scores higher.

So organisationally it is beneficial to hire better qualified and more experienced drivers. There may be a cost premium for this though and that's a commercial decision whether the budget is available.

At an individual driver level, how does the driver view their own development – do they see the link between qualifications, experience, and performance (and pay)? If both the driver and the organisation have aligned views on qualifications, then the budget question is whether to spend hiring better qualified drivers, or to develop existing drivers. The third option is that no budget is available and this is where budget is a clear moderator of the OMIT positive effects.

However, instead of working down from available budget and deciding what to spend on, OMIT highlights areas for development and working from this end up, it would be interesting to look to develop skills within the budget constraints. For example, the better qualified and more experienced drivers could help develop the others – some of the effects of the development would be realised without the cost of the qualification/test.

Scarcity of resources will always act as moderators, but that makes ATC and OMIT more powerful potentially. If there were no constraints on what could be developed, then arguably everyone would be performing at their maximum capability, eventually.

The "eventually" here is key – OMIT and ATC are both about prioritisation and timing of development activities, and even with the same resource constraints as your competitors, the sequence of development may deliver an important advantage.

Note

1. https://www.bbc.co.uk/sport/olympics/19174302

References

Hall, D., James, D., & Marsden, N. (2012). Marginal gains: Olympic lessons in high performance for organisations. *HR Bulletin: Research and Practice*, 7(2), 9–13.

Smith, W. Bret. (2018). Marginal gains. *Foot & Ankle Specialist*, 11(4), 306–307.

Research and data **4**

In 2017, I conducted a small research project to explore hypotheses around front-loading development time. The title of the research was: "Topical sequencing and spaced practice – their impact on task performance, motivation and learning. Do quantifiable differences in spacing (front-loading, back-loading or linear) correlate with objective and subjective performance measures and allow for a cumulative advantage?"

I have set out below a summary of the thinking, design and outcomes of the research, and Appendix has an edited version of the research paper, that has only been shortened to remove the elements that have been updated and included elsewhere in the book, such as other theories and literature reviews.

Background

Sometime around 2014, whilst working at ApplianSys, Roger Clark, and I realised we shared common backgrounds, interests, and goals around sporting achievements not just when we were younger, but for our similarly aged children. My son Charlie and I had been doing Triathlons for a while (I swam competitively as a youngster), but Charlie was knocking on the door of Team GB age-group events. Roger's older children swam competitively for Team GB and his younger children were excelling at various sports and academic pursuits. There's a lot of high achievement in both

DOI: 10.4324/9781032631530-4

of our families. Roger started to share his thinking around something he referred to as accelerate the curve, that front-loading development time could lead to achievement benefits. This piqued my interest and I decided to use the research environment to see what I could scientifically develop from Roger's ideas.

Research design

The format for the research was simple – find a skill where research participants would have reached a plateau and create a defined development programme that varied only the timing of the development and left the total amount of development time consistent.

In random groups, measure performance to set a benchmark and test for plateaus, and then measure performance at the end of the project when all candidates had completed exactly the same amount of cumulative development time over the same elapsed time. They would all spend 5 hours in total, spread out over 5 weeks.

I settled on typing speed and accuracy for a number of reasons. I worked mainly in offices where many people used a keyboard, so I had access to large pools of potential research candidates. The plateau was likely – we all spend plenty of time typing but do not expect our speed and accuracy to change. It's a very good example of a skill that does not change just by doing more of it – to develop, you really have to undertake deliberate practice.

The candidates were assigned randomly into one of three groups. One group spent 1 hour each week (linear pattern); another group spent 2 hours for each of the first 2 weeks, then 20 minutes for each of the final 3 weeks (front-loaded). The third group practised for 20 minutes for the first 3 weeks, then 2 hours for the final 2 weeks (back-loaded). For all groups, the total practice time (5 hours), the elapsed time (5 weeks), and the sequence (all followed typingclub.com typing skills online course) were the same in order to measure differences caused only by the patterns of practice. There were also tests a few weeks later to see what the lasting impact of the practice had been.

The shape of these three practice curves was differentiated by the area under the curve – the front-loading curve having the greatest area beneath, the back-loaded curve having the least area beneath.

Hypotheses

Hypothesis 1

Practice time AUC (area under the curve) positively influences typing speed performance gains.

Hypothesis 2.

Practice time AUC (area under the curve) positively influences typing accuracy performance gains.

Hypothesis 3.

Practice time AUC (area under the curve) positively influences self-efficacy.

Hypothesis 4.

Practice time AUC (area under the curve) positively influences skill retention longevity (measured by the decline in performance between weeks 6 and 7).

Results

Very simply, Hypothesis 1, typing speed increasing as the area under the curve increases – was supported. The group that front-loaded their development and did 80% of their practice in the first 2 weeks, saw a significantly greater performance increase.

However, between the linear group and the end-loaded group the results were not significant. So to achieve the best increase in typing speed over 7 weeks of practice, front-load the practice time pattern.

Not all hypotheses were supported by the research. I'd like to think that the main causes for this were poor study design and flaws in the process, and only more research will help uncover this.

Essentially though, what was seen was supportive of the principal hypothesis, and remember, each candidate spent exactly the same amount of time practising (5 hours spread over 5 weeks) and when only the shape of the practice curve was changed, significant increases were seen, not just from where their start position was, but compared with the other two practice groups, and to a statistically significant degree. Statistical significance means that this takes into account the possibility of false positives and the effect of group size (e.g. the likelihood that, though randomly selected, I managed to put the "better" candidates into the same front-loaded group).

Other key theories and psychologists

5

The purpose of this chapter of the book is to explore the boundaries and overlaps with other key theories. In some cases, there are other theories that help to explain accelerate the curve (ATC) and Optimal, Maximal, Incremental, and Threshold (OMIT); in other cases, there are theories that enjoy an additive effect in conjunction with ATC and OMIT.

As an example, if we look at theories of motivation, we know in over-simplified terms that increased motivation leads to greater performance, and if ATC and OMIT are looking for greater performance then it makes sense to overlay what is known about motivation with what is emerging with ATC and/or OMIT. If motivation and performance are positively correlated, then to what extent can ATC and OMIT be linked with motivation?

Where there may be additive effects, such as linking Augmented Feedback with the feedback aspects of goal-setting theory (GST), those areas will be highlighted and questions asked, but none of these questions have been tested here, so they are, at best, speculative.

The theories have been grouped together and cover change, cumulative advantage/disadvantage (CAD), motivation, self-efficacy, skill acquisition and practice, and talent.

DOI: 10.4324/9781032631530-5

Change – the change equation (Dannemiller)

Introduction

Performance development is about change. Changing the input to aim to change the output. Whether the change is to a process, or requires a person to do something, the focus is consistent, in that we're hoping that by doing something different, we get a different result. If I study harder, I'll do better in my exams; if I eat differently, I'll lose weight; if we enhance our recruitment, we will hire better candidates.

If performance is about change, then understanding the relationship that people have to change is important, because change doesn't happen just because it should.

The theory

In Chapter 3, I discussed the use of a keyboard and suggested that it would be an obvious choice to make the threshold change to touch-typing and then incrementally develop from there to a much higher level of performance than is possible with two-finger typing.

So why do so many people stick with two-finger typing? To broaden this further, when faced with clear improvements and potential benefits from changing an aspect of behaviour, why as humans do we often NOT make the change? Many of us could lose weight, eat more healthily, get fitter – we know how and we know the benefits, but often we do not actually change.

It might be useful here to introduce the change equation.

The version in Figure 5.1 is the one I have been working with professionally in Organisational Development since the late 1990s. I have always attributed it to David Gleicher and Richard Beckhard, but in the form shown here in Figure 5.1, it is more accurately attributed to Dannemiller (Cady et al., 2014; Dannemiller & Jacobs, 1992) as it is a development of the original Gleicher change formula.

D – Signifies the degree of dissatisfaction with the current situation.
V – The vision of what can be done and what is possible.
F – A plan of the first concrete steps that can be taken towards materialising the vision.
R – The resistance to change.

$$D \times V \times F > R$$

Dissatisfaction
with the status quo

Vision
of possibility, more than the
absence of pain in the
present situation

First steps
in the direction of the
vision

Resistance
to change

Figure 5.1 The change equation.

For the typing example:

D – There's insufficient dissatisfaction; 40 words per minute is OK!
V – I can't think or speak at 150 words a minute, so what's the point of being able to type that fast? (The vision isn't positively powerful enough)
F – How do I go about switching to touch typing?
R – Resistance can come from, for example, the perception that current speed and accuracy is sufficient. Positive changes to D, V and F can overcome the resistance.

The reason for the inclusion in this book is that many aspects of performance development require change. Unless the development is part of your routine and you are achieving incremental progress without changing your routine. Even then, the likelihood is that there may be another aspect of your performance that can be developed that, for the time invested, may give a greater gain and then the change that is required is to alter your routine.

A change in performance is almost guaranteed to require a change in you, in your inputs, in your behaviour or mindset. Newton's first law, the law of inertia, suggests that if nothing changes, then nothing changes.

Interpretation of the change equation

This formula for change suggests that a successful change is possible only when the product of D, V, and F, is greater than the resistance to change. Since the formula involves the multiplication of the three variables, if any variable is completely missing or is too low, the end result will also be low.

This implies that falling short on any one of these variables will make it difficult to get past the resistance. The change plans can fall back if any of these factors are ignored during the change process.

To implement the change successfully, performers need to strategically work towards increasing the three variables. And for that, understanding these variables and making them to work for you are the two important caveats to get the most out of this change formula.

D — DISSATISFACTION WITH THE CURRENT SITUATION

If people are completely satisfied with the current situation, they will have no reason or motivation to change. Increasing dissatisfaction is important, or deliberately focussing on the negative aspects in order to notice the dissatisfaction.

As a trivial example. Why would you change your refrigerator if you have no problems with it? If you needed to change the item, then you could choose to notice aspects of dissatisfaction that you would not be immediately aware of. You could investigate its electricity consumption, its noise levels, its efficiency or other aspects that would help you to create even a small amount of dissatisfaction.

When you're comfortable in your current situation, you have no inclination to leave your comfort zone and embrace change. Change is welcomed only when there is a degree of dissatisfaction, and how much dissatisfaction may depend on the other variables.

To create that willingness for change, you need to explain why things cannot go on the way they currently are.

From an organisational perspective, when you're trying to bring about change you may need to help notice dissatisfaction, and this could be at multiple levels.

- Problems for the organisation as a whole
- Problems for the consumers or clients
- Problems for the employees.

The dissatisfaction, as with the other variables, need to be felt by the person who needs to change. Wanting to change is in part down to wanting to avoid the current dissatisfaction.

V — VISION OF THE POSSIBILITIES

If you're not aware of the possibilities ahead, why would you take on a new path? We all need a concrete and tangible vision of the possibilities and the end results, in order to accept and implement change.

Organisationally, management has to make efforts to get everyone to buy into this vision of the future. The picture of what lies ahead has to be crystal clear, because any ambiguity in what can be achieved will make everyone to go off course. Again, this is not management's vision – the vision needs to be personal for the person changing. Too often, change projects are derailed by this. If you want someone else to change, they need to have a positive vision, and that vision may not be the same as yours.

Each individual involved will be keen to know what's in store for him or her. Thus, when painting this picture of the future, how the organisation will benefit from the change is less important than how the individual will benefit.

The clearer the vision, the more enthusiastic people will be to put in their efforts to realise it. Let them know how the change will benefit them, and they will be your allies in achieving that change.

F — FIRST STEPS TOWARDS CHANGE

Being dissatisfied with the current and possessing a clear, positive picture of the future is not enough to motivate people to change. The third variable of the formula for change steps is knowledge of the first steps in the direction of the vision.

Is there a planned path or a sure-fire way to achieve the vision? Unless everyone one knows how the vision will be achieved and what the process entails, they will not be open to change.

There are plenty of quotes relating to these first steps.

> the hardest step for a runner is the first one out of the front door
>
> the heaviest weight at the gym is the door
>
> everything begins with the first step

There is a UK domestic abuse charity called first step. Domestic abuse is a terrible example for change, but a useful one. We can fully understand the level of dissatisfaction, but often what is missing is a positive vision, and knowing how to take the first step.

With each of the components of the change equation, they need to be sufficient, together, to overcome resistance. If there is still resistance, then explore which of the three factors could be enhanced.

The second aspect of this formula is to link resistance with Johanna Konta's pain equation "pain × resistance = suffering", (see Chapter 6) which again highlights the importance of resistance, or rather the acknowledgement of and personal understanding of resistance. In Konta's case,

resistance isn't something to be overcome (which is the focus of the change equation), it is something to be understood and reduced.

From the pain equation perspective, resistance is the desire to change when you can't. This contradicts what I said above "many aspects of performance development require change" – it would seem that some aspects of performance require no change and that may also be difficult to achieve.

R – RESISTANCE

Resistance is a factor in this equation. Even change, which seems necessary has only happened because resistance has been overcome, even if resistance was only slight. That's an important point to make because in looking at the other aspects of the equation (dissatisfaction, vision, and first steps) we can overlook the point, which is that resistance is an almost human constant.

Overcoming resistance then is in part down to the other three aspects being sufficient. But it is also key to understand the resistance with greater clarity.

It would be easy to posit that resistance is just about pain, and that we are simply avoiding pain – and because we all perceive and experience pain differently this accounts for the wide range of resistance. Risk, for example, is something we each have a different appetite for or attitude to. It could be said that our attitude to risk is only serving to mitigate what we perceive is the likely pain that derives.

An example

An organisation I worked with many years ago was experiencing pain from an important member of staff who created issues within the team. A bully.

They knew that they should deal with the issue, but the person in question was a high-performer (as they defined performance in terms of financial results, sales).

The organisational resistance to dealing with the situation was that sales would suffer.

The dissatisfaction was high, but not as high as they perceived would be the case from the financial impact.

Their vision of the future was not positive enough.

The first steps – yes, they knew these.

Ultimately, until they were prepared to acknowledge the actual resistance (sales might drop) and overcome this, they were unprepared to take action.

Conclusion

Change is constant, and high performance is likely to involve doing something differently from how you are currently. Looking at all the components of the change equation is likely to enable the change.

Skill acquisition and practice

ATC started as a theory around skill acquisition and practice. The simple question of whether it would be beneficial to front-load practice, get to a reasonable level, and then all subsequent practice is at a higher level.

There are other theories of skill acquisition that are worth exploring here.

Non-linear pedagogy

There is a degree to which when I think about developing a skill, I think of that development journey as linear, sequential, structured, and I suppose traditional.

The idea that we "learn the basics" and then progress from there, and that practice is often single-skill, repetitive and based around some sense of what the ideal is. This approach would be termed Linear Pedagogy. A one-size-fits-all sequential approach that includes drills and repeated practice, skills that are taught, and often practiced outside of the real environment. We are all maybe familiar with the idea of everything being fine in practice and then falling apart when we have a real opponent. "Everyone has a plan until they get punched in the face" according to Mike Tyson.[1]

By contrast, nonlinear pedagogy is based on development within complex, adaptive systems. It is more learner-centred and dynamic. Other broader differences compared with Linear Pedagogy are that it is non-proportionate, meaning that inputs and causes can bring about a disproportionate outcome, and that a single cause could lead to multiple effects (known as multi-stability). This non-proportionality and multi-stability is interesting to me as this resonates with the effect of ATC that we are seeking. There is also mention of threshold in relation to Nonlinear Pedagogy, with the example of learning to ride a bike – there is a speed threshold for balance and being below the threshold, even if the speed is faster than before, will still be below the balance threshold and not easy to balance (Chow et al., 2021).

The link with ATC is unclear; Nonlinear Pedagogy may well enhance ATC further, with development activities designed along these lines; adaptive practice that takes account of an interactive, complex, and adaptive system.

Anders Ericsson; Deliberate practice

Introduction

ATC started as a theory looking at the pattern of practice time, to see if front-loading practice made a material difference (compared with end-loading – cramming – or a linear approach).

The brief summary outcome of the research is that there is a positive effect for no additional time cost.

If, therefore, we can say that the timing pattern of the practice is relevant, and not just how many hours of practice, then it makes sense to have a look at one of the best-known and widely acknowledged theories of development, that of Anders Ericsson's deliberate practice.

The theory

Any writing on the subject of skill acquisition would be incomplete without mention of Anders Ericsson. Popularised by Malcolm Gladwell, the idea is that mastery takes 10,000 hours of deliberate practice.[2]

Ericsson's paper "The Role of Deliberate Practice in the Acquisition of Expert Performance" highlights even from the title the narrower focus that this "rule" has (Ericsson et al., 1993).

Gladwell's promotion of this as a "rule" is somewhat of an oversimplification, but at the same time has helped move another aspect of psychology into public awareness. It has also influenced subsequent studies, such as the 2014 meta-analysis (Macnamara et al., 2014). Their results showed that deliberate practice accounted for a maximum of only 26% of the variance in performance, and as little as 1% of the variance – these in games and professions, respectively. Deliberate practice therefore may not be as important as thought, and that is before we look at how much deliberate practice.

It also suggests that we look for the moderators of the success of deliberate practice.

Next, the question of success vs mastery – The Sex Pistols (1970's punk band) were successful despite Sid Vicious certainly not having mastered the bass guitar, and Duran Duran (1980's pop band) stating that at the time of their initial

success they were "playing every note they knew". It might be therefore that success and mastery are being conflated. For many people that distinction may not be relevant, but for this book it could be critical. We are absolutely focussed on the idea of high performance, and that is dependent on what the goal is – for some, the goal might be success, and for others, the goal might be mastery.

In relation to ATC, then we are looking to maximise the effect of the 10,000 hours.

In relation to OMIT, we are looking to narrowing the focus which will depend on where mastery is required, and this is starting to sound like the distinction between Optimal and Maximal. Mastery certainly being Maximal, but for high-performance, it is not necessary for every aspect or component of performance to be Maximal.

An example

Ericsson's theory is about cumulative practice time, and that practice being deliberate. We saw from the research into ATC that time spent merely doing a task is not the same as time spent deliberately practising. You may spend time every day typing, and as we saw from our research subjects, their typing speed and accuracy does not change from one month to the next, irrespective of how much time spent typing. The only factor in developing typing speed and accuracy was when the subjects spent time on speed and accuracy development.

Conclusion

Where you are looking for performance gains, you may want to think about how you are currently approaching development. Doing an activity may not be as beneficial as actively practising. And if your active practice follows ATC principles of front-loading development time and steepening the learning curve, then your invested time may well bring about better returns.

Augmented feedback

Introduction

Augmented feedback is where additional extrinsic feedback is given to the performer about their performance – feedback that would not otherwise be known to themselves (intrinsic feedback).

I read a study on jumping and landing forces. It seems that in many sports there are a lot of injuries that occur as a result of landing from jumps. The research looked at how augmented feedback (and other feedback mechanisms) compare for softening the landing. (Onate et al., 2001). The outcome of the research was that Augmented Feedback was a relevant factor in reducing landing injuries. Compared with participants determining for themselves how to land more softly, subjects who received video and verbal analysis suffered reduced incidence and severity of injuries. This is despite all subjects of course having the aim and intention to land softly and reduce injury!

The link to this book is that "feedback" has been a factor in many areas of development, and in other theories such as the GST of motivation. It seemed therefore to be useful that if there are parallels that can come from augmented feedback into other areas in order to enhance "feedback" then this is worth looking at further.

The theory

In the field of motor control and learning, including injury rehabilitation, augmented feedback is referred to as any feedback extrinsic to the performer. A physiotherapist may be able to notice patterns and shifts that the individual themselves is not aware of.

Organisationally, in behavioural development, I often use video to augment my feedback to an individual as they are looking to master a new skill – a particular influence style, for example. In this case, my feedback and the video would serve as augmented feedback.

Links to ATC and OMIT

First – for any performer, to introduce augmented feedback into any performance development feedback where possible – that is to develop processes that include knowledge of performance feedback that the performer would not otherwise know. To clarify further, Knowledge of Performance would be better described as knowledge of the "how" of performance, where the intrinsic feedback would be the "what" of performance. An example of this might be that a sales person will know (intrinsic) whether a sale has been made, so they are aware of their performance. But to have augmented feedback on their skill and behaviours from an observer (extrinsic feedback around knowledge of performance) will help them to adjust their behaviour in order to be more successful. This is of

course the way in which organisations develop their individuals, but less so how they develop teams.

Second – for sports, to note the link between injury and softer landing when jumping. Therefore, if jumping is a factor in the given sport, and if injury prevention is on the ATC map for that sport, then it would be useful to incorporate augmented feedback into developing softer landing when jumping.

An example

Video, or any external perspective may be useful for any motor-skill or behaviour. This may be useful alongside a version of "what good looks like".

Conclusion

Feedback is an important part of the development process, and augmented feedback looks to enhance this.

Self-efficacy

Whilst self-efficacy can be defined broadly as task-specific confidence, with the resulting correlation between increased self-efficacy and increased performance as a simple yet obvious outcome. However, the interest for me in this book is the link to not just effort, but to perseverance in order to overcome obstacles.

"Success seems to be largely a matter of hanging on after others have let go". William Feather, US Author, 1889–1981.

So high performance can be synonymous with success, and hanging-on synonymous with perseverance.

The Team GB canoeing Olympic gold-medallist Ed McKeever spoke to a group of graduates in a global oil and gas company that I was working with a short time after the 2012 London Olympics. He said that he was one of the only athletes in the team that turned up to every training session for 4 years. When asked by the graduates how he managed to do that, Ed replied that it was his job, in the same way that he expected that they would turn up to work every day. I'm not sure which was more of a shock to the graduates; the realisation that his job as he saw it was to turn up and train, or that his job seemed so different from anyone else's that the idea of diligence and

perseverance was alien. Is there a correlation between turning up every day and high performance? I would think so and certainly would not want to bet against it.

I have not yet talked about team culture, but turning up every day says as much about the culture of a team as it does about training discipline. In the same way that GST highlights performance difference between goals that are high, and specific, and goals that are "do your best", a culture of turning up every day is different from "turn up as often as possible". This small section of the book is discussing self-efficacy, but already it is highlighting links to other theories such as GST.

Back to self-efficacy. Task-specific confidence, the belief that the behaviour will attain the goal, and the belief that you can achieve the behaviour. This section of the book will also look at how other's belief in you, as well as your own self-belief, impacts on your performance (known as Pygmalion and Galatea effects).

Social cognitive theory; Albert Bandura

Introduction

Social cognitive theory (Bandura, 1986) is concerned with the developmental changes that humans undertake in the course of their lives and the causes and mechanisms of their behaviour and motivation (Bandura, 1989). Core to this is the understanding that self-regulation and self-direction are in effect skills that can be developed (or have component skill elements that can be developed). The link to this book therefore is that if self-efficacy is positively correlated with performance, and if self-efficacy is to some degree skill-based, then there are skills that can be measured, developed and implemented alongside any other skills required for high performance in any pursuit.

The theory

Albert Bandura is best known for his work on self-efficacy (Bandura, 1977), but this focus is itself a continuation of his work on human development, which encompasses transitions into adulthood and the shift to self-regulation and self-direction. There is a strong possibility that his work is taken out of context and forced to suit the narrative of this book, so I will resist this as much as possible and look at the aspects where there are clear connections.

Social cognitive theory is concerned with the developmental changes that humans undertake in the course of their lives and the causes and mechanisms of their behaviour and motivation (Bandura, 1989). Core to this is the understanding that self-regulation and self-direction are in effect skills that can be developed (or have component skill elements that can be developed).

Bandura's reciprocal determinism is the understanding that people's behaviour, their cognition, and the environment have a bi-directional influence on each other.

So, one's behaviour influences the environment just as the environment influences behaviour. One's thoughts are influenced by the environment and by our behaviour, just as our behaviour influences our thoughts. Bandura is clear that this is not a momentary or immediate influential relationship – or people would behave like "weathervanes, constantly shifting direction to conform to whatever momentary influence happened to impinge upon them. Instead – people possess internal self-regulation mechanisms to enable a degree of control over feelings, thoughts and actions". (Bandura, 1991)

This is of critical importance to us as we are interested in any and all aspects of behaviour that can be developed, if they have the potential to impact on performance.

An example

If two teams are competing, both have the same goals, both have had a recruitment focus on maximising performance, yet one team will still win. It is worth looking beyond momentary application of skill, beyond the on-the-job performance to see what else impacts ultimate performance.

Sports commentators often say statements such as "it's down to which team wants it more" which could translate to which team has the belief that they can win.

In a work context, individual and team performance is impacted by how the individuals have viewed past events (successes, failures) and how they see themselves on their development journey.

Conclusion

As we saw with Control Theory, self-regulation involves comparison with the conceptual self – or the idea of how we see ourselves. And how we see ourselves is in part influenced by our development journey, by our life path

and the individual and collective influential determinants along the way that are unique to each of us. Our life path is individually unique, but so is how we process and are shaped by these determinants. We don't all respond in the same way to the same event.

To complete the circle here; self-efficacy is positively correlated with performance, self-regulation, and self-control are developable skills, and our thinking and behaviours are also influenced by our life path which is worth understanding, because our self-regulation, control, thinking, and behaviours are not just in-the-moment influenced, but influence the 30,000 ft higher-level conceptual self.

The Matthew effect, Pygmalion effect, and Galatea effect

Introduction

These three effects are linked by the nature of expectations matching outcomes, each in a slightly different way. Their inclusion in this book, like other included theories, is because of links to high performance that we can look to leverage to our advantage. These three in particular could be seen as "unfair" due to the nature of the non-objective and disproportionate positive effects. As with other theories, we are looking to achieve high performance, and are very happy to include unfair and disproportionate effects if we know how to make them work to our advantage.

The theory

THE MATTHEW EFFECT

Cumulative advantage is often known by the biblical reference the Matthew effect (Merton, 1968) coined by Merton in relation to sociology in the science community where initial comparative advantages grow. Well-known scientists get disproportionately greater attention and credit than the less well-known scientists, and thus emerges an accumulation of advantage and disadvantage.

We see this in the world of social media, where quotes, memes and tweets get retweeted in proportion to how popular they already are. The idea of something "going viral" is that in relation to other news or quotes, something is shared almost exponentially compared with other contemporary news items.

We see the disproportionate effect when we compare like or identical examples. Ericsson's work around development put forward the idea that

mastery takes 10,000 hours of deliberate practice. But it wasn't until Malcolm Gladwell wrote about this in his best-selling book Outliers that "10,000 hours" has almost become one of the best-known psychology effects among the general populace. The theory has not changed, but Malcolm Gladwell has much wider reach than Anders Ericsson, and the spread of the theory is much wider now.

The Matthew Effect then is the outcome matching the expectation that's driven by being at "the top". The popular get more popular.

THE PYGMALION EFFECT (ROSENTHAL, 2002)

In contrast, the Pygmalion effect is when a person's performance meets the expectations that another person has for them. These self-fulfilling prophecies have been seen most clearly with research in education, where the expectations of teachers in terms of which pupils they expect to do well, are fulfilled by those pupils performing as the teacher expects.

Key to this from our perspective is not just whether teachers predict the performance of pupils, but when teachers raise their expectations, the attainment of the pupils also increases. They do better when more is expected of them and when they are treated as capable of success.

The effect goes further, as research carried out showed that if the teachers were given high expectations of the pupils, then the teachers expected and got enhanced results from the pupils. (Rosenthal & Jacobson, 1968). The pupils who were randomly selected, achieved a four-point IQ boost as a result of the teachers believing that they were working with more-capable pupils.

The name for this effect comes from the Greek myth about a statue coming to life, but the effect is actually closer to the George Bernard Shaw play Pygmalion (and West End show My Fair Lady) where Henry Higgins bets that he can pass-off the cockney flower girl, Eliza Doolittle, as a duchess by teaching her to speak properly.

Again, the purpose and focus within this book is to acknowledge and accept the Pygmalion Effect and ensure that we create the conditions for high expectations and expected success. If a four-point IQ gain is possible, then what else could be achievable in other high-performance areas?

THE GALATEA EFFECT

The name is related to Pygmalion, in that in Greek Mythology, Galatea is the name of the statue by Pygmalion that comes to life.

If the Pygmalion effect can be succinctly abbreviated to people living up to the expectations that others have of them, then the Galatea effect is when people live up to the expectations that they have of themselves (McNatt & Judge, 2004).

Whilst the research around these effects were unfortunately based around deception in order I suppose to measure the effect alone, outside of the research environment we are looking to create a positive effect on performance without deception. Whilst teachers were deceived into believing that the pupils were more capable, the effect is still apparent.

The Galatea effect is also closely related to self-efficacy (Bandura, 1982) and self-fulfilling prophecy theory (Merton, 1948) although Merton's work was based around social and racial injustice so we are looking to bring it to individual, team, or organisational performance.

An example

Matthew Effect: The rich get richer and the poor get poorer. Not just a pithy phrase unfortunately. In the UK, the poverty premium is estimated at up to £1190 per annum, as the poor pay more for essential goods and services. Examples such as being unable to buy in bulk (which would often be at a discount) or even having to shop locally at convenience stores due to lack of transport or lack of storage (or a freezer) at home, borrowing at higher interest rates, even being unable to pay using the cheapest billing method. Older, cheaper cars are less reliable and cost more in maintenance.

Pygmalion Effect: When leaders expect more of others, the individuals tend to perform better. Experiments for the effect randomly distribute students. Teachers told that certain pupils are high-achievers then tend to actually achiever higher attainment with those pupils.

Galatea Effect: The England football team have a poor record in penalty shoot-outs in World Cup competition. They have played four and lost all of them. Germany on the other hand have played four and won all of them. It is highly likely that were England and Germany to face each other again in a penalty shoot-out, Germany would expect themselves to win. This would be despite NONE of the team being the same individuals that have previously won any of Germany's other shoot-outs.

Conclusion

Whether the effect is labelled as Galatea, Pygmalion, Mathew, self-fulfilling prophecy, or specific self-efficacy, the excellent research by McNatt & Judge has shown that the performance of individuals in an organisational context

(in their case auditors within Big 4 consulting firms) can be raised as the result of expectations being high, and that self-expectations can of course be boosted by leaders who, without deception, find opportunities to raise the expectations of their people.

This will be covered in the practical section of this book, but essentially there is a real effect from raising self-expectations, and that this should come from any information and knowledge that we have about the individual – resumes, past, and current performance, observed behaviours and characteristics. For low performers, McNatt and Judge advocate focussing on improvement rather than absolute (low) performance, coaching around overcoming difficulties and development, and focussing on positives – as they say "even poor employees do some things well".

Learned optimism

Introduction

There are some very familiar themes elsewhere in this book when we look at Learned Optimism – themes of self-fulfilling prophecies, persistence in overcoming adversity, the degree to which ability and motivation lead to success, and belief and expectation. ATC and OMIT look for ways to increase performance and links with existing theories both support and enhance the ATC and OMIT models.

Learned Optimism looks at how we habitually explain both good and bad events to ourselves.

The theory

Learned Optimism's so-called explanatory styles may be either Pessimistic or Optimistic, centred around the degree to which the good or bad events will affect other areas of one's life, how long it may last and who caused the situation. The result is a pleasantly alliterative three Ps – Pervasiveness, Permanence, and Personalisation.

Personalisation is the degree to which the event's cause is internal (I'm to blame) or external (I'm not to blame)

Permanence is the degree to which this event is lasting, referred to as stable or unstable

Pervasiveness relates to how widespread the effect is, global (everything) or specific (just this one thing) (Seligman, 2006).

Seligman's earlier work on Learned Helplessness concerns the idea that if we believe that we can't control an objective or situation, then we won't try. The "learned" aspect is that it becomes habitual in the way that we understand events and the part that we play, and our pattern of thinking and processing can be deliberately changed, ideally maybe to a more optimistic style. My challenge is that at elite levels, it would appear that being able to hold what Seligman would call a Pessimistic view can unlock personal development in a way that could otherwise be masked by optimism.

Helplessness sounds like an unhelpful psychological position to hold, and conversely Learned Optimism is a way to shift our explanatory style to a more positive version, but if we are looking for ultimate high performance, then we can shift the boundaries here for maximum positive effect for the performer.

Optimist:

Good events. Stable (cause will last a long time), Global (will affect other areas of my life), and Internal (it's down to me)

Bad events: Unstable (it won't last), Specific (wrong place, wrong time), and External (it was just (bad) luck).

Pessimist:

Bad events – Stable (cause will last a long time), Global (will affect other areas of my life), and Internal (it's my fault)

Good events: Unstable (it won't last), Specific (right place, right time), and External (it was just luck).

Learned optimism then is a way of creating psychological safety, and moving away from destructive ways of thinking.

But at elite levels of performance, there appears to be greater value in a realistic interpretation of events, both good and bad, without the need for psychological safety. As an example, this is a quote from a multiple world champion:

> I'm trying to master the game and have never been able to do so, so I will keep trying to.
>
> (BBS Sport)[3]

Analysis:

- "never" sounds like permanence, so for a bad event this would be pessimistic.
- "trying to master" – despite multiple world championships, these positive events have not created any permanence or pervasiveness.
- "I'm trying" "so I will keep trying". Can be interpreted as low personalisation for positive events;

For a short statement, it has many ways to be perceived as pessimistic, yet what we know is that this is a multiple world champion over a 32-year professional career.

Is this elite performance then in spite of a pessimistic view, or is the pessimistic view helping to inspire individual effort?

There are two possible positions; the first that Ronnie O'Sullivan would have been more successful had it not been for a pessimistic explanatory style, the second that a pessimistic explanatory style has allowed greater self-development.

The second position is to me more likely, especially given that no other snooker player has ever achieved what Ronnie has. His elite level is unquestioned, so his level of performance is objectively elite. And if it is objectively elite, then it is very unlikely that his performance could have been greater. I'm not ruling it out, but it would be much harder to maintain this view had Ronnie not achieved what he had.

This leads to the possible conclusion that there are some ways in which a pessimistic explanatory style can create conditions for increased performance, because it retains the focus on what the individual performer can do to develop further; every possible negative event is an opportunity to explore what the performer could have done differently – where the Optimist would say something with low personalisation (other things contributed), specific causes (wrong time and place), and temporary timescales (back to winning soon) were apparent. Psychologically healthy, but for ultimate performance, the ability to hold the pessimistic perspective may still enable a developmental approach that the otherwise optimistic perspective could deny.

So for any performer, holding a pessimistic perspective may still enable a developmental approach that the otherwise optimistic perspective could deny.

This could take the form of still looking for negatives in otherwise positive events. In other words, it's either that they can still hold a pessimistic explanatory style, or that they can see a positive event in a negative light and optimistically process that.

Good event – either viewed pessimistically, or viewed optimistically as a negative event

> it went well, but there are things I could have done better

> yes, that one went well but I need to now focus on the next one

The Optimist might say

> it went well, I think I did a great job

> yes that one went well, I'm on a really good streak

As another example, I recall an Olympic swimming event where a Team GB swimmer said afterwards (apparently being disappointed with their performance)

> It was my first Olympics, and I was just glad to be here to get experience and to do my best

My view: Optimistic view of a negative event:

Permanence: Unstable – of course, I will be better next time
Pervasiveness: Specific – focussed on this event only
Personalisation: External – in effect, others did better (rather than I did badly).

Contrast this with the pessimistic view:

Permanence: Stable – my current form is not good enough
Pervasiveness: Global – my fitness and form affect every event
Personalisation: Internal – I need to see what I can do differently.

Another example is the actor Michael Caine who I saw in an interview talking about his philosophic views, where he said one should "use the difficulty". An example was a scene where he had to enter the room but another actor had thrown a chair, which lodged against the door. Caine said to the director that he couldn't get in the room, and the director had replied by saying that he should "use the difficulty – if it's a comedy, fall over it, if it's a drama, smash it"

What's the relevance here? The bad event – the chair blocking the door – is viewed pessimistically – I can do something about this; the difficulty is within my control.

My final example is Bill Gates. This example looks at personalisation, and the degree and way in which we attribute luck – good or bad – to a situation. Seligman would suggest that Optimistically, bad things that happen are down to bad luck, and good things that happen are down to us. It would be a Pessimistic approach to view good events as down to good luck and bad events down to us.

But this is exactly how Bill Gates talks about his career. He talks about how much good luck was involved in his success, realising the extent to which events outside of his control played such a large part. When he talks about the failures in his life he is very quick to talk about his part in these events. He also talks about how much he reads and seems to never stop learning. As a link to OMIT, with Gates' apparent limitless appetite for growth and development, how does he choose what to focus on? This is very similar to a top athlete who *could* develop any one or more of the aspects of the skills or attributes required to perform at an elite level in their field.

Again, as with Ronnie O'Sullivan, we have an example of objective elite performance where the overriding explanatory style is pessimistic.

An example

> Optimism vs Pessimism
>
> "Normal" optimism for a bad event – a sales meeting went badly – would be to be able to objectively say that not all sales meetings go badly, that the client already had a preferred candidate and had made their mind up before the meeting. "It's bad luck".
>
> The high-performing Pessimistic view, is of questioning my role, my behaviours, what I did to contribute to the outcome. To ask for feedback. "It's down to me".
>
> For a good event – to not take the Optimistic view that it was down to you – instead to say that luck played a part and you still need to find a way to develop.
>
> At club motorsport events, do you think the race winners send as much time analysing their race videos and data as the drivers who came second or third? Yet the winner may still have made mistakes, could still find more improvement.

Conclusion

Whilst the examples above are situational, Pessimism in the context of this book is more at a macro level; being able to put aside the Optimistic views

in order to make sure that personal development happens. To constantly question what you did that contributed to the "bad" event.

Equally, for "good" events, to NOT put these down to you; instead take the Pessimistic view that it was down to luck, and what could you do to develop further. If anything, questioning the winning might be more unusual, and definitely more ATC in approach.

If Optimism is psychologically the safest, then that doesn't seem to be the most developmental. It would seem that if you have the resilience and self-esteem to deal with it, the Pessimistic view could unlock much higher levels of performance.

Cumulative advantage/disadvantage (CAD)

Introduction

Initial thinking for the ATC model was the pragmatic view that earlier practice leads to aggregated time spent on higher-value activities. This translates well into the theories of cumulative advantage/disadvantage, including links to learning and education that have generally been applied to school learners (Baumert et al., 2012).

In essence, getting an early head start means the gap grows over time particularly as the disadvantages are also cumulative.

The difference for this book, however, is that we are not aiming to change what looks like an unfair effect – we are looking to do everything we can to maximise the effect.

If earlier practice leads to aggregated time spent on higher-value activities, then this would suggest that over time, the person spending the same amount of time on higher-value activities as someone else is spending on lower-value activities would see their advantage grow.

ATC works irrespective of whether you believe it is working, or what your level of self-confidence etc. It is a by-product of spending more time on higher-value practice.

But the psychological benefits also exist – knowing that your time is being spent more effectively, knowing that the performance gap is widening, has a positive effect.

To some degree, the cumulative advantage effects are mathematical. Consider this example. Two players toss a coin and after each flip, the loser hands a penny to the other player and the game ends when one player has all the pennies. I'll spare you (OK, me) the mathematics, but Christiaan Huygens, Dutch mathematician (1629–1695) calculated this exact scenario

and assuming 50/50 probability for the coin toss, said that whichever player starts the game with the least amount of money will eventually lose. This is known more broadly as the Gambler's Ruin, as gamblers often believe that a winning streak is due to them eventually.

The nature of ATC is to seek as much cumulative advantage as is possible, especially as the tendencies of cumulative advantage are apparently independent of merit (Merton, 1968, 2016) or even mathematically probable.

Whilst many social scientists and psychologists look to understand and to a great extent find ways to mitigate cumulative advantage and disadvantage, we are doing the opposite in the competitive high-performance arena.

The theory

The cumulative advantage effect has been researched in a few areas. In health, Ross and Wu (1996) show that as we age, the early health benefits associated with education continue, and widen the gap, such that the health advantages of the well-educated become more pronounced with age. This ties with Gerontology (the study of ageing and older adults) (Dannefer, 2003)

We also know that cumulative advantage/disadvantage exists in education (Walberg & Tsai, 1983) where prior education, family, and motivation are three factors that are not just collinear but are cumulative.

So can we apply this to learning and also to high performance generally? Mazur and Hastie (1978) state "An old notion in psychology is that the rate of learning declines systematically as study or practice proceeds. Learning is said to occur most rapidly early in training, with equal increments in performance requiring more and more practice later in training" and they presented an "alternate model which describes learning as a process of accumulation where incorrect response tendencies remain constant and correct response tendencies increase with practice". This again goes back to learning curves of any shape being found, yet none still measuring the area under the curve. This seems to have fallen aside in research.

If the rate of learning declines, why is this? Is it because the potential gap is shrinking and much like the charging of batteries (low potential at the start means they can charge at a faster rate when empty) that follow the standard decay equation (e.g. Sproul, 1994)? Or is it that motivation is higher at the start?

However, a decline in the rate of learning is not the same as a cumulative advantage. For cumulative advantage to be in effect, we would need to see a lower rate of decline for learners who gained an initial advantage.

If therefore we plot the rate of learning – a learning curve, this leads to Snoddy's 1926 research in timescales for motor learning (Stratton et al., 2007). The comment that

> Researchers have often stated that learning curves of almost every conceivable shape can be found.
>
> (Mazur & Hastie, 1978; Stratton, 2007)

is not helpful, as again this appears to have led researchers away from quantifying the learning curve, although Wiersma (2007) and Dutton and Thomas (1984) create the link to "learning organisations" and looking for ways to enhance the learning curve. Dutton's link to continuous improvement link to the spiral nature of learning, and how, when learning complex tasks, individuals are moving through multiple learning curves simultaneously, both for individual micro-tasks, and the macro task as a whole.

An example

Cumulative advantage is seen regularly in sport. Teams that are losing at half time are not expected to win - think about how sports reporters talk about teams that win after being down.

Any work or personal target can be hard to achieve, yet there will always be times when you get ahead early and that advantage stays with you.

Conclusion

Let's revert to the assumption that cumulative advantage exists, and that we are looking to maximise the effect.

One of the ways in which ATC delivers value as a development tool is by cumulative advantage, and by the psychologically positive impact of this.

ATC is fundamentally about getting an early advantage; make early practice count and then all subsequent practice is at a higher level and on higher value activities.

As we have seen from OMIT, focus on aspects that are in the Optimal / Threshold quadrant could amplify the ATC effect further, as once over a threshold all subsequent activities and practice are above that threshold.

Relative age effect

Introduction

I am including a short piece on relative age effect (RAE) within cumulative advantage/disadvantage theories because the effect seems similar, and also because it fits the same approach of appearing intrinsic and to a large degree the world – the sporting world in particular – is trying to negate the effects, not maximise them. This book conversely is principally concerned with maximising any possible performance effects.

The theory

Relative age effect is the often seen in age-grouped sports, especially youth sports where teams and competitions are grouped by age, and as such, performers within the same age band have a significant advantage as they can be for example nearly a year older than competitors in the same age band who happen to be born at the opposite end of the cut-off. As such, the relative age effect is a performance advantage as a result of simply being a little older than your competitors.

This is a fascinating area of research and in a world where sports excellence is a lucrative and much sought career path, it seems that young athletes with potential are being excluded early in their career through being relatively young.

Academic and non-academic studies are revealing the same trend. In the UK, casino.co.uk plotted the birth month of male football players from the top two tiers of English football (birth dates taken from the players' clubs' websites). The findings again support the relative age effect:

> Almost 60% of footballers in the top two tiers of the English game were born early in their school year.
>
> This means that children born from September to November are almost twice as likely to make it as professional players than classmates born between June and August. (casino.co.uk/footballers-birthdays).[4]

Academic research goes further and looks at as the relationship between chronological age and biological age with factors such as growth (body/parts) and development (physical, e.g., puberty). This means that in addition to performance (i.e. the chronologically older athletes) being selection

criteria, so are physical size and physique also selection criteria. The research also shows that sports where it is an advantage to NOT grow and develop early as an advantage (such as gymnastics), there is no relative age effect evident, or referred to as the reverse relative age effect. (Baxter-Jones, 1995)

RAE is linked to cumulative advantage because the effect is the same – success breeds success. If children are successful early on in their chosen sport, partly because of age-related physical characteristics, then they are likely to carry that advantage through their sports career. For the chronologically younger athletes, who in their early days may have the same potential but are physically not able to complete at the same level, disappointment and lack of success may be a factor in them choosing a different sport.

If we look at other sports, in swimming (Baxter-Jones, 1995) and female youth volleyball (Okazaki et al., 2011). RAEs seem to depend on age and the categories. RAEs were found in the age championship swimmers (11–14) but not in youth championship swimmers (14–17) (Andronikos et al., 2016; Costa et al., 2013).

Could it be that the RAE is not found for the age group 14–17 because those who were affected 11–14 dropped out?!

Example

As someone with a birthday in the middle of July, I was relatively young through my schooling. In the UK, the academic year starts in September, so the oldest pupils in any year group have birthdays closer to September onwards. July birthdays left me relatively young – 10 months younger than the oldest in my class. RAE for me meant feeling noticeably younger and less able.

Conclusion

As with other theories and effects, in this book we're looking to see what can be done to maximise the effect, not minimise. So how can high performers look to benefit positively from RAE and how then, can something as uncontrollable as age be used as a positive performance advantage?

This is easy to answer if you are positively affected by RAE – it makes sense to acknowledge the effect, but also to be aware that the effect could diminish. Whilst it lasts, make the most of it by outperforming when you have the opportunity.

If you are negatively affected by RAE, then again understanding and acknowledging can be important, as can recognising that the effect is not

about absolute ability – it is only relative. Noticing absolute performance and comparisons with same-age performers will help to nullify the effect.

Pareto/Trueswell/Juran

Introduction

The law of the vital few and the trivial many.

Pareto's law, originally applied to unequal income distribution has incorrectly given its name to a more general principle of 80/20 distribution – where for example it is suggested that 20% of the workforce deliver 80% of the output.

In many ways, this 80/20 concept is one of ATC's fundamental principles and components. ATC is enhanced by seeking the vital few components of success, or gaining 80% of the performance gain before switching to another area where the improvement in this new area is steeper than the remaining 20% of the previous one.

This is not the same as not seeking the final 20% of the gains; you may ONLY be working on the final 20% of the gains, but within each area of even this final tranche, there will be again a steeper curve where the majority of the available gain is sought and achieved. Even if you are looking to develop the final 1% marginal gain, there may be a steeper element that's the focus.

The theory

A little background and context to the naming confusion for this effect; it was Juran's Quality Control Handbook (Juran, 1951) that first incorrectly credited Pareto. In academic circles the law of the vital few was attributed to Juran. Pareto's principle originally applied to income distribution and was on logarithmic axes, and as such income distribution would be more accurately shown on Lorenz type curves (Lorenz, 1905) where the axes are arithmetic and not logarithmic.

That said, it would be more accurate now to refer to Pareto's Law as Juran's law of the vital few, despite Juran being the person who started to incorrectly cite Pareto (Eldredge, 1998).

In the next twist, when we talk of "80/20", the most accurate citation would be Trueswell whose work measuring the behavioural pattern of library users and the distribution of monographs in circulation specifically introduces the 80/20 rule (Kantor, 1980; Trueswell, 1969).

So a dilemma – do we introduce this as Pareto's principle, Juran's law of the vital few or Trueswell's 80/20 principle? For the purposes of this book I

am going to use Juran – the law of the vital few is what underpins the principle of ATC and OMIT best.

What we are looking for, as with other theories mentioned, is to take what looks like an unfair principle and ensure that it works in our favour. In other words, seek the vital few marginal gains that will create the largest performance improvement effect.

One of the principles of OMIT is that not all gains are equal. It is a mistake to assume that in the accumulation of marginal gains, choice of development area could be random because they're all just small; the performance gains coming from the amalgamation. Instead, our assertion is that some gains (the vital few) even if small, will have a disproportionate effect compared to the trivial many, also small, gains.

This is a great principle and goal, but how do we discover which are the vital few? This is partly answered by the OMIT quadrants; any performance aspects that are in the Optimal/Threshold quadrant that are currently BELOW threshold are definitely to be considered vital. It may even be that through development and multiple iterations of OMIT that each time new thresholds are met, there are always new factors that move to the Optimal/Threshold quadrant that are below the threshold.

Iterating OMIT is key and one of the aspects that we believe can make this model so useful. Rather than mapping all of the performance attributes just once, as performance develops the opportunity to iterate means that factors will change quadrants.

An example

As an example, think of Amazon setting up; Jeff Bezos worked on a desk made from an office door; yes there were better desks available, but the critical element is that until he had a desk to work on, it would have been extremely difficult to work. You might say that a desk would have been in the Optimal/Threshold quadrant of OMIT – the threshold is whether or not there is a desk. Optimal because anything that functions as a desk is good enough.

This applies to any piece of office equipment. The cheapest PC can probably do 80% of what the most expensive PC can do, and the steepest part of the development curve is the shift from not having a PC to having one.

If I have £1000 to spend; do I upgrade equipment or buy a new piece of equipment? If the new piece of equipment can open up more development than the upgraded PC, then this sounds like the steeper development curve. A new piece of equipment is the binary threshold shift from zero to one. A better PC is a small step on a relatively less steep Maximal development curve, unless of course that upgraded PC itself unlocks a binary threshold.

Conclusion

ATC is fundamentally about staying on the steepest development curves. It may be helpful to think of these in Juran's terms, always looking for the vital few. It is tempting to think of marginal gains as being beneficial irrespective of which gains you look for, as long as they add up to something. High performance can be sought by being more selective. If OMIT and ATC principles can help with better selection and with the focus on steeper development curves, then we have Pareto, Trueswell and Juran to thank for summarising and developing these principles.

Motivation theories

Introduction

"Motivation is the study of why people think and behave as they do" (Graham & Weiner, 1996).

Why are we interested in motivation? From an organisational psychologist perspective, there's an assumption that greater motivation leads to higher performance. Why else would organisations be keen for their employees to be more motivated?

If increased motivation led to lower performance, then would anyone be interested in increasing motivation? The assumption therefore is a fair one. And if performance increases with motivation, then motivation is one of the areas we must look at.

The theories

Performance motivation is a little different from, say Maslow's hierarchy of needs (Maslow, 1943) and Herzberg's hygiene factors (Gawel, 2019; Herzberg, 1966), in that safety and shelter would probably take precedence over learning should safety and shelter be compromised, so the focus here is on theories more specifically linked with high performance and goal achievement, and how the knowledge and understanding of these theories can impact with developing performance and the ATC and OMIT models.

In the research on typing speed and accuracy, in addition to measuring these objective performance factors we also sought to measure the psychological impact of the accelerated learning – the subjective measures of

performance; did motivation or self-belief increase as the area under the development curve increased?

Unfortunately, the initial research (typing speed and accuracy) did not show enhanced subjective measures of performance. So the theories of ATC and OMIT have an as yet untested view that a steeper learning curve is more intrinsically motivational, and that multiple steep curves compound this effect – multiple victory cycles. What was measured though was the link between performance and motivation – did increased performance lead to increased motivation? This section of the book will focus on the alternative direction of the relationship between these two factors and the assumption that when motivation increased, so does performance.

That again asks for a definition of performance and whilst most motivation theories talk about task performance, that is still sufficient here, as developing performance can be considered as a task, or multiple tasks.

If increased performance is the goal, then increased motivation should be a factor, and if increased motivation is the goal, then we need to understand motivation in greater depth.

This section of the book looks at three theories of motivation; GST, control theory (CT), and expectancy theory (ET) all of which are evidence-based theories of motivation that surround a goal – setting goals, measuring progress, and how our expectation of success links to achievement.

With both GST and CT there is a clear purpose to having a goal and then measuring the progress towards the goal. This is also important with ATC/OMIT – one of the ways that you know that you're on the steep learning curve is by measuring progress. Measuring progress in turn helps with intrinsic motivation.

This is where the ATC map helps, as there are so many aspects to overall performance that one of the aims of ATC is to always be able to find a performance area where steep development can be found, developed and measured.

For example, if I'm trying to improve my 5k running time, it might be some time before I see progress in the overall goal, but there will be smaller aspects that I can focus on to develop and measure – by looking for the measures where my development is likely to be steeper. For me this could a specific training session such as hill sprints. I know that if I focus on hill sprints for a short time, my performance in this will improve more quickly than if I focus on the overall 5k pace. I also know that my performance in hill sprints contributes eventually to my overall 5k pace. The intrinsic motivation effect of seeing the improvement in hill sprints is more valuable to me than seeing very little overall progress if I just measured my 5k pace.

The practical guide chapter will provide more detail on goal setting and progress measurement, where we can maximise the effectiveness of ATC

and OMIT by understanding how to maximise both goal-setting and the tracking of the progress against that goal.

This chapter however looks at three motivation theories – GST, Control Theory, and Expectancy Theory. They are not the only motivation theories in psychology, but I have selected these for their links to ATC and OMIT.

Goal setting theory

Introduction

Goal Setting Theory (GST) in my over-simplified description is that both motivation and performance will be higher when goals are clear, difficult, accepted, and where there is feedback as a mechanism for the performer to evaluate and adjust their behaviour.

The link with ATC and OMIT is that motivation and performance are of vital importance.

The theory

Edwin Locke and Gary Latham, individually and collaboratively are both responsible for developing GST to the point that it is today – very well researched and with plenty of academic support since their joint book in 1990 – A Theory of Goal Setting and Task Performance. (Locke & Latham, 1990).

In ATC and OMIT terms, the performance sought can be linked with goals around task or learning, and it's notable that Latham (2012) puts forward a contrast between goals that are set for performance and goals that are set for learning. He says that "a specific high performance goal should be set only when a person already has the ability to attain it. A specific high learning goal should be set only when the person lacks the requisite ability to perform the task and the behaviours necessary to do so are unknown".

A performance goal is no use if the person doesn't have the knowledge or skills to achieve that goal. In these cases, a learning goal is beneficial because the person is not focussed on the performance, instead focussed on the means of acquiring the skill or knowledge. Interestingly, in these cases it is possible for performance to also be higher. Latham and Brown (2006) showed that MBA students achieved higher marks when set a specific, high learning goal than students who only set high performance goals.

The research is clear for GST, but it's useful to distil some key elements as this will be helpful in us using GST to maximum effect in developing any aspect of performance.

Clear: The acronym SMART works well here – Specific, Measurable, Achievable/Agreed, Realistic, Timed (Doran, 1981). There is some overlap with the other key aspects of GST but none that undermine. Research showed that a specific goal led to higher performance than "do your best" type goals

Difficult: This emerged from the research and essentially, the higher the goal, the higher the performance. This may appear to contradict the "R" in SMART for realistic, but the evidence is clear; the goal should be difficult if high performance is sought. The moderator here is commitment to the goal which leads to the next step

Accepted: In my experience, many organisational and therefore cascaded personal goals are assigned without full acceptance and are therefore lacking commitment. Organisations have no issue assigning specific, measurable, timed objectives, but achievable/agreed is often lacking

Feedback: The goal provides the means to measure performance gap and as such awareness of the gap – a feedback loop – is important for the performer to be able to adjust their actions in order to reach the goal. The timing of the feedback is important in order for actions to be adjusted. It is useful here to look also at augmented feedback (see Skill acquisition and practice). Augmented feedback is where additional extrinsic feedback is given to the performer about their performance – feedback that would not otherwise be known to themselves. Where GST includes subjective evaluation for feedback, I think that including augmented, extrinsic feedback, can be beneficial.

Developing high performance is fundamentally about moving from the current level to a new, higher, desired level – a new goal. GST is possibly the most important part of this book – even more so than the ATC and OMIT models, because GST enables the shift. ATC maps the possible areas to look to develop, OMIT helps prioritise, but after that, change needs to happen and goals need to be met.

High-performing teams are often (always?) competing against other high performing teams who have access to the same talent pool, the same resources and the same goals. GST is the marginal difference, even where teams are near identical.

Gary Latham's research with loggers, where the teams were made as even as possible still found that the teams that had their goal set in accordance with

GST, consistently showed greater productivity than other teams who were assigned a goal of doing their best. In other words, when the skill, motivation, pay, supervision, equipment, knowledge, experience, and physical attributes were equalised, GST made a positive performance difference. That's too good to ignore when we are looking for ways to enhance performance.

When people are more experienced at their job, I see a move AWAY from clearer goals – it's almost as if setting clear goals and delivering feedback is reserved for inexperienced people. This needs to change if we're looking for high performance. The idea that people who are experienced, skilful, and otherwise at the top of their game should be left to "do their best" is, according to GST, bound to result in lower performance.

An example

In 2022, I cycled from Land's End to John O'Groats as part of the Ride Across Britain (RAB) organised event, with friends. It's just under 1000 miles in 9 days.

For me, this is a great example of a goal that is first, difficult. It is akin to running a marathon, in that nobody completing the event has done so without training for it. The event is relatively easy, for everything is organised, you've left "life" behind for nine days and all you have to do is get up in the morning and the ride happens, every day. Training, however, is a challenge, for there's no infrastructure, "life" is getting in. the way and a year before the event, training is just not urgent.

The goal is also clear – very clear that you need to be able to cycle up to 120 miles in a day with around 2500 m of elevation (uphill). You can train for this specifically.

The goal for me was accepted. No-one made me do it, it was something I wanted to do and there are many opportunities in the year or so before the event to either back out or cement your acceptance. I made the point of telling people, I attended all the online RAB briefings, I absorbed the training suggestion materials. In short, I had internally accepted, and I reinforced this in many small ways.

Feedback is the final component of GST, and here both in training and on the ride itself there is plenty of feedback.

There are plenty of things that we want to do in life, and often the things that get done are the ones that we feel most intrinsic motivation towards.

Conclusion

The difference in life between the things we'd like to do/should do and the things we actually do, is partly down to motivation – or to go back to the motivation definition, is down to why we think and behave as we do.

Tony Robbins, US author, asks people if they could break down the door of a house. If people say that they couldn't, he asks the same question but this time the house is on fire with the person's family inside. People at this point change their opinion of whether they could break a door down. Yes, the situation has changed, but in GST terms what changes is both how difficult the goal or task is, and also the acceptance of the goal.

Achieving goals is not just about setting goals, and it doesn't matter who sets the goal – whether others or self – what matters, when it comes to the motivation to achieve the goal, is that the goal is clear, difficult, accepted, and with feedback.

Control theory

Introduction

Control Theory earns its place in this book for its contribution to feedback. As we have already seen with GST, feedback is a key aspect to goal performance.

The theory

Control theory has, as its basic construct, the self-regulating "discrepancy-reducing feedback loop" (Carver & Scheier, 1982; Figure 5.2).

Staring at "output function (behaviour)" we can see that as a result of the behaviour there is an impact on the environment, which may also be impacted by "disturbance" – i.e. not everything that is happening is as a result of the behaviour of the person. The input function is a result of the performer's perception of what's happening; the comparator is whatever the performer sees as the required ideal state; as a result, behaviour is the next output with the intent to adjust the environment to reduce the discrepancy between what is being observed and the reference comparator.

If I'm throwing balls into a bucket, then my reference comparator is the expected level of accuracy. I can adjust my throwing (behaviour) as a result of what I perceive (hitting or missing the target). The disturbance could be strong gusts of wind.

There is depth to this feedback though, for there are multiple feedback loops at different levels – from the immediate current behaviours and their effect on performance through to the performer's concept of their ideal self. In an organisational context, an example of the immediate level would

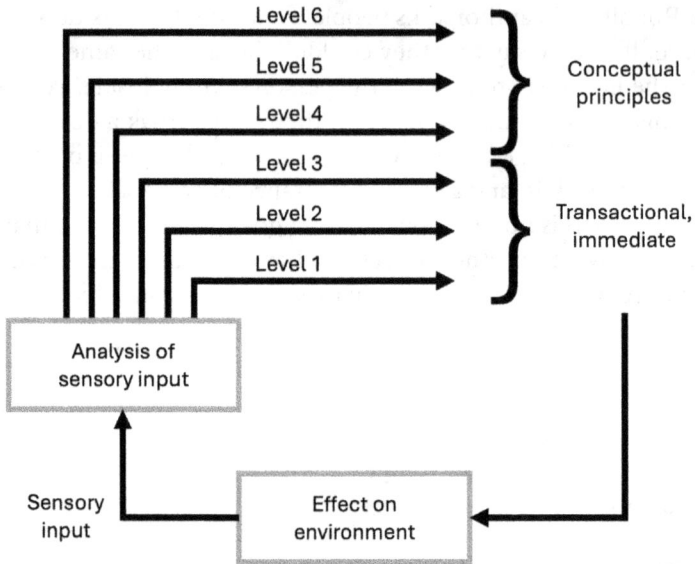

Figure 5.2 A modified Carver and Scheier's negative feedback loop.

be what the person is doing in a meeting – how others are reacting to their behaviour, and the adjustments required in order for the person to see the response they are expecting – so a question that is a little too direct has the impact of the recipient being reticent; if noticed, this can result in the question being asked again in a different way.

An example of the ideal-self level could be the person seeing themselves as a good leader who acts with integrity. Again, this is self-regulating and could be both immediate and at a distance on reflection. There are levels in between, as highlighted in Figure 5.3.

I have adapted Carver and Scheier's (1981) diagram, itself adapted from Powers' hierarchy of control (Powers, 1973).

Compared with the previous Figure 5.2, there are now multiple perception levels, that I have grouped as transactional/immediate and conceptual/principled.

The idea here is that the self-regulation occurs and impacts on a wider range of concepts than just the immediate behaviours. For a leader the conceptual/principled could include being a good leader, having integrity or respect for others, to being on time, or always delivering on commitments. If for example I'm writing a book, the quality of my work is in part determined by how I see myself as a writer, the depth that I'm prepared to research, how much I'm prepared to learn, and whether I rush or go the

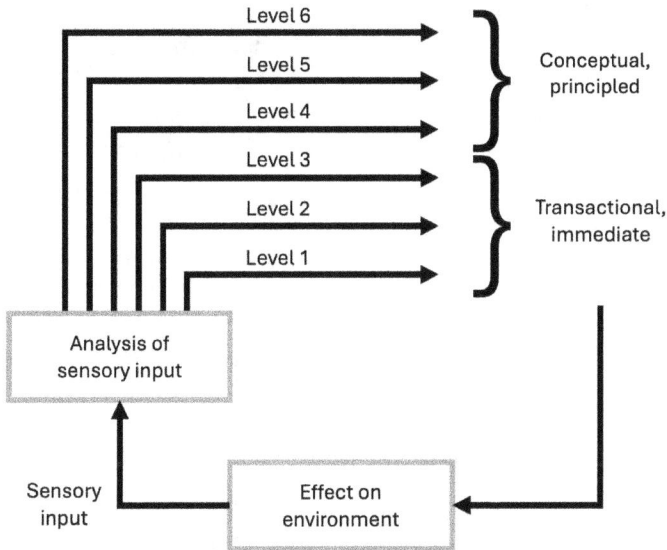

Figure 5.3 Carver and Scheier's (1982) negative feedback loop.

extra mile. The immediate/transactional could be around my use of language, my word count, my spelling, grammar, and punctuation.

Understanding myself therefore, how I see myself as a writer, what I see as important – these are self-regulatory concepts too but they apply at a different level. If I see myself as thorough, going the extra mile, then I might need to allocate more time in order to meet my publisher's deadline. My sense of my ideal self is therefore being adapted, challenged, and my behaviours adjusting to meet this concept.

With leadership clients I often explore their personal values (Table 7.5); starting from a generic set of 19 typical values (security, wisdom, community, independence, love, health, family, creativity, integrity, authenticity, prestige, expertise, enjoyment, power, personal accomplishment, leadership, personal development, wealth, and loyalty) these are whittled down through a series of short exercises to just five that are important to the person, that they see as core to their identity and that they believe are non-negotiable.

The exercise helps them to anchor their sense of self; this in turn helps to create the standard, the reference level for them to self-regulate.

The leaders do not change themselves during this selection process; their values do not shift in the few minutes that the exercise takes – they have the same values before and after, but their awareness of their values has shifted. This does have a behavioural as well as conceptual bearing on how they

are as leaders. Imagine two leaders, leading identical teams with the same purpose and goals, but the leaders may well have top values that are different from each other – then their sense of high performance will be different as they compare themselves to what is most important to them.

In any high-performance environment then, it's important (per CT), to understand the reference value and to have a mechanism for the comparator.

In other words – decide what's ideal (reference) at as many different levels as possible – depth (e.g. personal values) through to short-term actions and then to have effective feedback (as the mechanism for the comparator) to highlight the difference between actual and ideal.

An example

> How might a senior leadership team member make the shift to CEO, or a shift in that direction? This pool of talent is often to be heard saying that they would not want to be CEO, or don't see themselves as CEO, and whilst this may be the case it is also true that the most likely future CEOs will come from this pool. This sense of idealised future self can be a limiting factor as much as it can be a draw.

Conclusion

The link from CT to ATC and OMIT then, is fundamentally about looking at ways to enhance feedback, and specifically to provide feedback at multiple levels including some sense of an idealised self – the person that the performer sees themselves as being or becoming. The feedback comes as seeing the discrepancy between the ideal and the actual.

Expectancy theory

Introduction

There are a few key contributors to Expectancy Theory, but notably Victor Vroom, and Layman Porter & Edward Lawler (Vroom et al., 2015). Expectancy theory is so-called because of the belief that one's effort will

lead to performance. People apply effort to tasks that they believe they can do (Expectation), that lead to performance outcomes (Instrumentality) that they find attractive (Valence). These three components lead to Vroom's V-I-E Model, a key version of Expectancy Theory (Eerde & Thierry, 1996).

Expectancy Theory is another theory of motivation that is included in this book because of how motivation, and in this case effort and performance are linked to the achievement of goals – which is one of the key principles of ATC and OMIT. High performance is about achieving higher goals.

If goals were automatically achieved then motivation and all the other theories in the book would be irrelevant, the only focus would be on goal setting. So if we are looking to maximise the achievement of goals, then theories that link to one's tendency to achieve them are vital.

The theory

"If a worker sees high (or low) productivity as a path to the attainment of one or more of his personal goals in the work situation, he will tend to be a high (or low) producer, assuming that his need is sufficiently high, or his goal is relatively salient, and that he is free from barriers to follow the desired path (high or low productivity)" Georgopoulos et al. (1957).

Expectancy Theory and the VIE (valence, instrumentality, expectation) model are explicitly linked to the intrinsic tendency to achieve goals under certain circumstances, so our aim in this book is to be clear about those circumstances.

The additional layer that ATC and OMIT bring, is that expectation and instrumentality are both positively affected by the steep learning curve and signs of early progress, which are inherent with the ATC model in particular.

If layered with GST and control theory, we can then add to goal selection the need for the goal to be attractive, and for clear progress to be measured and known to the performer, mainly through feedback.

A closer look at VIE and how we might go about maximising the effect.

Valence: The attractiveness of the goal. We can extend this to include other subjective factors such as importance, both of the objective and the outcome of achieving the objective, such as satisfaction. So for any performer, the goal needs to be important, and if that importance is not obvious (more than "it's my job") then it is worth exploring the ways in

which importance can be found and attributed to the goal. We can link this to Control Theory too, the conceptual ideal self, as the goal may lead to or lead from achievement of the ideal self. GST looks for goal acceptance, and this acceptance is itself enhanced by increased valence. If this sounds circular then that's great – the more that these theories positively interact with each other the better.

Instrumentality: The probability of achieving the outcome. Understandably this aspect of VIE is not controversial. It makes absolute sense that the greater our belief in the probability of success, the more likely we are to put effort into achieving the goal. Again, our focus is on maximising the effect, so we are not interested in just measuring instrumentality, we are assuming that the goal is already decided and therefore it is helpful to see if there are ways that we can increase the performer's instrumentality – their subjective view of the likelihood of success. Not just at the start, but throughout the journey of achieving the goal.

What have they achieved in the past that could predict success here?
What skills and attributes do they bring?
Look for the positives; what is going well?

Expectancy: The subjective view of whether an action will lead to an outcome. How many readers have children who don't see the link between homework and revision and exam success? And yet those same children will be cramming hard the night before an exam. The difference is that they think that anything they learn in the hours before an exam will be remembered. Their expectancy of learning is that they have short memories. If they had the same level of expectancy for homework, could this be attended to with the same energy as last-minute cramming?

What do you need to do for your team/performers to link actions to the expectation that these actions will bring about the results required?

If the expectation is low, the VIE model suggests that this is important to know, and to explore – for the effort expended will be lower on actions that have lower expectancy.

How can expectancy be raised? Spend more time raising expectancy than just pushing for actions to be carried out anyway. Some processes are far removed from the final outcome to appear disconnected.

Some actions are inconsistently carried out. A client sales team that I work with appear to have different sales processes when sales are good, compared with when sales results are poor. When poor, they focus on whether all the (mundane) processes are being followed.

When results are good, they don't care if these processes are followed. In short, I'm not sure that there is much expectancy with the sales processes – especially the mundane ones.

What actions do your team struggle to have high expectancy for?

An example

A high performer is not reaching their potential; appears to be lazily doing just enough to perform well. They are still the highest performer in the team but could be so much more.

Valence: The goal (our goal of higher performance) is not their goal, and not attractive to them. How could the goal be adapted to meet their needs and to raise the attractiveness of the goal as they see it. Too often we give people goals that we ourselves see as attractive.

Instrumentality: Self-limiting behaviour includes setting low goals, or not aiming high enough. Sometimes this is out of low self-esteem and not wanting to fail. Even with an attractive goal, if the person does not have a high degree of certainty that the goal will be achieved, then they may not seek to try. It may be valuable to focus on their strengths and past successes in order to increase this positive view.

Expectancy: Will their focus on the goal and the subsequent actions lead to the achievement of the goal? What are the actions and are they sufficiently linked to the outcome? What if these actions are data entry or cold-calling? What data can be used to support the action achieving the outcomes?

Conclusion

In summary, VIE adds another layer to goal setting to move closer to goal achievement. It's a helpful theory of motivation that shows how our expectation of success can impact our motivation to do what's necessary to achieve.

Notes

1. The origin of the Mike Tyson quote goes back to 1871. "No plan survives first contact with the enemy" or as it would appear to have been originally stated **"Kein Operationsplan reicht mit einiger Sicherheit über das erste Zusammentreffen mit der feindlichen Hauptmacht hinaus"** (**No plan of operations extends with any certainty beyond the first encounter with the main enemy forces.** Prussian Field Marshal Helmuth von Moltke, 1871).
2. Gladwell (2008). Outliers.

3. https://www.bbc.co.uk/sport/live/snooker/67433684
4. https://www.casino.co.uk/footballers-birthdays/

References

Andronikos, G., Elumaro, A. I., Westbury, T., & Martindale, R. J. J. (2016). Relative age effect implications for effective practice. *Journal of Sports Sciences*, *34*(12), 1124–1131. https://doi.org/10.1080/02640414.2015.1093647

Bandura, A. (1977). Self-efficacy: Toward a unifying theory of behavioral change. *Psychological Review*, *84*(2), 191.

Bandura, A. (1982). Self-efficacy mechanism in human agency. *American Psychologist*, *37*(2), 122–147.

Bandura, A. (1986). *Social foundations of thought and action* (pp. 23–28). Prentice Hall.

Bandura, A. (1989). Social cognitive theory. In R. Vasta (Ed.), *Annals of child development. Six theories of child development* (vol. 6, pp. 1–60). JAI Press.

Bandura, A. (1991). Social cognitive theory of self-regulation. *Organizational Behavior and Human Decision Processes*, *50*(2), 248–287.

Baumert, J., Nagy, G., & Lehmann, R. (2012). Cumulative advantages and the emergence of social and ethnic inequality: Matthew effects in reading and mathematics development within elementary schools? *Child Development*, *83*(4), 1347–1367.

Baxter-Jones, A. (1995). Growth and development of young athletes. Should competition levels be age related? *Sports Medicine (Auckland, N.Z.)*, *20*, 59–64.

Cady, S., Jacobs, J., Koller, R., & Spalding, J. (2014). The change formula: Myth, legend, or Lore? *OD Practitioner*, *46*(3), 32–39.

Carver, C. S., & Scheier, M. F. (1981). The self-attention-induced feedback loop and social facilitation. *Journal of Experimental Social Psychology*, *17*(6), 545–568.

Carver, C. S., & Scheier, M. F. (1982). Control theory: A useful conceptual framework for personality – Social, clinical, and health psychology. *Psychological Bulletin*, *92*(1), 111.

Chow, J. Y., Davids, K., Button, C., & Renshaw, I. (2021). *Nonlinear pedagogy in skill acquisition: An introduction*. Routledge.

Costa, A. M., Marques, M. C., Louro, H., Ferreira, S. S., & Marinho, D. A. (2013). The relative age effect among elite youth competitive swimmers. *European Journal of Sport Science*, *13*(5), 437–444.

Dannefer, D. (2003). Cumulative advantage/disadvantage and the life course: Cross-fertilizing age and social science theory. *The Journals of Gerontology. Series B, Psychological Sciences and Social Sciences*, *58*, S327–S337. https://doi.org/10.1093/geronb/58.6.S327

Dannemiller, K. D., & Jacobs, R. W. (1992). Changing the way organizations change: A revolution of common sense. *The Journal of Applied Behavioral Science*, *28*(4), 480–498.

Doran, G. T. (1981). There's a S.M.A.R.T. way to write management's goals and objectives. *Management Review*, *70*(11), 35–36.

Dutton, J. M., & Thomas, A. (1984). Treating progress functions as a managerial opportunity. *Academy of Management Review*, *9*(2), 235–247. http://doi.org/10.5465/AMR.1984.4277639

Eerde, W. V., & Thierry, H. (1996). Vroom's expectancy models and work-related criteria: A meta-analysis. *Journal of Applied Psychology, 81*(5), 575–586.

Eldredge, J. D. (1998). The vital few meet the trivial many: Unexpected use patterns in a monographs collection. *Bulletin of the Medical Library Association, 86*(4), 496–503.

Ericsson, K. A., Krampe, R. T., & Tesch-Römer, C. (1993). The role of deliberate practice in the acquisition of expert performance. *Psychological Review, 100*(3), 363.

Gawel, J. E. (2019). Herzberg's theory of motivation and Maslow's hierarchy of needs. *Practical Assessment, Research, and Evaluation, 5*(1), 11.

Gladwell, Malcolm. (2008). *Outliers: The story of success.* Hachette Book Group.

Georgopoulos, B. S., Mahoney, G. M., & Jones Jr., N. W. (1957). A path-goal approach to productivity. *Journal of Applied Psychology, 41*(6), 345–353.

Graham, S., & Weiner, B. (1996). Theories and principles of motivation. *Handbook of Educational Psychology, 4*(1), 63–84.

Herzberg, F. I. (1966). *Work and the nature of man.* World.

Juran, J. M. (1951). *Quality-control handbook.* McGraw-Hill.

Kantor, P. B. (1980). On the stability of distributions of the type described by Trueswell. *College & Research Libraries, 41*(6), 514–516. https://doi.org/10.5860/crl_41_06_514

Latham, G. (2012). *Work motivation: History, theory, research, and practice* (2nd ed.). Sage.

Latham, G. P., & Brown, T. C. (2006). The effect of learning vs. outcome goals on self-Efficacy, satisfaction and performance in an MBA program. *Applied Psychology, 55*(4), 606–623.

Locke, E. A., & Latham, G. P. (1990). *A theory of goal setting & task performance* (pp. xviii, 413). Prentice-Hall, Inc.

Lorenz, M. O. (1905). Methods of measuring the concentration of wealth. *Publications of the American Statistical Association, 9*(70), 209–219.

Macnamara, B. N., Hambrick, D. Z., & Oswald, F. L. (2014). Deliberate practice and performance in music, games, sports, education, and professions: A meta-analysis. *Psychological Science, 25*(8), 1608–1618.

Maslow, A. H. (1943). A theory of human motivation. *Psychological Review, 50*(4), 370.

Mazur, J. E., & Hastie, R. (1978). Learning as accumulation: A reexamination of the learning curve. *Psychological Bulletin, 85*(6), 1256.

McNatt, D. B., & Judge, T. A. (2004). Boundary conditions of the Galatea effect: A field experiment and constructive replication. *Academy of Management Journal, 47*(4), 550–565.

Merton, R. K. (1942). A note on science and democracy. *Journal of Law and Social Policy, 1*, 115.

Merton, R. K. (1948). The self-fulfilling prophecy. *The Antioch Review, 8*(2), 193.

Merton, R. K. (1968). The Matthew effect in science. *Science, 159*(3810), 56–63.

Okazaki, F. H. A., Keller, B., Fontana, F. E., & Gallagher, J. D. (2011). The relative age effect among female Brazilian youth volleyball players. *Research Quarterly for Exercise and Sport, 82*(1), 135–139. https://doi.org/10.1080/02701367.2011.10599730

Onate, J. A., Guskiewicz, K. M., & Sullivan, R. J. (2001). Augmented feedback reduces jump landing forces. *Journal of Orthopaedic & Sports Physical Therapy, 31*(9), 511–517. https://doi.org/10.2519/jospt.2001.31.9.511

Powers, W. T. (1973). Feedback: Beyond behaviorism. *Science, New Series, 179*(4071), 351–356.

Rosenthal, R. (2002). The Pygmalion effect and its mediating mechanisms. In *Improving academic achievement* (pp. 25–36). Academic Press.

Rosenthal, R., & Jacobson, L. (1968). *Pygmalion in the classroom*. Rinehart and Winston

Ross, C. E., & Wu, C. L. (1996). Education, age, and the cumulative advantage in health. *Journal of Health and Social Behavior, 37*(1), 104–120.

Seligman, M. E. (2006). *Learned optimism: How to change your mind and your life*. Vintage.

Sproul, A. B. (1994). Dimensionless solution of the equation describing the effect of surface recombination on carrier decay in semiconductors. *Journal of Applied Physics, 76*(5), 2851–2854.

Stratton, S. M., Liu, Y.-T., Hong, S. L., Mayer-Kress, G., & Newell, K. M. (2007). Snoddy (1926) revisited: Time scales of motor learning. *Journal of Motor Behavior, 39*(6), 503–515. http://doi.org/10.3200/jmbr.39.6.503-516

Trueswell, R. L. (1969). *Some behavioral patterns of library users: The 80/20 rule*. Wilson Libr Bull.

Moltke, H. V. (1871). Über Strategie. *Kriegsgeschichtliche Einzelschriften, zitiert nach: Militärische Werke, 2*, 291.

Vroom, V., Porter, L., & Lawler, E. (2015). Expectancy theories. In *Organizational behavior 1* (pp. 94–113). Routledge.

Walberg, H. J., & Tsai, S. L. (1983). Matthew effects in education. *American Educational Research Journal, 20*(3), 359–373.

Wiersma, E. (2007). Conditions that shape the learning curve: Factors that increase the ability and opportunity to learn. *Management Science, 53*(12), 1903–1915. http://doi.org/10.1287/mnsc.1070.0733

Case studies

6

The examples in this section are to show that the Accelerate The Curve (ATC) and Optimal, Maximal, Incremental, and Threshold (OMIT) models are actively and naturally in use all over the world and in many different disciplines – sport, business, and everything in between; gravity existed before it was given its name and scientists started to understand it more clearly. I am not comparing my models with gravity of course.

The purpose of this section is to highlight examples of the models – gathered from a few years of research and noticing clear examples as they are reposted either in press, books, or as well-known examples.

The examples also apply to what we often consider to be very successful organisations, and I'm not trying to suggest that their success is down to their use of the models – more that I am trying to show that small parts of the models already exist, but that I haven't found an example where all aspects of the models are used.

If this book were a recipe book I would hope that through understanding the ingredients and cooking processes more deeply, different recipes are possible.

All the examples are therefore retrospective and only partial in relation to the ATC and OMIT models. Importantly, the interviews or articles were not written with either of the models in mind but they all highlight one or more aspects that they have chosen to cite as important for their success, and I have been quick to hang on to these examples. I think this is different from me asking direct or indirect questions about the models as I could

DOI: 10.4324/9781032631530-6

well then be steering their thinking and answers. So, if I have also been able to interview the performers myself, I've also included the original source that piqued my interest. My favourite examples though are ones written by others where they unknowingly illuminate examples of the ATC or OMIT models.

Ultimately, my assertion is this – that elite performers have been finding elite performance already, without any help from this book. But this book might explain how they did what they did. And it might help them reach new heights, or others to raise their performance to similar levels. The second aspect is that of repeated high performance or maintaining your position at the top – through detailed understanding of the concepts, it makes iterations more accessible.

Team Sky/British Cycling

Introduction

Sir Dave Brailsford is credited with bringing marginal or incremental gains into mainstream consciousness with Team Sky and British Cycling. Given the connection that this book has with incremental gains, I am using cycling as an example of how the areas for development could have arisen through ATC mapping, and how the subsequent development areas could have been highlighted through both ATC and OMIT models.

The story

In 2012, Sir Dave Brailsford explained the idea of marginal gains to the BBC. He said:

> The whole principle came from the idea that if you broke down everything you could think of, that goes into riding a bike, and then improved it by 1%, you will get a significant increase when you put them all together.

> There's fitness and conditioning, of course, but there are other things that might seem on the periphery, like sleeping in the right position, having the same pillow when you are away and training in different places.

> They're tiny things but if you clump them together it makes a big difference.

Team Sky and British Cycling have had remarkable success. Team Sky won the Tour de France three times in four years, and multiple other stage and event successes. British Cycling has dominated track cycling in particular at several recent Olympic Games. It is no coincidence that Dave Brailsford is involved in both teams.

Team Sky cycling became Ineos Grenadiers in 2019 as a result of Sky moving their sponsorship elsewhere and Jim Ratcliffe's Ineos organisation becoming the team's title sponsor.

Team Sky / Ineos riders have won the individual Tour De France General Classification in 2012 and 2013, then for five straight years 2015–2019. That is a remarkable achievement. They also won the Team GC in 2017 and 2022.

Links with ATC/OMIT

If marginal gains are easy to accumulate, then why does this not create success with more certainty? Partly because "everyone else is doing it", but our analysis goes further.

Our analysis of marginal gains asks:

- Why doesn't everyone do it, and if they do, how do you stay ahead?
- Not everything can be improved marginally.
- Not all gains deliver an advantage.
- Not all gains are equal.
- The cost of the gain might be disproportionately high.
- How does the timing and sequence of gains impact the overall position?

I'll answer these in relation to Team Sky.

Why doesn't everyone do it, and if they do, how do you stay ahead?

Everyone else may of course also be developing marginal gains. Staying ahead becomes a case of deeper understanding, mainly of which gains deliver an advantage and whether the timing and sequence of development is important. These two aspects are of course OMIT ad ATC.

One of Brailsford's most quoted examples is that of taking all riders' pillows on tour for the Tour De France. Improving their sleep was one of the marginal gains. So, every other team copies them. Then what do you do?

Get 1% better pillows? Can you keep getting better pillows? No – because pillows can't be improved incrementally. To me, pillows are a great example of Optimal/Threshold. By which I mean there's a point at which they need to be good enough, but then you can stop developing them further. Not until you can reach the next Threshold – maybe if a fundamentally different approach is found.

Their approach shows how they were successful, and it also shows why their success is hard to iterate. Without the understanding of OMIT, they may very soon run out of things to incrementally improve – or rather that they may still find things to incrementally improve, but those things may not deliver the benefits that they are looking for. Their list of possible improvements will diminish. You can't repeat "pillows" on next year's list as a GAIN.

Not everything can be improved marginally

OMIT maps aspects with greater precision, and distinguishes between aspects that can be developed marginally (Incremental) and those where the steps are much greater (Threshold).

Not all gains deliver an advantage

If a gain fails to deliver an advantage, then the likely cause is that there is a threshold that has not been taken into account. If my computer needs 4 Tb of storage and it currently has 1 Tb, then increasing to 2 Tb is still insufficient. The gain of 1 Tb has not lead to a meaningful performance increase. OMIT principles help to identify these thresholds and effective choices can then be made. In this case, either increase to 4 Tb or focus attention elsewhere, because a 1Tb marginal gain will not achieve anything meaningful.

Not all gains are equal

Thankfully not, as this is one area for competitive advantage. Assuming all 1% gains will all contribute the same is the mistake you want your competitors to make. It may be Incremental or Threshold, or it may be a tiny gain that achieves the next threshold which would give a disproportionately high gain.

The cost of the gain might be disproportionately high

If the cost is financial, then this may not be an issue for Sky/Ineos, as they are known to have the largest budget on the Tour. However, even with large budgets, there may be disproportionate gains – not all expenditure will deliver the same outcomes.

If the cost is measured in time, then this is finite for every performer. A team or project however could increase the number of available person-hours by recruiting and adding more people to the project. The excellent book "The Mythical Man Month" shows in great detail how this is not as straightforward as it would seem. A project that would take one person ten months to complete would not take ten people one month to complete, for those people bring additional costs in terms of collaborating, communicating, and how the work is allocated. "The bearing of a child takes 9 months no matter how many women are assigned" refers to whether the task is partitionable.

The unit measure of the size of a job in man-months is "a dangerous and deceptive myth" as factors such as partitioning, communicating, and the complexity of the relationships all change as the task grows and as the number of people assigned to the task changes.

How does the timing and sequence of gains impact the overall position?

This is an ATC question. ATC suggests that early gains are beneficial, and that there is a compound effect and cumulative advantage. ATC also fundamentally proposes the adoption of steep learning curves.

The other examples for Team Sky also fit into the two incremental quadrants on OMIT (Incremental/Optimal and Incremental/Maximal).

Example 1. Redesigning the team bus to enhance comfort and recuperation.

Yes, you can continue to make improvements to the bus to make it increasingly more comfortable. But "redesign" the bus sounds like a threshold activity. You commit to a redesign and then, short of another threshold (the next redesign) your comfort is going to be bound by the level comfort you've baked-in to the design of the bus. I'd suggest this goes into the Optimal/Threshold quadrant and if the bus is insufficiently comfortable (i.e. below threshold) that this is addressed. That will then (post-refurb) still be in the same quadrant but now be above the threshold and therefore not an area for future effort.

Example 2. Infection reduction with anti-bacterial hand gel.

These really are two separate items. Infection reduction is, on its own, in the Maximal/Incremental quadrant. You want as much infection reduction as possible, and the likelihood is that infections are stopped one at a time through good hygiene.

Hand gel, though, as a part of infection reduction is Optimal/Threshold. It's binary if you have hand gel or not, and anti-bacterial hand gel works if used. There's no "better" gel to incrementally move towards. Seeing infection reduction and gel as two separate items though allows you to consider what else could be done to reduce infection, and this allows for further action and future iteration.

Hindsight

My question here is whether the examples quoted by Team Sky could have been outputs from the use of the OMIT model.

For this I'd like to look at the example of the riders' pillows. Again, for OMIT this is potentially Incremental. You *can* get pillows that are slightly better, in small increments. But the intention was for the riders to bring their pillows from home so that they move to the threshold of (for each rider) the optimum pillow. This then is Optimal/Threshold, and if the pillows are below the necessary threshold then improve them as soon as possible and then they do not need improving beyond that.

OMIT and ATC as proactive steps though could have more performance aspects under a wider "quality of sleep" branch, and that for me is what's missing from Brailsford's approach. It's too focussed on finding something, however small, to improve, and allowing those improvements to accumulate.

The risk of only improving small things that can be improved incrementally, is that you end up only improving small things by a small amount.

Let's unpack the quality of sleep area then, and place that category itself in a wider category of "travel".

The "branch" in Figure 6.1 represents TRAVEL, from which (one of many) is the branch "sleep" and contains as many leaves as you can think of that would determine performance in that area. You can see that "pillows" is a leaf on that branch.

What's brilliant is that aspects such as pillows can be dealt with swiftly, and once. Then they're done, leaving you to consider what else is on the

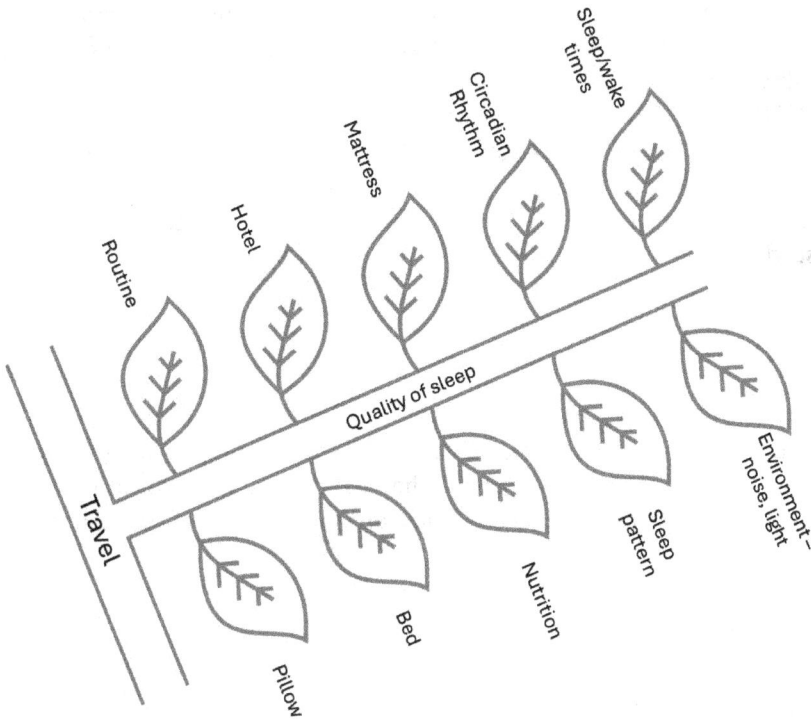

Figure 6.1 ATC branch and leaves for "travel".

"quality of sleep" branch that could be improved, to highlight any of those that are also Optimal/Threshold and to be done swiftly, whilst then exploring the genuinely incremental gains which exist in our model in two quadrants – Optimal/Incremental and Maximal/Incremental.

We define these as things which CAN be improved incrementally, and either to a point at which no further benefit is gained (Optimal) or where better is always better (Maximal). For sleep quality, an example of Optimal/Incremental would be the duration of sleep. Yes, more is better, but only up to a point. It's clear that 24 hours of sleep in each 24-hour period would not be beneficial. So the research and the gains need to be focussed on determining the optimum duration, and then looking at ways of achieving that. Once achieved, focus can again be placed elsewhere.

For Maximal/Incremental and sleep quality – I'd have to guess at something like nutrition – there's likely to be a link between what and when we eat, and our sleep quality. But we also need to balance the recovery and

fuelling aspects of nutrition. The likelihood is that this fine balance can be tweaked almost ad infinitum to attain an ever-increasing benefit to sleep quality – i.e. Maximal.

With ATC and OMIT – you can iterate. You know that pillows are a one-time Optimal/Threshold item, but that still leaves plenty to address in order to improve the quality of sleep. Or if sleep quality is now itself above the threshold of good enough, it allows resources to be diverted elsewhere.

Conclusion

Team Sky have had great success and they themselves cite incremental gains as a key development strategy. OMIT and ATC models both could be used proactively to curate an approach that seems less random, more precise, and ultimately is iterative so that gains are sought that maximise impact on performance.

Red Bull F1 team

Introduction

Dominant in 2010–2013 with four consecutive world drivers' championships, Red Bull F1 then were left behind by Mercedes F1 who dominated from 2014 to 2020. However, in 2022 Red Bull's winning margin was such that they appear to have been able to develop at a faster rate than their competitors, using cumulative advantage to apparently stay easily ahead of their competitors. They have now won another three consecutive World Drivers' Championship titles and at the time of writing are on their way to a fourth consecutive drivers' title.

Formula 1 regulations appear to facilitate dominance, through teams being able to focus development time on next season's car ahead of their rivals if they create a large enough points advantage in the season. This is almost a perfect representation of cumulative advantage.

The story

It's not difficult to find examples of what looks like cumulative advantage in F1; many times over the years the same team has dominated for a period. McLaren won 7 out of 8 years from 1984; 1992–1993 Williams,

1994–1995 Benneton, 1996–1997 Williams, 1998–1999 McLaren, 2000–2004 Ferrari (five consecutive).

Formula 1 is an interesting case study because unlike most other elite single-seater racing around the world, Formula 1 does not pitch drivers against each other in identical cars, rather the individual teams construct a car from the ground up using only the rule book as their guide. This is an over-simplification of course, but the point I am making is that the development of the car is a huge part of F1, and the development of the following season's car can be started if you are in a position to not need to continue to develop the current season's car.

This has been somewhat exacerbated by the cost cap, introduced a couple of years ago to try to create a more even playing field. More on this later.

This case study looks more deeply at F1 and uses Red Bull, the current dominant team as the focus.

In 2004, Red Bull purchased the Jaguar F1 team and renamed the team Red Bull Racing. Jaguar F1 had finished seventh in the constructor's championship in 2004, which was about par for the team which had formed in 2000, following the purchase of Jackie Stewart's F1 team.

The Red Bull team's previous iterations as Stewart F1 and then Jaguar F1 were not hugely successful, to make the point that Red Bull did not buy a "winning" team. The winning came later. As said above, in 2004 the team, as Jaguar, had finished seventh in the F1 Constructors' championship.

However, during the 2005 season Red Bull announced that Adrian Newey would be joining the team from 2005 onwards. Adrian Newey was at the time, and still is, known as the best F1 car designer, having won 12 constructors' titles with 3 different F1 teams. Cars designed by Newey have won over 200 Grand Prix. This should set the scene well. The best car designed in F1 moved in 2006 to a team that had not won a race or finished higher than seventh in the constructors' championship, and by 2010 won the first of four consecutive championships.

Links with ATC/OMIT

One of the principles of ATC is to get an early advantage and it's clear that Newey joining was exactly that kind of advantage, and one that propelled them to the position that they are now the fifth most successful F1 team in the history of the sport as measured by World Constructors' Championships (WCC) and fourth all time for Driver's Championships (WDC), this despite them only having been around since 2004. This is a remarkable achievement.

Adrian Newey joining the team is certainly an example of an ATC principle, that front-loading this advantage creates a lasting effect, but there is a much more recent example that is a result of success in one year leading to success the next – the Matthew Effect – or cumulative advantage.

Teams have limited and capped budgets in Formula 1, and teams have to, to some degree, weigh up the option of continuing to develop and enhance the current year's car against the option of developing the car for the following season.

If championships are hard-fought, there is a necessity to continue with the current car. If you're way ahead of your competitors you can afford to stall development on the current car, let the competitors catch up a little and refocus your efforts on next year's car.

In 2022, Red Bull were so dominant and won the Constructor's Championship by such a margin that development for the 2023 car could easily have started well before other teams, and the effect of this was seen with their 2023 performance, which was even more dominant than 2022. 2024 has started in an equally dominant fashion.

Formula 1 is unusual in that the teams each develop their own cars within the regulations, and in recent years the regulations have been relatively stable so as to try to allow smaller teams (or less well-funded teams) to catch up over time. There is also the assumption that over time, there will be fewer performance gains still to find, so that the playing field becomes more level as the years progress.

In addition, the FIA (The Fédération Internationale de l'Automobile, Motorsport and Formula 1's governing body) introduced a cost-cap for 2021 onwards. This limits the total expenditure for teams, with the intention of further levelling the teams.

With ATC's principle of cumulative advantage in mind, it becomes even more important for teams to maximise expenditure in the final year before the cap. What we saw with Red Bull is the perfect storm of dominance in 2021/2022 and the cost cap introduction. Whilst not designed this way – the intention was to level the teams – the timing of the cost cap introduction actually appears to have increased the advantage for a dominant team.

Red Bull increased this advantage further by making sure they spent all of the budget; their 2021 audit actually finding a cost-cap overspend, which was punished, but not in a way that compromised any performance gains already developed.

The cumulative advantage of winning the World Drivers' Championship (WDC) and World Constructors' Championship (WCC) in 2022 as a result of overspending (assuming the overspend can be turned into a performance

advantage, and if it can't then the cost cap wouldn't be necessary) is surely greater than the potential downsides of the penalty for overspend, because success breeds success. 2022 and 2023 WDCs would suggest that it was indeed a penalty worth paying

Now that Red Bull have firmly settled as the current successful team, cumulative advantage means that they will (probably) be able to attract more sponsorship, attract elite talent at every level through the organisation. Whilst there is a cap on what the team can spend, there is no cap on what a team can earn/generate in revenues, and of course some costs are excluded from the cap anyway. ATC principles therefore allow them to continue their success both financially, organisationally, and – as we are seeing – competitively.

Hindsight

F1 success is not just down to Adrian Newey; the four main factors are the designer, the engine, the driver, and the team/team principal. Teams probably need to be near the top in all four in order to win.

If you are Red Bull, what would you need to do to keep your advantage?

If you are NOT Red Bull, what would you need to do to close the gap and maybe even start the journey to being the next dominant team?

HaasF1 have just (January 2024) fired team boss Guenther Steiner; as Gene Haas (the Haas team owner) said, "It's about performance. I have no interest in being 10th any more". Haas later also went on to say that their annual expenditure is very close to the cost cap. One of the downsides of the cost cap is that it removes one potential area for accelerated development, although what remains is the possibility of utilising the budget differently by focussing a disproportionately high budget on one particular cost area in order to try to skew the success of that one area by affording that area a steeper ATC development curve.

You cannot just hope to become successful though. Haas team principal Guenther Steiner is one of the most charismatic team principals on the F1 grid and certainly attracts a lot of media and Netflix attention. If there is one area that Haas F1 were near the top in F1, it was with their team principal and his ability to generate attention. It will be interesting to see how Haas does in 2024.

The next set of major regulation changes are with the 2026 car, and interestingly the FIA have specifically banned development of the 2026 car until 2025, so whilst this still allows for the "normal" level of cumulative advantage for any team that can afford to spend some of their development

time and budget on the following year's car, it does not allow any of the less-successful teams to abort the currently season (2024) and start in 2026 now, on the basis that they will probably finish last anyway for the next two seasons.

I think this is a little disappointing – this is exactly the kind of compromise that creates interest in the sport, especially when regulations and budgets are capped. If there is so little scope for team differences, because budgets and regulations have been stable for so long, then it will almost become a one-make series.

In the meantime, teams need to find ways to bake-in cumulative advantage in any way possible by being more selective about which development curves to accelerate. When budgets were not capped, teams could arguably allocate budget and focus on ALL development areas in a steep way. Now that they can no longer look at every possible area, selecting fewer, better areas to develop is key.

Conclusion

F1 has a budget cap and restrictions on developing the 2026 car before 2025. The 2026 car is to be built under a new set of regulations. The intention is to level the playing field, but who would bet against the current dominant teams from continuing to dominate in 2026?

My suggestion to any team would be to use ATC to map every performance area for every person, role and area of F1. The aim will be to look for potentially disproportionate cost/benefit gains (i.e. higher benefits for lower cost).

OMIT will then be helpful to highlight in the first instance the Optimal/Threshold aspects which are currently below threshold.

Johanna Konta

Introduction

Professional tennis has a key threshold, that being the world top 100, as entry to tournaments and share of prize money jumps significantly within the 100.

This case study looks at a professional player who has benefitted from sports psychologists, understanding the importance of accelerated development curves and achieving thresholds.

The story

Johanna Konta is a British Tennis player who was British Number 1, and ranked World number 4 at her peak. Disappointingly, she missed the Tokyo Olympics after testing positive for COVID-19.

I first heard Jo Konta speak on a podcast (The High Performance Podcast – Jake Humphrey and Damian Hughes) and there were a few things that she said, or that Jake or Damian said that resonated powerfully with ATC.

Johanna and her family took risks, made sacrifices, and looked to specifically accelerate the development in certain key areas that were thought to be able to unlock performance.

Links with ATC/OMIT

Firstly, Konta sounds like her ATC map (if she had one) would be broad, and covering plenty of aspects and not just tennis. She also sounds like she has benefitted from having a psychologist (Juan Coto) in her team, not just for her tennis but for the impact that psychology has had on her life. Some examples of this are:

Anxiety, guilt, and responsibility. Specifically guilt around what her parents have sacrificed. Konta says that when the guilt was alleviated was she able to make "room to become a better tennis player". Konta then went on to say that she can have anxiety, struggle, and fear, and carry all of it, but that she "doesn't have to be impacted by it. I'm fully equipped to deal with it". Linking this to ATC at one level is understanding the psychological impact of guilt, of the weight of expectations that can be caused by sacrifices that others make for your performance.

"Pain x resistance = suffering". Konta gives the example that if pain is 10, suffering is either 100 (if resistance is 10) or zero (if resistance is zero). Again, within the Psychological branch of an ATC map would be Resilience, and Konta demonstrates how her resilience has been positively affected by being able to process the concept of pain differently. This pain equation seems to be attributed to Dr Kristin Neff whose work on self-compassion is linked to many areas of performance, self-esteem, and the various psychological factors that this book has covered (Germer & Neff, 2019; Neff, 2011, Neff et al., 2005, 2019).

"Process, not results". When talking about the shift to be able to enjoy playing, it was important to let go of the concept of being happy only if she was winning. Focussing on the process allows her to be happy if she's delivered on the process well, irrespective of the result. This is a clear link to

goals, and the realisation that if the goal is winning, then it is unfortunately easier, and more likely to bring disappointment or failure. Nobody wins all the time, so linking your success to the goal of winning, knowing that it is not possible all of the time, sounds a poor strategy.

Phrases like "I'm fully equipped to deal with it" and "pain times resistance equals suffering" and "process, not results" sound like phrases that she has said to herself many times. They sit alongside her tennis ability and contribute to winning matches.

In the research for this book, I did not find another interview that conveyed the power of psychology contributing to results as well as Johanna Konta's. Her ATC Success Tree would definitely have branches relating to multiple aspects of psychology.

Her interview also then gives a great example for marginal gains, and OMIT. Jake Humphrey talks about the degree to which psychology has been a help, and says

> It's a good point though when not many people are doing it focusing on the mental side of something is really valuable – It's revolutionary. When everyone's doing it, you have to be extra good at that to be any better, don't you?

Marginal Gains have the most impact when they create a gap between you and your competitors, not just a gain for you. So when your competitors catch up, the gain is lost unless there is a way to iterate.

Iterating marginal gains is a fundamental part of OMIT. Understanding whether something is Maximal or Optimal will help to define the future development of that aspect. In Konta's case, what Jake Humphrey is essentially saying is that psychology is Maximal, in that you can keep developing. Contrast this with Team Sky's pillows which are Optimal – once the pillows are good enough to contribute to better sleep, you can't keep improving pillows (although you could keep improving sleep, rest, and recovery). Your competitors also can catch up quickly (by also improving their pillows) but with psychology, being Maximal, you can continue to develop, and look to retain a competitive advantage.

Hindsight

Jo Konta's ATC map, as for all other people, may have many psychological elements, but that's not to say that this is where the ATC map could provide most value. It is possible that many performance benefits would still be there to uncover through competing the rest of the ATC map.

Staying with the psychological aspects though, dealing with failure (however the individual defines this) is an important aspect that ATC deals with well. This nis because ATC maps so many components that can each be measured and developed that there are positive psychological benefits from always seeing progress. Marginal gains are not just about moving overall performance forward, there is a strong psychological benefit from noticing the overall direction of travel.

Conclusion

ATC is about finding multiple ways to define success; every single leaf on an ATC map offers the opportunity to occasionally reach a new level of performance for that sometimes tiny aspect.

Johanna Konta has shown specifically many of the performance aspects that the psychological aspects of performance can bring.

Software development

Introduction

Software development has many parallels with personal development, and in some cases is highly process-driven which allows us to look for the processes which support or develop ATC and OMIT.

Software development has been around much longer than ATC and OMIT, has been well researched and understood, and has plenty of stories of failure that they, and we, can learn from.

The story

Apple releases a new iPhone every 12 months, around September. They have done since the first iPhone was launched in (June) 2007.

Apple is always working on developments to both the hardware and software. Every year, Apple completes sufficient hardware development to justify the next generation of iPhone.

Software releases are more regular, and follow the industry standard software Semantic Versioning convention (e.g. Major.Minor.Patch – version 3.2.7). Currently, for Apple's iPhone the operating system iOS is version 17.4.1. The final iteration of version 16 was 16.7.7. Having started with iOS 1 in 2007, it would seem that the iPhone software major releases

are slightly more frequent than the hardware – iPhone 15 was released in September 2023.

A software CEO mentioned to me that software development was very easy to link to the OMIT model. He talked about how software cannot be sold to customers until it's "ready" because there's a natural threshold below which it is still software in development. It cannot be monetised until there is a product to sell. This threshold is referred to as MVP – or the Minimum Viable Product.

Once it is being sold to customers, then incremental development can continue. Early adopters can give valuable feedback that will allow for incremental development from this point onwards. Regularly, there will be further thresholds though – where the entire product needs to be migrated to a new platform or architecture, for example.

Semantic versioning fits well with OMIT. In the example of Apple's iPhone iOS, Version 17.4.1, version 17 is the threshold release that would have followed version 16. The second digit (.4) in the sequence is the minor release, so would have followed version 17.3, and could be either an Incremental or Threshold release. The third digit (.1) is a clear Incremental release – often a minor or security release that can often be urgent.

Does this mean that software development is straightforward and easy to set and deliver to thresholds? Certainly not for Microsoft when they first developed MS Word. In Steve McConnell's book "Rapid Development" (McConnell, 1996) he cites the scheduling history of Word for Windows 1.0. In September 1984, Microsoft estimated the shipping date as September 1985 – so they gave themselves a year for development. Eventually shipping in November 1989, 4 years late. With the goal from Bill Gates to "deliver the best word processor ever" it is not surprising that they delivered Word for Windows late, as it's not clear what their MVP was. Alternatively, it is clear, and the MVP was "best word processor ever" and that took 5 years.

What we learn from this is that there is a difference between a goal and the MVP, and that the MVP should be a clear threshold. Subsequent thresholds can be planned as both developmental stages and also as sales opportunities as customers upgrade to the next version.

Again referencing Steve McConnell's book Rapid Development, he cites many areas that contribute to performance in the software development field, under the heading of Classic Mistakes. It is apparent that only a few of these are specific to software development, and many can be applied to any project or development area.

People-related

- Undermined motivation
- Weak personnel
- Uncontrolled problem employees
- Heroics
- Adding people to a late project
- Noisy, crowded offices
- Friction between developers and customers
- Unrealistic expectations
- Lack of effective project sponsorship
- Lack of stakeholder buy-in
- Lack of user input
- Politics placed over substance
- Wishful thinking

Process-related

- Overly optimistic schedules
- Insufficient risk management
- Contractor failure
- Insufficient planning
- Abandonment of planning under pressure
- Wasted time during the fuzzy front end
- Short-changed upstream activities
- Inadequate design
- Short-changed quality assurance
- Insufficient management controls
- Premature or overly frequent convergence
- Omitting necessary tasks from estimates
- Planning to catch up later
- Code-like-hell programming

Product-related

- Requirements gold-plating
- Feature creep
- Developer gold plating
- Push-me pull-me negotiation
- Research oriented development

Technology-related

- Silver bullet syndrome
- Over-estimated savings from new tools or methods
- Switching tools in the middle of a project
- Lack of automated source code control

Links with ATC/OMIT

Taking Steve McConnell's list above, the inverse of many if not all of these problems can be mapped onto OMIT quadrants, and are at organisation, team, or individual levels.

For example, the first point "undermined motivation" would be seen on an ATC map as Motivation, but then would have many other branches and leaves from there.

When mapping ATC, it is interesting to note that aspects can be derived from the problem end of the question (what goes wrong) as well as the other end (what are the components of success).

Specific correlations from software development to ATC/OMIT as I see them are:

1. Very specific thresholds. From MVP initially to clarity around versioning. There will be aspects which are to be developed for the next iteration, and others which are held until a future version.
2. The clarity of approach. The project plan will contain every individual aspect being worked on. Including bug-fixes.
3. The sense of overall progression.
4. Clear increments.
5. Clear understanding of the difference between increments and thresholds.

Hindsight

There are still areas where software development could benefit from ATC/ OMIT approaches. ATC specifically looks to include any and all aspects that lead to overall high performance where I would see a contrast with software development being only focussed on the software. ATC would allow and encourage an ATC map that includes all human factors, such as motivation, collaboration, psychological aspects, recruitment, etc.

Steve McConnel's list of Classic Mistakes could read across into any other performance area – learning from others' mistakes or from previous mistakes.

Conclusion

Software development reads across well into ATC and OMIT, but not completely, but also informs ATC around weaknesses/mistakes.

The clarity of focus around versions, which OMIT would class as Thresholds is helpful, as is the incremental approach from Minor and Patch releases. The people-related mistakes are a reminder in any discipline that performance comes from people, and only mapping the process or the thresholds at a technical level is to miss opportunities to prevent mistakes, and to maximise performance.

Leicester City Football Club

Introduction

This is an example of a professional sports team who performed beyond expectations, elevating performance dramatically in a very short space of time. Articles written about this dramatic shift show some clear examples of ATC and OMIT concepts.

The story

Leicester City Football Club famously won the UK Premier League in the 2015–2016 season but in the previous 2014–2015 season, Leicester's form was so poor in the first half of the season that they were under the threat of relegation, caused by scoring only 19 points from 29 matches (29 wins would have scored 87 points by way of comparison). At the end of the season though, they won seven of their final nine matches and managed to stay in the Premier League. No team scoring 19 points from 29 matches had ever managed to avoid relegation before. They achieved a remarkable feat in just managing to stay in the Premier League.

At the start of the 2015–2016 season then, Leicester were given 5000-1 odds of winning the league, but looking to go further than their remarkable achievement of 2014–2015, this is precisely what they went on to achieve.

Links with ATC/OMIT

The BBC news article that I've quoted here refers to a number of tactics that are easily noticeable as aspects of the ATC and OMIT models.

Here's a link to the full BBC article: http://www.bbc.co.uk/sport/football/36189778

I'll select key paragraphs for analysis.

> … an innovative sports science and medical team, carefully integrated into the decision-making process, has created a perfect model for success.

I'll start by saying that this BBC News article in 2016 really resonated with the idea of the book that was in my mind at the time. To have so clearly laid out many aspects that I felt fitted well with the ATC and OMIT models was something of a revelation.

One of the key factors for the ATC and OMIT models is that I think they point more towards a model for success because they allow performers to be proactive about developing the strategies and tactics.

If there are say 100 performance factors that lead to overall high performance then we already know that these 100 factors are not all equal, some of them will be more important than others. This relative importance comes from two factors – the first factor is the delta between current performance and peak performance. The bigger the delta the more potential for improvement. The second factor is the intrinsic nature of the performance factor. Some will only have a 0.01% possible impact overall irrespective of how well developed it is. The third factor is how things change – something that was once critical to develop may no longer be critical to develop further in the second iteration if something else has become more important.

If it is a relatively unimportant factor but can still be very easily developed and implemented, then there is a case for improving it. Especially if, once developed to a new threshold it needs very little ongoing effort to maintain. So this factor may be part of the first iteration of your success plan, but not subsequent iterations. To a degree, I think what Leicester City missed was the chance for the second iteration to take into account this opportunity to re-prioritise development areas.

First then, I will look at how the reported development fits into ATC and OMIT models (Figures 6.2 and 6.3). After that, I'll look at what I see as how ATC and OMIT could have shaped subsequent iterations.

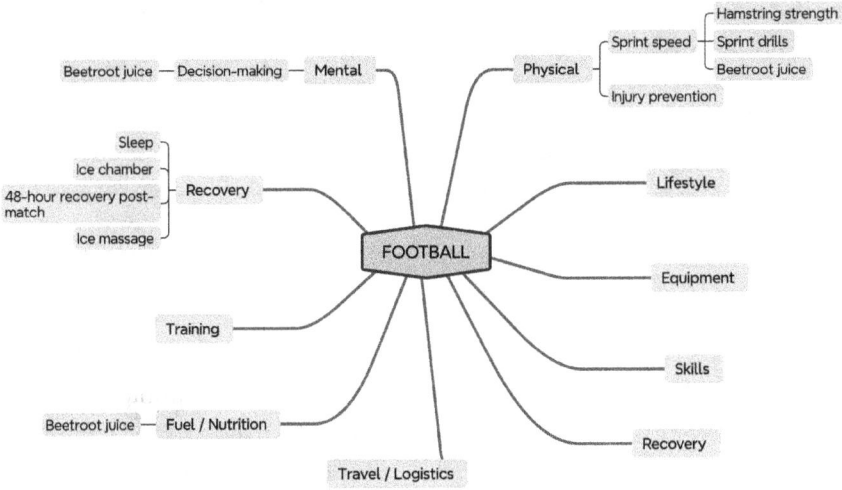

Figure 6.2 ATC map for "football".

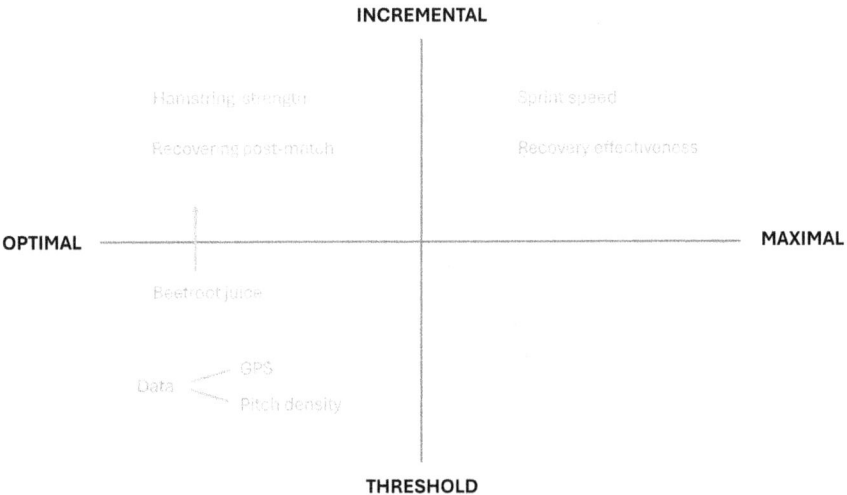

Figure 6.3 Possible OMIT quadrants for "football".

ATC and Leicester City

Remembering that both models are subjective, this is my first draft of the ATC map. I actually started with the same map as for Tour de France cycling – almost a generic athlete map – that includes physical, mental, training, equipment, recovery, nutrition, lifestyle, travel, and skills. There's

overlap and repetition but remember that the goal is to get MORE on the map, not necessarily to get it right first time.

From the BBC article, I was able to plot quite a few aspects into Recovery (ice chamber, sleep, 48-hour post-match recovery, and ice massage). Into physical, I plotted the sprint speed aspects that the BBC mentioned (hamstring strength, sprint drills, and beetroot juice). Beetroot juice also appeared in the fuel/nutrition category.

So sprint speed can ONLY get on the map if this is an area that has been highlighted as important. What the ATC map doesn't tell us is how important it is and for how long it will be important.

Interestingly, it would appear that there is a positive correlation between sprint speed and winning matches; the teams with the fastest sprinters win more matches. So this highlights sprint speed as important – and once you've got the fastest sprinters you can shift to maintaining sprint speed, unless every other team notices this and also works on sprint speed, and you need to continue development beyond this new threshold (we're moving towards OMIT now).

OMIT and Leicester City

Again, it's important to remember that this is subjective and a discussion among the team would be valuable.

Quadrant selection decision process

Beetroot juice: If the current state is NO juice, then the threshold is to start taking juice, so that is a threshold (binary, on/off). I also think it is likely to be Optimal – i.e. there's a certain level that's useful and it's unlikely to be Maximal where you continue to get a greater benefit the more you drink. So beetroot juice starts in Optimal/Threshold. However, in the second iteration it's likely to move into the Optimal/Incremental quadrant for the reasons above – it's still Optimal but it is possible to adjust the dose incrementally.

Data: It depends how much data you have currently, and how good that data is. So again. This could be in the Optimal/Incremental quadrant. It may even be in Maximal/Incremental quadrant (where the equipment can just keep getting better and better, and the more/data you have the better it is. I've put it as Threshold for the first iteration because my assumption was that it was a binary switch from not having GPS data to having the equipment to measure it.

Sprint speed. I've subjectively put it in Maximal/Incremental. It may be possible to increase speed incrementally, even though there's likely to be a plateau. (remember though from Ericsson's research with Morse Code operators that the plateau was often below the maximum performance level, and that it could be overcome with extended effort).

However, with some players it may be that sprit speed is in some ways threshold – they may have to fundamentally change some aspect of their technique to unlock the next level of performance, in which case treating sprint speed as Incremental for that player would be incorrect.

Recovery effectiveness. The BBC article talks about this a lot and includes the ice chamber and ice massages, as well as longer rest periods as helping. I have put the macro Recovery Effectiveness into the Maximal/Incremental quadrant and at the same time put post-match recovery into the Optimal/Incremental quadrant. (Because post-match recovery of 48 hours sounds like Optimal and unlikely to improve performance by extending the recovery period beyond 48 hours – it may be that 48 is not actually Optimal, but it can be changed incrementally [by an hour at a time for example] and maybe 39 hours is actually Optimal.)

Analysis of the Leicester City plan

My view is that without the ATC and OMIT models, through analysis they sought key performance factors (such as sprint speed) that they could develop. Areas such as recovery, injury prevention, and nutrition were looked at to make changes that could be immediate but long-lasting. They also noticed and included the positive mental effects not just the physical effects (e.g. ice massage they said the players noticed the red skin marks as a sign that recovery had started).

From an ATC perspective they looked to accelerate the performance improvements to key levels and then maintain, whilst then focussing on new accelerated areas. Sprint speed is a great example of this; once they had the fastest sprinters, they only needed to then maintain those speeds.

Hindsight

> … an innovative sports science and medical team, carefully integrated into the decision-making process, has created a perfect model for success.

> If this was indeed a perfect model for success … what happened subsequently?

I think that the success that they enjoyed in the 2015–2016 season was very much down to the way that they developed performance however it was flawed as a model for success because as things turned out it didn't allow them to build any kind of continued success after the 2015–2016 season.

The next iteration of the Leicester City plan

This is where I think the ATC and OMIT models would have been of benefit as it would have helped the team understand what they did and how it helped with performance. It would have helped make the next iteration of performance choices and priorities.

This isn't meant to be a football analysis, just a way of illuminating ATC and OMIT, but it is also important to remember that football teams, like any other business, have multiple priorities and I really only mapped the football aspects, not the wide business aspects. This is my way of saying that finishing 12th in the league in the season after winning the league is OK, and that selling a player for £32 m a year after buying him for £5.6 m is good financial business.

However, these priorities could still have been on the ATC map – factors such as team culture, financial performance, player retention – who outside of the club knows the relative importance of these in comparison with match performance.

Conclusion

Leicester City's success in 2015–2016 was based on fine margins. Sometimes the gap between winning and losing can be very small. But as a team they were able to plan some changes that they then saw as leading to more success. Recovery, injury prevention, sprint speed, data – all proactively improved and all easy to map on ATC and then OMIT.

But their relative lack of continued success was in part down to not understanding how to iterate the success. Understanding where aspects are now below Optimal Threshold for example, or being able to keep players (or any team members) on multiple victory cycles could have made a difference.

They were also hindered by losing key players furthering their careers at other clubs and this is often a penalty of success for teams, but even here, player retention – just as any successful team needs to look at retention of key personnel – is a factor that should be on any team's ATC map.

Duran Duran

Introduction

This case study is an example of how, even in its early stages, a team (in this case a music group) can achieve success after having reached a key threshold.

The story

Duran Duran formed in 1978 and their 1981 eponymous debut album peaked at number 3 in the UK charts and number 10 in the US billboard. The success of the album and of the band overall cannot be doubted, but it's interesting that in a TV documentary, John Taylor, bass player with the band said:

> "On that first album we're all playing the BEST that we could play; we're playing every note we know".

The second aspect that helped Duran Duran's early success was the launch – also in 1981 – of the music cable channel MTV. Keyboard player Nick Rhodes said

> "Video is to us like stereo was to Pink Floyd".

MTV launched to air music videos and related content yet music videos were still relatively new. Duran Duran really took to video as an art and as such had a platform with MTV to promote their songs.

The cumulative advantage that followed has led to sales of over 100 million albums, 11 awards including 2 each of Grammy, Ivor Novello, Brit, and Q awards and being inducted into the Hollywood, and Rock & Roll Halls of Fame.

Links to ATC/OMIT

The timing of Duran Duran's first album coincided with the launch of MTV, and the band's talent was identifiably just above the Optimal Threshold in both their music ability and their video ability.

Playing musical instruments would normally be considered a Maximal and Incremental skill; it is possible to increase the skill level in measurable and demonstrable ways with no apparent limit. I am sure that even

the best instrumentalists are still looking to improve further. Despite this Maximal/Incremental approach, it would appear that Duran Duran in their early days found their music skill to be Optimal/Threshold. This is clear from the quote

> "On that first album we're all playing the BEST that we could play; we're playing every note we know".

The Threshold was the point where they could play sufficiently well to play their songs, as this was the only requirement. Good enough was all that was required.

They could have spent countless hours perfecting their craft but instead they say that what they knew at the time was enough, albeit the peak of everything they knew at that time. OMIT suggests that they had reached OPTIMAL for several skills between them (instruments, live performances, video, marketing, their fan appeal). Just enough was apparently just enough.

It is almost certain that their skill has developed since, after all they have now all been professional musician and performers for 40 years. It is likely that today they now see their musical skill as Maximal/Incremental and indeed will have been improving incrementally since 1981, but at the time, all they needed was enough skill to play their songs.

This is useful to illustrate the iterative nature of the OMIT model; a skill is not confined to just one quadrant, nor is the skill absolute as defined in the model or each individual performer. Instead, the skill or attribute can be placed in one quadrant based on how it is for the individual only at this point in time, and at any future point or development stage it may be in a different quadrant.

Given that we see anything that is below a threshold as a priority for development, it is important to recognise that the OMIT model requires re-writing regularly in order to see how the skills have moved and to recognise new priorities.

ATC

Their early development had been on a steep curve and included their focus on music video which was arguably as important as their music for their early success. That's not to say they lacked expertise – so what we actually see is that they were on a very steep ATC curve right from their early days. In addition to the steep curve, their ATC map (had there been one) would have included music video for a high-level factor, and within the vocal skillset, included the impact of smoking on Simon Le Bon's voice.

Links to other theories

The clearest link is to cumulative advantage; the timing of the launch of MTV and Duran Duran's first album and their music videos gave them airplay that simply would not have been the same without the videos. Both benefitted from the success of the other.

For Duran Duran, the success of their videos would have served as promotional material for the album (different from today where video plays on media channels are themselves revenue-generating).

If we link the timing and importance of MTV and the cumulative advantage that followed, with their view that they were "playing every note they knew" then it is even more important that they launched their album in 1981 rather than wait until they had mastered playing music.

I read that Simon Le Bon's vocals were called into question as not being good enough and yet they were apparently "good enough". That's important with Threshold – you don't need to overachieve.

Hindsight

Could the band have done even better with the knowledge of the OMIT and ATC models? That's hard to say, but it may be better to understand where the thresholds are that we could otherwise not notice. If we maintain development in one area despite achieving threshold, are we preventing development in another area that would deliver greater gains?

It may be hard to recognise how Duran Duran could have done better, but it's straightforward to see how easy it would have been for them to miss the opportunity:

- Waiting until they were better musicians
- Hiring a "better" vocalist, undermining the value of the charismatic front-man Simon Le Bon
- Waiting for music videos to be more mainstream, or to see themselves as more skilled

Conclusion

Other bands may well have perceived themselves to be "better" without the success that Duran Duran had – maybe they were indeed better – looking to move beyond Optimal for some skills whilst being below Optimal for others.

The upshot is, that to succeed, you need to have Just Enough in EVERY area that matters.

For me this is really insightful and goes right back to the foundation of ATC – the concept of getting ahead through a very steep development curve and maintaining that advantage.

AJ Tracey

Introduction

An aspiring rap artist took a year out of university in order to focus on becoming a musician. He recognises that the ability to market himself is a key skill to be successful and that he needs to develop that aspect further, more than he needs to develop his rap skills. He gets his breakthrough after a mainstream station DJ plays his music.

The story

From AJ Tracey's episode of The High-Performance Podcast – Che Grant, known professionally as rap artist AJ Tracey, disclosed that his mother said he could take a year out of university and she would support him. During that year, it sounds from the podcast that it wasn't his music skills that needed to be developed, it was his skill at pushing his music to get a mainstream audience.

Whilst Che subjectively believed his music was good enough, his platform and popularity were below the threshold; you've got to be above a certain threshold to get Radio play. In the podcast, Che says he looked up email addresses for everyone he could think of in all the mainstream media and send them the track to listen to.

He managed to get Radio 1 Extra DJ Sian Anderson to play his track and he appears to credit this as his breakthrough.

Links with ATC/OMIT

If we first look at ATC, it is clear that Che had an understanding of his whole performance ATC map, and that audience reach was a key part, and not only this but he identified actions that could unlock this. Every artist of course want to sell more – for this is the point of having a wider audience,

so the value in having AJ Tracey in this case study is to highlight that whilst the desire for high performance is the same as for other artists, the proactive and deliberate accelerated curve to develop this, and the actions that Che took to promote his material, as well as the recognition that some things would have to reduce focus (his academic studies), together show an unwitting adherence to ATC and OMIT.

For OMIT, Che identified one key area where he was below an Optimal Threshold – reaching this Threshold would unlock mainstream audiences. This area was his visibility and his audience. This helps to illustrate that the OMIT areas are not absolute – they are always relative and not just to each individual performer, but they can change over time for each performer, too.

Breakthrough then relies on the ATC accelerated curve to generate cumulative advantage as its powerhouse; reaching a threshold beyond which the door is opened to a completely different level of popularity. Che could have focussed his time and attention on his music skills, but he recognised that being a better musician and performer was not going to deliver the same kind of results as increased popularity

In ATC terms, this would be a partial view of Che's map (Figure 6.4).

Music is obviously an important part, and Che's subjective view was that he has at least sufficient skill rapping here.

Uni was a large part of his life and permission to stall this for a year helped focus on other aspects.

Income too; the need for income was removed by his mother who said she's support him fully for a year.

As Che needed to ATC for his audience platform, he could afford to pause deliberate practice on his music skills.

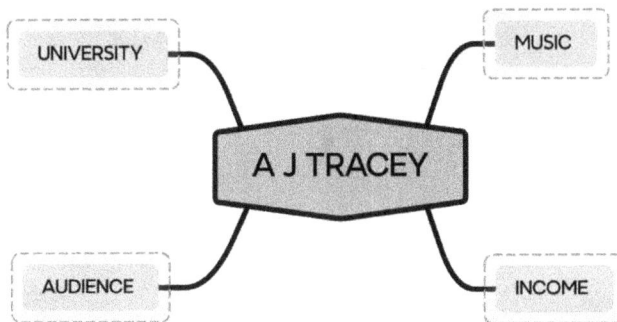

Figure 6.4 Che's partial ATC map.

In OMIT terms, if we just map a few key skills, we can see that music skills are Incremental and Maximal. You can keep improving indefinitely, and for the main the improvements will be Incremental – that is until we discover a Threshold. Whilst I have put "production" in the Maximal/Incremental quadrant, it may well be that it only exists here after a threshold has already been reached.

Whilst Che subjectively believed his music was good enough, his platform and popularity were below the threshold; you've got to be above a certain threshold to get Radio play. The Optimal/Threshold quadrant is where we say to reach this ASAP, and that appears to be what Che did. He managed to get Radio 1 Extra DJ Sian Anderson to play his track.

Again, if we look at ATC and the OMIT models, they both point at a high level to the audience reach as a priority (below threshold) and Che apparently had sufficient skill to achieve the goal of mainstream media play (Figure 6.5). At the point that he is trying to get his track out there, he's very much on an accelerated learning curve for this – it's not something he'd done before – successfully or unsuccessfully – so the learning curve is very steep.

I also heard that Che said that he practised rap at a higher speed so that when he had to rap "freestyle" he could do it more slowly than when he practices – good example of both ATC (as the ability to think/create fast and to rap fast could both be in the ATC map) and OMIT (he made sure that he treated rap speed as either Maximal, or he created a new threshold for himself so that he could perform at the lower threshold).

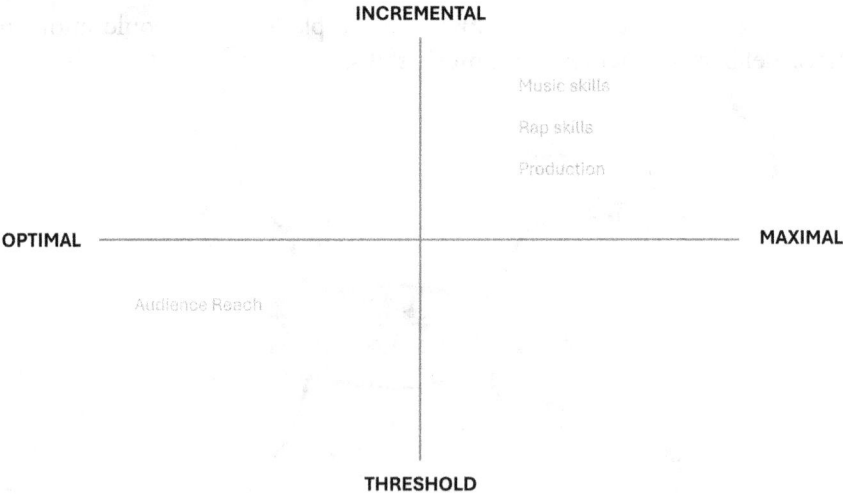

INCREMENTAL

Music skills

Rap skills

Production

OPTIMAL ———————————————|——————————————— MAXIMAL

Audience Reach

THRESHOLD

Figure 6.5 Che's OMIT quadrants (partial).

Hindsight

One of the interesting points about AJ Tracey's case study is that it highlights much more clearly than other cases the issue of risk – in Che's case, the risk of stopping university for a year. When we focus on one aspect at the expense of another, the risk can be sometimes high. There may also be a disconnect between perceived risk and objective risk.

This begs the question of whether attitude to risk is in itself an important skill or attribute and whether it can be developed. It could be a leaf on the ATC tree and itself impacted by our individual attitude to risk, our tolerance of risk, and the gap between subjective and objective risk. We can therefore seek to understand how to mitigate our own risk atti-tude depending on whether our risk aversion is subjectively high or low.

For some people who perceive risk as much higher than the objective risk, they may need to find ways to either shift their risk attitude, or take actions anyway. For people whom we might see as taking too much risk, it might be important to find a way to balance that.

Conclusion

AJ Tracey/Che Grant had sufficient understanding of the aspects that could enhance the achievement of his goals (work on his popularity and getting a platform), and the risk of pausing university for a year was mitigated by his mother, who financially supported him.

This balance of awareness and the mitigation of risk allowed Che to focus on accelerating the curve for his audience reach and to spend time and energy promoting his work to radio DJs.

Once above the threshold of mainstream radio play, he benefitted from the cumulative advantage effect and has continued to be successful.

Podcast link: https://www.thehighperformancepodcast.com/podcast/ajtracey

Alex Zanardi

Introduction

Alex is an ex-Formula 1 driver who moved to racing in the United States, then lost his legs in an awful motorsport crash in 2001. He switched to hand cycling, a paralympic discipline and went on to win Olympic Gold medals in 2012 and 2016.

By any metric, he is a high performer, but more importantly, he is a high performer in multiple disciplines after having his performance reset rather abruptly.

The story

When Alex Zanardi lost his legs, his first priority was survival. After that, his focus was to drive again, and he returned, only 2 years later, to the circuit (Lausitzring in Germany) where his accident happened and completed the 13 laps that he'd missed in 2001. Beyond this symbolic return, Zanardi then returned fully to motorsport in 2003 to European Touring Cars and at Monza, Italy, he finished his first race just 15 seconds off the lead. He continued into World Touring Cars and won four races between 2005 and 2009.

Taking up hand cycling to aid rehabilitation, he has since competed in Ironman competitions, Marathons and two Summer Paralympics, where he won two gold medals and one silver medal in London 2012, and a gold and a silver medal in Rio 2016.

Key to his story is his sense of what high performance is; he does not relate current performance to what once was, instead being able to set a new benchmark and work from there.

Links with ATC/OMIT

> … A person maximises their potential when their ability and their experience paths cross …

Zanardi said this in his episode of Formula 1's "Beyond the Grid" podcast.[1] It is reminiscent of the Ability-Motivation-Opportunity (AMO) framework that has been linked to so many developmental areas of performance (Hughes, 2007). Behaviour is a function of the three components of the framework.

On hearing this quote, I immediately thought of ATC and the accelerated development curve. We tend to think of talented people as those who either achieve beyond everyone else, or who achieve beyond others at the same age. A child prodigy is simply a way of saying that their development is well beyond their years (see also relative age effect).

The main reflection here in relation to ATC and OMIT though, is that rehabilitation is a goal that has many development aspects – both physical

and mental. Rehabilitation from injury generally is treated as a linear process, albeit with an "as soon as possible" focus, but one where OMIT seems to be easily applied.

If we start with medical triage, then urgency is defined by the threat to life threshold – keeping a patient above this threshold is the single most important aspect and is definitely Optimal/Threshold.

For Zanardi's 2001 accident, keeping him alive in the immediate aftermath was appropriately the most important priority.

Later, Zanardi talks about how it was important for him to regain independence from the people who had to look after him daily. This is another threshold example and reinforces the OMIT idea that the priorities are the Optimal/Threshold performance areas that currently fall below threshold. Once that threshold has been met, there will be the next threshold to look towards.

Optimal/Threshold gives us the opportunity to focus on a valid priority, and then reduce to maintaining this threshold whilst moving key focus elsewhere. It seems obvious when we're talking about life or death, but less obvious if we're talking about hiring new people for a team, or developing the skills of a team but the urgency is still there IF the threshold is currently not being met.

> ... I didn't aim for wins, that was too much – I aimed for 2nd place

This second quote also has a link to OMIT – this is Zanardi making a distinction between Optimal and Maximal. First place would be Maximal and if this was the focus it could take priority over other aspects that need to be developed. It also shows how subjective OMIT is; even that small shift from first to second as the goal, shifted it sufficiently away from Maximal. There would be many other people who would have the finishing position as a Maximal goal. The issue with Maximal is that unlike Optimal where "good enough is good enough" it could be seen as "never enough".

What is ability?

It's interesting to note that Zanardi went on to race again with prosthetics and hand controls, so it would seem that he didn't see that his ABILITY had been compromised much by the loss of his legs. Indeed, it is likely that he saw prosthetics as maintaining his ability.

I am short-sighted, and wearing glasses of the correct prescription allows my eyesight to have the same ability as someone with perfect vision. I am not in any way drawing a parallel between me wearing glasses and Zanardi being a double-amputee other than eyeglasses being an ability-enhancing prosthetic.

Motivation

In AMO terms, motivation mediators are intrinsic and extrinsic motivation, affective commitment, and perceived climate. Affective commitment (an individual's sense of commitment to their employer organisation) and perceived (organisational) climate are most relevant in work-related contexts (Bos-Nehles et al., 2020).

If we remove management-related aspects, we would likely be left with Intrinsic and Extrinsic Motivation. It is interesting that Zanardi does not reference motivation in his quote – saying "… A person maximises their potential when their ability and their experience paths cross …."

Opportunity

Zanardi refers to Experience; and it is at this point that I wonder whether my link to the AMO framework is valid. Can Experience be synonymous with Opportunity? I see experience as an enabler for opportunity. For Zanardi, his experience as a professional racing driver helped shape the opportunity for him to progress as an athlete after racing. Not that Zanardi's transition from motor sport into hand cycling could be seen as an opportunity, but the hand cycling success was certainly related to the attributed and abilities that he carried with him in life, including through motor sport.

Hindsight

Alex Zanardi's achievements stand out for me, principally because I am in awe of his resilience and attitude that has been a clear part of his ability to achieve at the level that he does. What Alex's case study highlights is the importance of motivation, self-efficacy, and self-belief.

In ATC and OMIT terms, shifting goals to Optimal from what would otherwise be Maximal is an important step to allow for stepped progress. Thresholds that deliver meaningful milestones to be aimed for and then celebrated feel much more powerful than small increments that could feel less meaningful and never-ending.

Conclusion

If OMIT helps us focus on priorities, then ATC helps us focus on the shape of the development curve, always making sure we're on the steepest possible. Zanardi's development curve has definitely been steep, and his ATC map before his accident would have been very different from the map just after his accident. The new ATC map would have had survival and independence, which I doubt would have been there before. Again, this highlights the importance of not treating the ATC map as "finished", the iterations are critical as they allow for change.

OMIT then plays a part in goal setting and goal achievement. Thresholds hold more meaning and significance, first as goals and then as benchmarks to punctuate and recognise achievement.

ATC and OMIT then work together. ATC changes the shape of the development curves, being steeper. Multiple ATC curves then combine to create an overall steeper compound curve.

Ronnie O'Sullivan

Introduction

Ronnie O'Sullivan is arguably the best snooker player ever, yet his own opinion is different from that. He comments on how he sees others as better (Steve Davis and Stephen Hendry) and how he is still trying to master the game.

Examples like Ronnie O'Sullivan's where the pattern would suggest that he's not holding views that would tie with a learned optimism approach are interesting, because it would appear that sometimes, to be as successful as Ronnie, you actually can take the more pessimistic view in order to keep developing yourself.

One of the key principles of ATC is to seek steep learning curves to maximise development, and the ability to continue to improve, even when you're a multiple world champion, reflects ATC perfectly.

The story

January 2024 Ronnie won The Masters tournament for the eighth time. Also, becoming the oldest winner in the tournament's history. Ronnie first won The Masters in 1995 aged 19, becoming at the time the youngest ever winner of the tournament.

These are some of the notable statistics of his career so far:

In addition to winning The Masters a record eight times, he has also won the World Championship seven times (a record he shares with Stephen Hendry), the Premier League ten times, and the UK championship eight times. He has won a record 40 ranking tournament titles. He's competed in 125 tournament finals (ranking, non-ranking, and minor) and has won 81 of them. Over 64% of every tournament final he has played in.

This week, on winning The masters for the record eighth time, BBC Sport reported Ronnie as saying:

> To all the snooker fans, thank you for your support. I will keep trying until I can't pot any more balls. I've never been driven by titles or numbers, I just want to play well and enjoy the game. If I happen to pick up a few titles, that's a bonus. I'm trying to master the game and have never been able to do so, so I will keep trying to.

Links with ATC/OMIT

In order to keep developing, we have to be aware of the areas in need of development. At an elite level of any discipline, there is a requirement to be able to continue to develop, long after most people would have achieved "good enough". What ATC aims to do therefore, it to remain on steep learning curves, even at elite level. The principle is that if we are sufficiently granular in the breakdown of the components of the whole skill area, we will always be able to find areas that can be improved and then look for ways to steepen the learning curve for that area. The blunt approach then says that any area where development can occur is beneficial. The sharper approach is to continue to map and use OMIT to help prioritise.

OMIT helps prioritise these by looking for areas that are below a key threshold. Self-awareness from the individual performer is critical in understanding the gap between the current and desired level of performance. Any over-assessment of performance is not helpful in developing further. Simply, if I don't think I need to improve, then I won't put effort into improving.

What we see from Ronnie O'Sullivan is a desire to keep improving – there is a macro view that he's still not good enough. From the outside, we can view that as a strange approach given his achievements, but it is precisely this mindset that has meant that he has continued to develop, improve, and achieve. Imagine achieving this level and still looking for ways to improve. This is the mindset of the elite, and whether we apply this to an individual,

or a team or organisation the ATC principles are the same – keep looking for steep learning curves.

There is a psychological cost though to this approach, which we can see if we look at Learned Optimism. Learned Optimism looks at ways of interpreting "good" events and "bad" events in terms of Pervasiveness (how much this event spills over into other areas), Permanence (how long this run of good/bad will last), and Personalisation (how much of the good/bad was down to me). I am interpreting aspects of low performance as "bad" – this could be outcome-related (losing a match) or process-related (lacking a particular subset of skill).

If we isolate Personalisation, then it is seen as psychologically positive (Optimistic) to see good events as being in our control and down to us, and bad events being down to bad luck and frankly, nothing to do with me.

However, if we look at Personalisation in relation to objective perform-ance, a "bad" event could be how we perceive a lack of success for example, and the optimistic view that the poor performance wasn't down to me is not quite as valuable as being able to look for all the elements that contributed, including where the individual could do better.

Optimism is psychologically safe, because I can't be overwhelmed with feelings of inadequacy under the burden of realising everything that I don't know or can't do.

Excellence requires letting go of personal psychological safety, for the good of development. Letting go of psychological safety requires resilience and a robust base level of psychological safety to be able to not require micro-psychological safety around everything that we do as "performers".

Ronnie O'Sullivan is a lovely example to use because of the contrast between his obvious achievements, and his stated desire to still improve fur-ther and master the game.

William Feather said, "Success seems to be largely a matter of hanging on after others have let go". ATC principles agree – high performance is a matter of continuing to look for areas to develop, after others have "let go". Ronnie O'Sullivan doesn't appear to be letting go yet.

Hindsight

Ronnie O'Sullivan appears to be highly self-critical, which allows him to keep striving for greater heights and mastery of the game. However, this case study is not a study of the person, but a study of some aspects of the person's behaviour that look like aspects of ATC or OMIT.

This level of self-critical thinking does, however, link with what Seligman would refer to as a Pessimistic approach, so my hindsight view is that

elevating performance critique to a more objective level may be helpful for those who are highly self-critical.

The other main hindsight perspective is that this approach (self-critical) would be very helpful in creating the broadest possible ATC map, for snooker in O'Sullivan's case. Where he has spoken about the importance of fitness and running, for example, this could have appeared on his ATC map a long time ago. ATC allows for, or encourages, the broadest possible map, where no matter how small, every component is on the map.

Conclusion

If we treat the ability to be self-critical and to keep developing as an innate skill that elite performers possess, then there is a question as to whether that is a skill that can be developed.

Instead, ATC operates at two levels. Firstly, mapping can move away from the subjective towards the objective – instead of looking at the performer, it looks at the role. Secondly, if the ability to be self-critical is a developable skill, then it can appear on the ATC map as an area to develop. If psychological safety is correlated with this ability, then this too can be on the ATC map.

Formula 1 pit crew

Introduction

The small team of people who carry out a pit stop in F1 have a clear performance objective that is very easily measured. It is an ideal case study for ATC as it is a microcosm of Formula 1's entirety in just 25 people, completely contained within a defined performance envelope, and a combination of process and human factors. The case study will look at how a Formula 1 pit stop could be mapped using ATC.

This case study then looks at the pit stop from the perspective of one person, and we will then extrapolate to see the relevance to many other aspects of F1.

The story

From when your driver comes to a standstill in the pit lane, safely switch all four wheels, complete with heated, new tyres, and get the car on its way back to the circuit. From stopping, to re-starting takes around 2.5 seconds. To date, the fastest-ever pit stop was in 2023 at the Qatar Grand Prix, where Mercedes F1 successfully completed the stop in just 1.80 seconds.

Links with ATC/OMIT

The relevance for this book is that in around 2 seconds, there is a group of people, working as a team, co-ordinating and delivering in what they have honed and practised. I am going to show how their performance development fits with the ATC and OMIT models and how the performance could be even greater.

ATC mapping

Tree: F1 pit stop – to the first 2 or 3 levels (Figure 6.6).

There are differences between Formula 1 teams. The world record is 1.80 seconds; any team not able to do 1.80 seconds during a race has

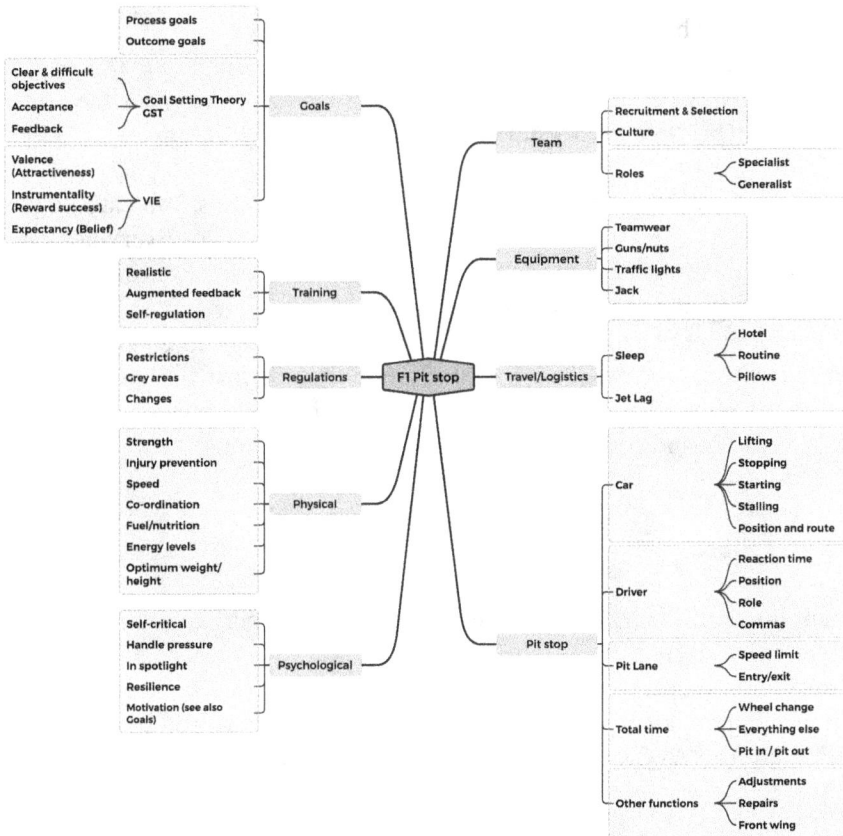

Figure 6.6 ATC map of F1 pit stop.

a performance gap that is already known. There is also an unknown performance gap, which is the gap between the current world record and the next world record. Michael Phelps did not stop when he broke the 200 m butterfly world record. Ronnie O'Sullivan is still working on mastering the game of snooker.

Anecdotal evidence of individual and team differences raises the following comments and questions:

- Better drivers are more precise in their positioning; therefore, the crew are able to position themselves closer to the car's anticipated position.
- Teams have in the past looked at replacing compressed air in the guns with compressed helium to see if it gives an advantage.
- Teams replaced lollipops (stop/go board on a stick) with a traffic light system; lights switch faster than a physical device can be moved.
- Does the car stop parallel to the pit lane or at a slight angle? Would one allow for a better entry or exit?
- Red Bull practise pit stops in the dark to demonstrate the muscle memory of the crew. 2.82 seconds was their best time. They have a full pit stop practice facility at HQ as I imagine do all F1 teams.

Already, with the ATC map only at two or three levels, you can see how many potential areas there are that contribute to a pit stop. Every person in the pit stop crew probably has slight but important differences in their map, with many generic aspects too.

Development beyond where the current performance level is depends on what resources are available for development, and what the goal is. Speed is not the only relevant metric, as safety and reliability are also vital. How these interact and compromise each other is important.

Hindsight

Mapping performance for a team and then prioritising the aspects where there are the greatest potential gains, or where there are performance thresholds that are currently below threshold, would be the next steps for any Formula 1 team. In ATC/OMIT terms, this would be looking to complete the ATC map for the pit team, and for each individual in that team.

Then, for OMIT to first look for any aspects which are in the Optimal/ Threshold quadrant. There will be some, I am sure, for it is in the nature of

teams and individuals to find ways around things that are below Optimal, rather than always addressing them.

There are few questions that come to mind that would help this process, and they can be asked at team and/or individual level

- Can you break down the attributes, skills, etc. (as many as possible) that collectively form the overall broad skillset for your performance?
- Which of these do you still consider to be a work in progress – i.e. you're still developing further?
- Which of these do you consider to be at a level that's "good enough" and you no longer spend time developing?
- Which of these do you consider to be underdeveloped or weaknesses?
 Are these still being developed, or do you consider them as allowable weaknesses, or are they compensated for by a key strength? (multiple examples if possible/appropriate)
- Are there any areas that you see as "undevelopable" and if so, why, and how do you work around them?
- If you consider your elite peer group; do you perceive skills or attributes where others are "better" than you?
 Would it help your performance if you could improve in these areas?
 Are they areas where you actively look to develop?

These questions help to bring the ATC map from an objective to a more subjective view.

Conclusion

Although an F1 pit stop is only a tiny fraction of what goes into making a Formula 1 team successful, it serves as an example because of the nature of the focus of a small team of people, and the differences in performance that we know already exist between teams, and even within teams from one pit stop to the next.

Performance in Formula 1 is paramount, and resources to achieve those goals are limited, so it is even more important to accelerate any potential development curves, and to reach key thresholds as quickly as possible to get the performance advantages that ATC and OMIT offer.

Note

1. "Beyond the Grid" Podcast https://www.youtube.com/watch?v=IOF61tDG YwM&t=5875s.

References

Bos-Nehles, A., Townsend, K., Cafferkey, K., & Trullen, J. (2023). Examining the ability, motivation and opportunity (AMO) framework in HRM research: Conceptualization, measurement and interactions. *International Journal of Management Reviews, 25*(4), 725–739. https://doi.org/10.1111/ijmr.12332

Germer, C., & Neff, K. (2019). Mindful self-compassion (MSC). In I. Ivtzan (Ed.), *Handbook of mindfulness-based programmes* (1st ed., pp. 357–367). Routledge.

Hughes, J. (2007). The ability-motivation-opportunity framework for behavior research in IS. *2007 40th Annual Hawaii International Conference on System Sciences (HICSS'07)*, 250a–250a. https://doi.org/10.1109/HICSS.2007.518

McConnell, S. C. (1996). *Rapid development: Taming wild software schedules* (1st ed.). Microsoft Press US.

Neff, K. D. (2011). Self-compassion, self-esteem, and well-being. *Social and Personality Psychology Compass, 5*(1), 1–12.

Neff, K. D., Hsieh, Y.-P., & Dejitterat, K. (2005). Self-compassion, achievement goals, and coping with academic failure. *Self and Identity, 4*(3), 263–287. https://doi.org/10.1080/13576500444000317

Neff, K. D., Tóth-Király, I., Yarnell, L. M., Arimitsu, K., Castilho, P., Ghorbani, N., Guo, H. X., Hirsch, J. K., Hupfeld, J., Hutz, C. S., Kotsou, I., Lee, W. K., Montero-Marin, J., Sirois, F. M., De Souza, L. K., Svendsen, J. L., Wilkinson, R. B., & Mantzios, M. (2019). Examining the factor structure of the Self-Compassion Scale in 20 diverse samples: Support for use of a total score and six subscale scores. *Psychological Assessment, 31*(1), 27–45.

Practical applications **7**

Introduction

Up to now, in this book, I have looked at explaining the theory and the research behind them, as well as showing retrospectively how these models have applied themselves to some well-known or well-documented high-performance situations.

This chapter takes the concepts from the theoretical to the practical. My aim is to leave you with something that you can use in a proactive manner, whether you are in the role of a high performer, or whether you lead a team of high performers.

Key points

1. There is always room for improvement. If you think there isn't, remember Michael Phelps beating his own world records over and over again. Are you a world record holder or a world champion? Even if you are, then find the next things to develop further.
2. High performers seem to over-compensate (or the compensating is more evident than for mediocre performers) so the development may come from a current weakness (note how this appears to contrast with Strength-based development?)
3. Not a one-off process; keep adding to the maps, keep iterating.
4. "Performance" can mean many things; map all of them that are relevant. Intangible measures may be as important to you as tangible ones.

DOI: 10.4324/9781032631530-7

Work/life balance might be a key performance measure, for example, not just work targets.

5. There are a few common elements – such as the psychological factors (resilience, optimism, conscientiousness, motivation, reliability, etc.) and Goal-related factors (objectives, belief, attractiveness, feedback, self-regulation, etc.) that apply to many accelerate the curve (ATC) and Optimal, Maximal, Incremental, and Threshold (OMIT) maps.

6. Not everyone is lucky enough to have objectively clear benchmarks or performance measures. Find ways to measure your performance against others; seek high performers to measure yourself against.

This chapter is structured as follows:

- ATC practical guide. The "map everything" section, how to do this, some tips and common aspects that appear on most maps. Some examples of my own maps.
- OMIT Practical Guide. How to choose and prioritise from the ATC map, a template, and some examples using the ATC examples.
- Practical development guides for some common areas. Many previously described in the book, but in this section are some helpful guides to developing in areas such as commitments, goals, motivation, personal blocks, self-efficacy, resilience, and optimism.

ATC practical guide

Self-reflection questions

When creating maps with other people, I tend to draw from a set of questions that I have included here as they are great questions for you to consider regarding your own specialist area of high performance.

- What's one area of your life where your performance is "elite" (by this, I mean that it is either objectively elite through competition or results or subjectively elite if you consider yourself compared with your peers)
- How did you develop to the level you're now at? Can you explain how you started and the journey?
- Could you please break down the attributes, skills, etc. (as many as possible) that collectively form the overall broad skillset for your performance?
- Which of these do you still consider to be a work in progress – i.e. you're still developing further?

- Which of these do you consider to be at a level that's "good enough" and you no longer spend time developing?
- Which of these do you consider to be underdeveloped or weaknesses.

 Are these still being developed,
 or do you consider them as allowable weaknesses,
 or are they compensated for by a key strength?
 (multiple examples if possible/appropriate)

- Are there any areas that you see as "undevelopable" and if so, why, and how do you work around them?
- If you consider your elite peer group; do you perceive skills or attributes where others are "better" than you?

 Would it help your performance if you could improve in these areas?
 Are they areas where you actively look to develop?

Of course, you do not have to be only developing areas where you are already "elite" – this is often the focus because of the perceived difficulty in developing further from this stage. You could, for example, look to develop your life as a parent, or to map your whole life in terms of work, friends, family, hobbies and interests, health, etc.

When creating ATC maps, I have a personal preference for spider diagrams/mind maps. They seem to give me the flexibility to keep adding to them over time. I still think of the elements on the map as "branches" and "leaves" though, and the leaf analogy is useful in always looking for a steep learning curve.

Step 1.

I tend to start with a blank sheet of paper, or mind map software. Software is easier to edit as I have never done a map and not continued to edit it for some time afterwards.

At the centre is the role, team, project, etc., that you are looking to map.

Radially, the first bubbles are the main groups or clusters of performance variables. Some consistent ones would be Health, Goals, Skills, Physical, Psychological, etc.

Get as far as you can, and then ask yourself

- What's missing?
- What makes this (job/project, etc.) difficult?
- People who perform at a higher level than me…what do they do differently?

You can be as detailed or as broad as you like here; nothing is too small or granular if you think there is a link to performance. You may be unsure if there is a link but these should definitely be added. For example, if health/

diet is on your map, might plant-based diet be there? The chance to look for evidence to support, and to decide if you are prepared to go down this route can come later when we look at OMIT.

You can't get this "wrong" – it can be subjective at this stage, and if it is your own work alone, you may be aware that your own view, however broad, can only ever be partial. You may want to ask others to help; you may want to leave it and come back to it later, or just keep adding to it over time as new aspects are realised.

Figure 7.1 has the start of a blank ATC map. What would be the first six categories that you would write in for your own performance?

Key to the ATC map is to not yet worry about the degree of importance or relative importance compared with other aspects that will come later, especially as we look at OMIT. ATC has two main concepts:

- The map of as many components as possible that contribute to overall performance, and
- Front-loading the shape of the subsequent development curve for any aspect that is developed in order to be on the steepest learning curve

If we use the Organisational Psychologist map, Figure 7.2, each person who looked at this would be able to score it differently in two dimensions – firstly on whether each component is relevant to their performance, and secondly how they personally would rate themselves. Even jobs like writing that are sedentary have performance benefits from better health, exercise, diet, etc.

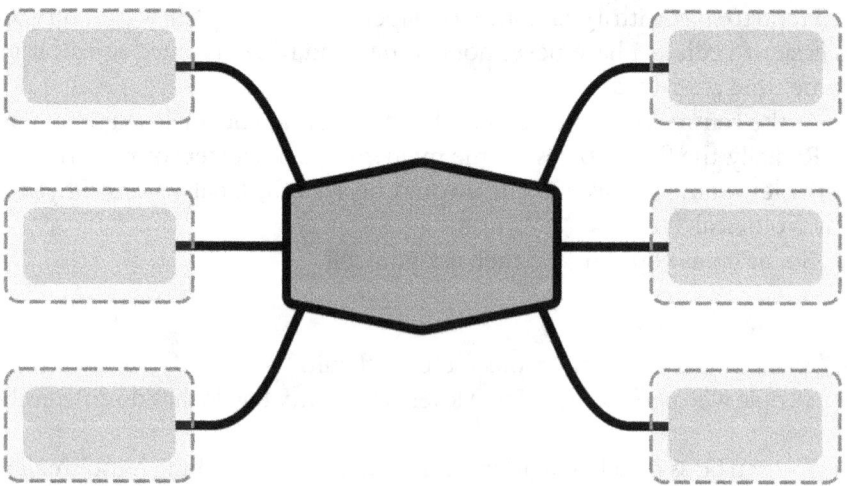

Figure 7.1 A blank ATC map.

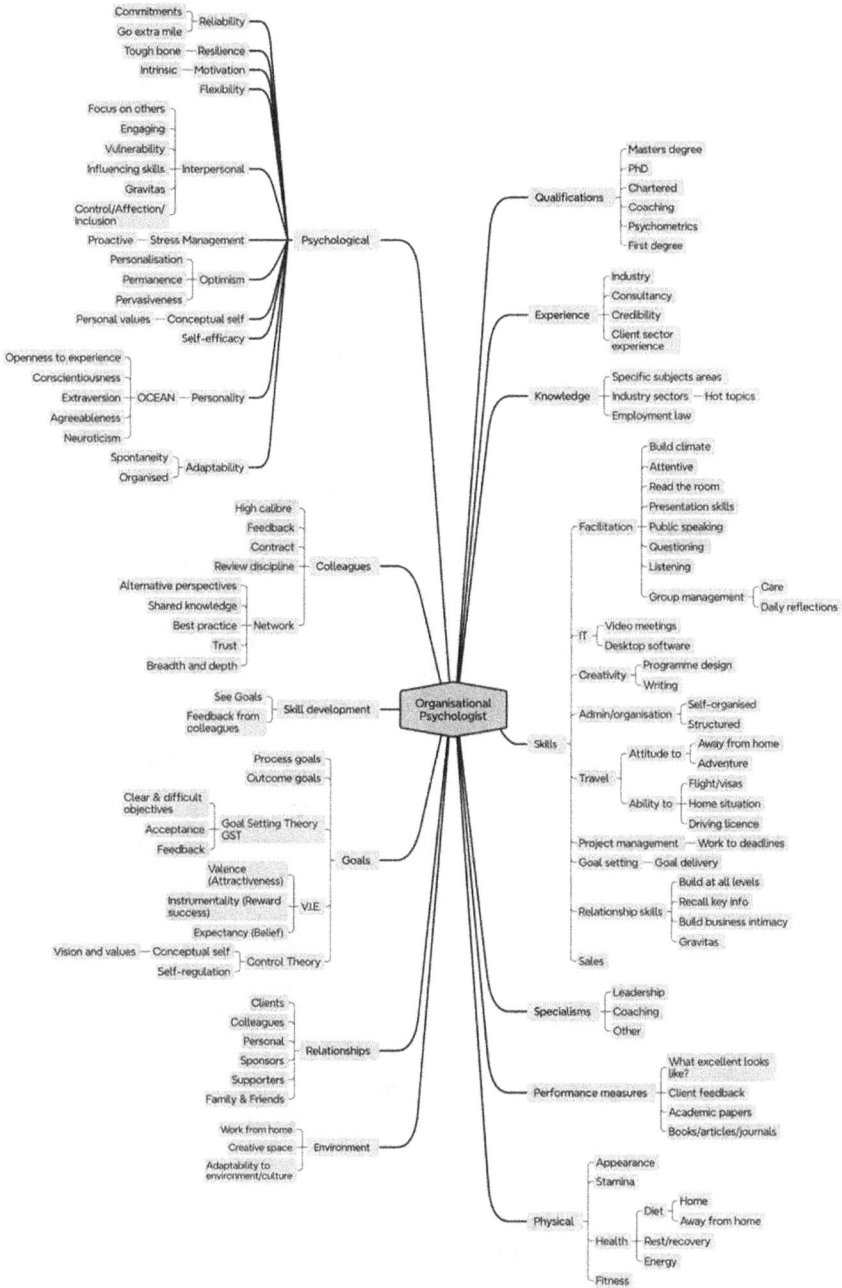

Figure 7.2 ATC map for my role as an organisational psychologist.

Whether we want to acknowledge this or develop our specific performance in this area is another question of course.

The steps then are:

1. ATC map – Capture and list many performance aspects as possible and as generically as possible for the role/team, etc.
2. Are they relevant to me.
3. To what extent.
4. Would I be prepared to do anything to develop any of these.

The likelihood is that there will be several hundred individual components that contribute to any entire map. My contention is that in the main, most of these will be overlooked most of the time, for absolute performance is not a requirement for most people.

However, for some organisations or individuals, absolute performance is priority and it is easy to see how, with hundreds of individual components, Marginal Gains has become popular, because it's not really terribly difficult to find a few things from this map of hundreds to improve.

It does not even need to be a deliberate or scientific approach – there are so many things to improve that finding a few is not difficult. And even if you then only apply the front-loading aspect of ATC to your methodology you will see greater benefit.

It becomes more difficult once you've improved the "easy" ones. Or when all of your competitors have also done the same, or when resources are limited.

As a final example, I've included the map that I created for my own work.

It took a while to get to this stage, and what helped me get beyond the first draft were the following:

Asking myself questions such as

- What's missing?
- Who's better than me … what do they do?
- What does the job actually entail? (that I may take for granted) – almost like I am explaining it to someone who has no idea.
- What makes it difficult?

An example of these led to me realising that there are days that I drive for 3–4 hours to get to a client at 8.30 am, then work until 6.30 having various meetings, 1:1 and team, where I'm building on previous meetings … then I have a 3–4 hour drive home. I do these really without thinking, but it is an example of where I realise that the job at tines can be tiring, and require stamina and concentration that not everybody has at the same level. How could I be better at it?

I also realised the value of colleagues; when working with my Chartwell colleagues facilitating Positive Power and Influence, I have to be at my best – they are an elite group of facilitators and I always learn something more. One of our routines is to spend time every day evaluating each other (directly), thinking about what we did that went well and not so well, how this affected the group or individuals in the group. We then turn our attention to the group and discuss what we can each do as facilitators for them individually. This review takes time, at the end of what is normally an already long day. But it's worth doing and separates us as facilitators from others who do not do this. Is it a marginal gain over others – yes, absolutely.

Common ATC map areas

Health

I can't see many performance areas where health is not a factor. Figure 7.3 shows a sample Health map, which in some areas goes to five levels of depth,

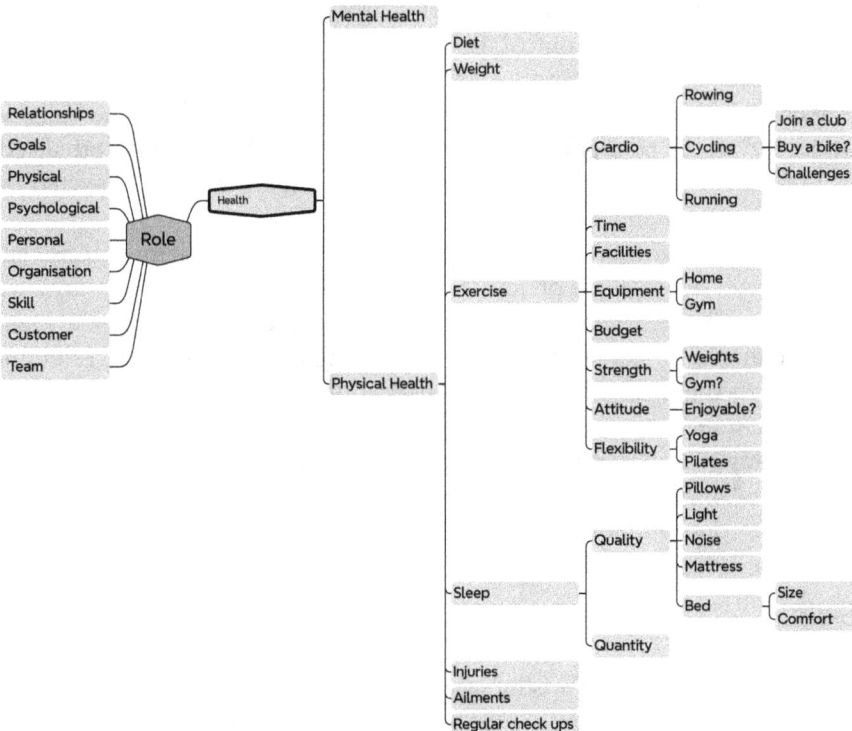

Figure 7.3 Showing ATC map for physical health.

but is incomplete and will change depending on the individual. It is interesting to see that Sleep – Quality – Pillows is on the map and reinforces how it would have been possible via ATC to arrive at, for Team Sky, the idea of improving pillow quality on the Tour De France for their riders.

Goals

Goals are a possible consistent ATC map component for two reasons; firstly, it would be difficult to imagine improving performance without translating this to a goal or goals of some sort. Secondly, because goals and the theories around goal setting have such a proven positive effect on achievement and motivation that even if not there in their own category may well have been there as a sub-level from motivation, for example.

Their appearance on an ATC map therefore is to remind the performer that how goals are set have a positive effect on the achievement of those goals. The goals themselves can be set around any aspect of performance – not necessarily project centred.

This book has provided some depth of information on individual theories such as goal setting theory (GST), Vroom's VIE (valence, instrumentality and expectation), control theory.

In this section, I am going to overlay some of these aspects because there is likely to be cross-over effects. For example, a key part of VIE, the Valence or attractiveness of a goal is going to be impacted by the conceptual self from Control Theory. How attractive a goal is could well be impacted by how I see myself and the direction I see for the future.

Similarly, we know from GST that feedback is a critical element. After all, how can we self-regulate or adjust our approach if we don't know how we are performing. If I were to throw balls into a bucket, I could adjust my aim and technique if I knew whether I was hitting or missing, but if I did not know then there would be no reason at all to change anything. Feedback though can be enhanced through a process called Augmented Feedback, so is there any reason to not overlay GST with Augmented Feedback?

Figure 7.4 maps the goals aspects that fit with ATC – goal setting theory, feedback, control theory, VIE and process / outcome goals

Skill

Skill is perhaps an unsurprising facet to see on the ATC map if overall performance is to be improved. On the ATC map though I would encourage you to look beyond the obvious skills and find skills that may be on the

Figure 7.4 Goals ATC map.

periphery of the broad skillset but that may be able to deliver marginal gains just as easily as elsewhere.

A recent example might be the use of video conferencing software. Whether or not you had used Zoom before 2020, you had almost certainly used it by the end of 2020. It moved very quickly to becoming an essential skill. And a multi-faceted skill at that. Being able to communicate with a group, hold their attention, facilitate discussions, etc., shifted a little, but in general, good facilitators of groups in a room were also good on Zoom. That assumed they could use the software well, and that is another skill in itself. Being able to use breakout rooms and move people around initially was a skill that could be at an acceptably poor level, but soon required higher skill. And then came Teams, or Hangouts as client preference dictated, so the skill expanded to be confident and capable in many platforms.

ATC is about mapping all possible areas for improvement and OMIT is about prioritising and often that entails looking for areas that are below an Optimal level – so with skills, my suggestion is to look for any skills required to perform at the level you are looking to achieve, where that skill is currently below an Optimal level.

When mapping the skill area for ATC, there are at least four tiers that I look for and these are shown in Figure 7.5; the first tier is the obvious skills that are critical for the role. I group these separately because it helps with the other tiers to have these out of the way. When mapping for OMIT, I would expect that many if not all skills in this area would also be already above threshold for someone who is competent in the role.

The next tier is for important skills that are related to the role. The distinction between these two top tiers is not a hard line, but as a guide there may be some allowable weakness in the second tier.

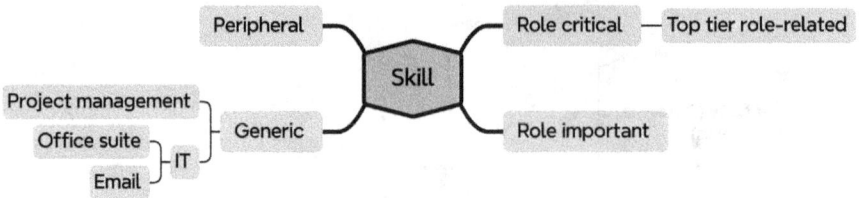

Figure 7.5 ATC map of skill.

The third tier is for peripheral skills. Even less obvious than the less obvious group. I work on a broad assumption that as we move through these first three tiers, that we are more likely to find areas where there may be opportunity for significant development. This is partly because the top tier is role critical and would be very difficult to perform the role without competence in these. It is also because the lower tiers are simply seen as less important – "nice to have" rather than critical. The gap between "enough" and "mastery" also may be broader in the lower tiers than for the obvious top tier.

The fourth tier is for generic skills – these, of course, may also be in any of the other three tiers, but being on the map is more important than getting the tier correct, so don't worry if you are unsure. The generic skill tier may help you if you are developing multiple ATC maps for several roles or people as it helps you to identify the role-specific skills more easily.

Physical

I shared my own ATC map with a colleague who remarked that she had not considered "physical" in her thinking of being an Occupational Psychologist. One of the main aims of ATC is to be able to find areas that might have an impact, no matter how small, that you may not have previously considered.

The compelling aspect of Team Sky riders taking their pillows on tour is that it seems simple, obvious, and yet everyone had overlooked it until then. I hope that you find your own version of pillows.

Secondly, there will be aspects on your own ATC map that you would prefer not to be there. Physical may well be one of those areas, for whatever reason.

But I'd encourage you to persevere and put it on your ATC map anyway. Look for every possible area that *could* lead to greater performance. You do not have to choose it as an area to work on, but a deliberate choice to NOT develop it is better than overlooking it and not realising. Figure 7.6 shows some of the aspects that may form part of a physical map within ATC.

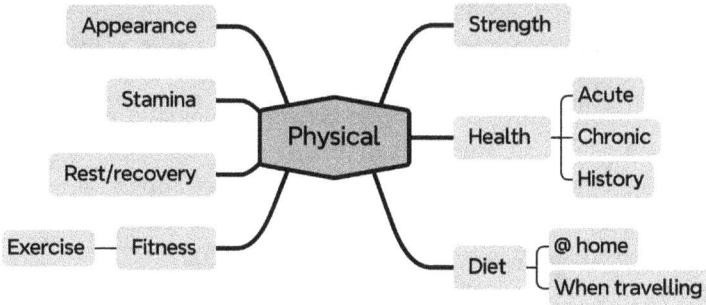

Figure 7.6 ATC map for physical.

Psychological

As an organisational psychologist, it may be obvious for me to include psychological factors in a map of human performance. However, there is clear evidence to suggest that there is a bi-directional positive relationship between high performance and many psychological aspects.

The main factors that will appear on many ATC maps could include the following, shown in Figure 7.7.

I see all of the above as positive, and having a potentially positive effect on increased performance, and yet I meet very few people who actively seek to develop these.

Figure 7.7 ATC map for psychological.

Conscientiousness has well-researched links to performance and is easy to measure. There are many free Five Factor Model tests available online, and conscientiousness is one of the five factors.

Resilience is something that can be actively developed and improved at individual, team, and organisational levels.

If resilience is defined loosely as our ability to deal with adverse events, then we can also consider the timing – whether resilience is to be developed after adverse events or preventatively (de Terte et al., 2009).

If developed preventatively, it can help to generate the capacity to absorb more – pressure, breadth, variety, stress, demands, quantity, stretch, and capacity.

This is not a book about developing resilience, but it is worth spending a little time on it because of the links with several other areas, and the likelihood that for so many people looking to increase performance, increasing resilience will be a factor.

The first thing to look at are the characteristics of resilient people.

From Table 7.1, there are several characteristics that can in my view be enhanced and promoted through deliberate action. It therefore follows that

Table 7.1 Characteristics of resilient people

Characteristics of resilient people

Reference	Characteristic
Kobasa (1979)	View change or stress as a challenge / opportunity
Kobasa (1979)	Commitment
Kobasa (1979)	Recognition of limits to control
Rutter (1985)	Engaging the support of others
Rutter (1985)	Close, secure attachment to others
Rutter (1985)	Personal or collective goals
Rutter (1985)	Self-efficacy
Rutter (1985)	Strengthening effect of stress
Rutter (1985)	Past successes
Rutter (1985)	Realistic sense of control / having choices
Rutter (1985)	Sense of humour
Rutter (1985)	Action-oriented approach
Lyons (1991)	Patience
Lyons (1991)	Tolerance of negative affect
Rutter (1985)	Adaptability to change
Connor and Davidson (2003)	Optimism
Connor and Davidson (2003)	Faith

Source: Connor and Davidson (2003).

the more characteristics you have, and the degree to which you have those increases, the more resilient you will be.

Engaging the support of others – this is relatively easy to self-score, and to do something about

Close, secure attachment to others – harder maybe to develop, but knowing that it helps resilience means it can be proactively developed

Personal or collective goals – again, we see links to goals, and there's plenty of information in this book about goal setting

Self-efficacy – if you believe that you have greater skill, your self-efficacy increases. So developing skills helps directly and indirectly develop resilience

Realistic sense of control/having choices – also linked with skill and self-efficacy.

Action-oriented approach – taking action is a deliberate step

Optimism – more information elsewhere in this book and it also links to the realistic sense of control/having choices.

Relationships

The final common area across ATC maps is "Relationships". I cannot think of a role or performance goal that would not have some degree of relationship focus helping with development, Figure 7.8 shows some of the possible relationship stems within an ATC map.

In addition to naming the key relationships, the next tier is to decide how each relationship or group of relationships can help with your performance, and what actions you can take.

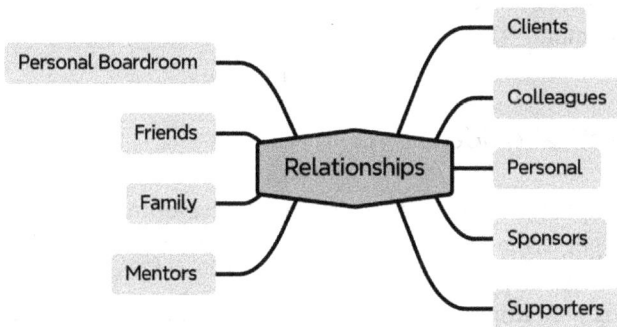

Figure 7.8 Relationships ATC map.

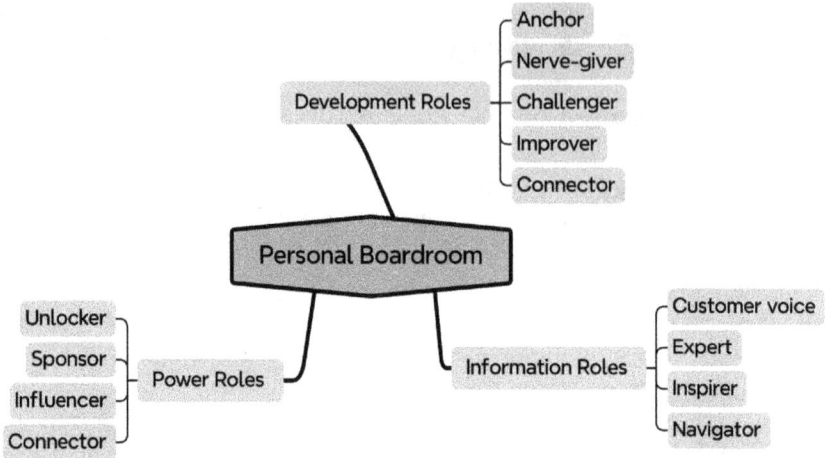

Figure 7.9 Personal Boardroom ATC map.

There is a link here to resilience too; engaging the support of others and close, secure attachment to others requires others. These "others" will be found within your relationships section on your ATC map.

I have included the stem "Personal Boardroom" as a prompt for a specific look at people who you can surround yourself with, as described in the book by King and Scott (2014).

The idea of the personal boardroom is that you identify people to fulfil key roles in your life, just as the board of a company would.

This would also change depending on who your ATC map is for – if for an individual then a personal boardroom might be appropriate. If for a role, or team, then different aspects may be suitable. For an organisation, an actual board would be required.

I have included it here in Figure 7.9 as it might be created for an individual performer.

OMIT practical guide

OMIT in simple terms is a way to prioritise development activities in order to improve performance. It can be used in conjunction with or independently of an ATC map.

If I look to improve my overall performance, there are in my Organisational Psychologist map in Figure 7.2 nearly 100 different aspects that I could choose, and each of those has multiple facets and layers which could then multiply those 100.

If marginal gains all have the potential to add value, then there is the view that it doesn't matter which you do as long as you're adding all the small gains to create a bigger resulting gain.

As I have said before though, your available resources will be limited (time, money, etc.) and recalling from much earlier in this book that:

- Not everything can be improved marginally.
- Sometimes there may be no advantage from a marginal gain.
- Not all gains are equal.
- The cost of the gain might be disproportionately high.

Then prioritisation is important, and this is where OMIT can be of value. It is also why the book is called beyond marginal gains, because we are not excluding marginal gains, more looking to understand and enhance. And the high-hanging fruit is relevant because the low-hanging fruit is easy, and accessible to everyone, so the competitive advantage does not last long.

Instructions/steps for mapping OMIT

To create your OMIT map:

Start with a blank OMIT template (Figure 7.10):

- Decide the domain for the OMIT map – is it for an individual, role, team, project, organisation, etc.?
- From a relevant ATC map, look for anything that you consider to be Optimal, and then write these in … decide whether O-I (Optimal/

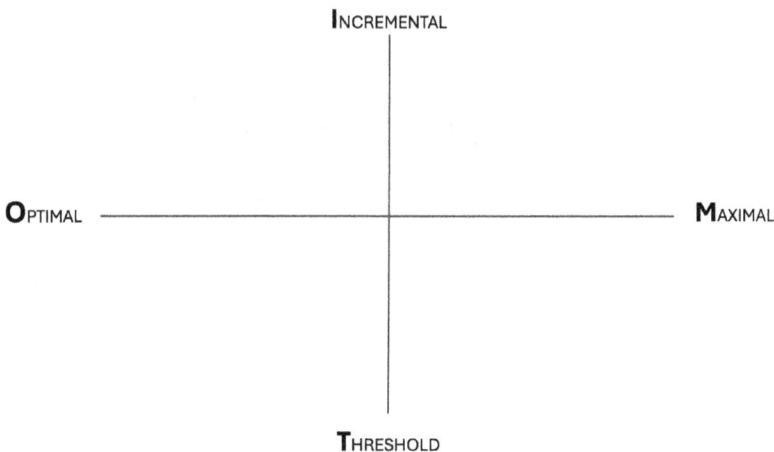

INCREMENTAL

OPTIMAL ——————————————— MAXIMAL

THRESHOLD

Figure 7.10 Blank OMIT map template.

Incremental) or O-T (Optimal/Threshold). If performance in any of these Optimal areas is below the required threshold level, then these components are potential priority items. Even slightly below Optimal means effectively zero performance.

Alternatively

- Move EVERY aspect from ATC onto OMIT and decide quadrants as you go.

Bear in mind that the quadrant that you choose is not an absolute choice for each item – the current levels of performance (required and delivered) have an impact on the quadrant, and both of these change over time.

- You may think of more items as you complete OMIT, and I'd suggest putting these on the ATC map too.

It is also necessary to take each item to the most appropriate granular level, for example, Health may be in the Optimal/Incremental quadrant for you, but unpacking Health further, you decide that Weight belongs in Optimal/Threshold, because you have a particular goal in mind and once that weight goal has been achieved you will no longer have weight on the map.

Some items may be in different quadrants.

The ATC map is often broader than the OMIT map – my generic Organisational Psychologist ATC map was transferred to OMIT as a person-specific (i.e. me) OMIT map. I also created an even more specific OMIT map for my role as an author. At the time of writing this, I am of course some way still from finishing writing the book, but my realisations from OMIT are that the things that I need to focus on to be a successful high-performing author are now not related to writing, but instead are related to promoting and selling copies of the book. It helps to define what high performance is – and around a year ago the OMIT map for this book would have looked very different, as the focus would have been on the concept and contracting with a publisher.

Figure 7.11 shows my draft OMIT map for the stage I am currently at with writing this book. It is clear that my focus needs to shift. Up until now, the focus has very much been on the process of writing, with even my definition of performance being the quality or writing, meeting deadlines, and success being how good the book is.

This highlights:

- OMIT is time-constrained.
- OMIT is more personal, shifting the focus from organisation/project to individual performance.

INCREMENTAL

Balancing other commitments

Sales

Vlogging/promoting

Promoting the book

OPTIMAL ——————————————————————————— MAXIMAL

Cover design

Website

THRESHOLD

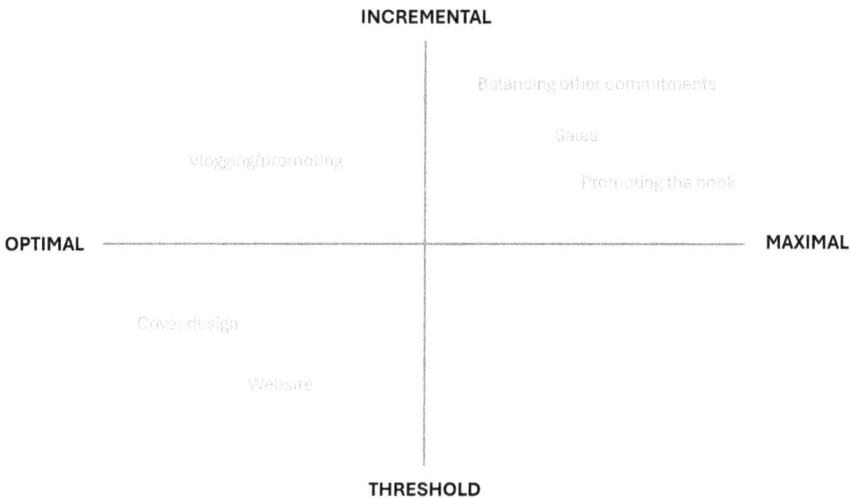

Figure 7.11 Partial OMIT map for my role as an author.

- OMIT Maps can be at any level, and will be different for each level or individual. There may be similarities and repeated sections, but overall they will be different.
- Quadrant judgement is sometimes subjective, and as such can be skewed or even incorrect.

My process overall is to create the ATC map first to give a broad set of attributes, then plot each attribute onto the OMIT grid, considering carefully the quadrant placement. Remember that where they sit is sometimes time-bound, and will not be in the same quadrant forever. Quadrant judgement is subjective and that's to be enjoyed – there are rich discussions to come from these subjective views.

There are some useful questions that help to challenge placement, and to develop further.

Quadrant-specific questions, for each item within each quadrant.

Optimal – Threshold quadrant

- Are you currently performing below or above a key threshold? If you are below, then focus as quickly as possible on achieving the threshold. Even if it means stopping development activities elsewhere.

 If you are above a key threshold, then you have already done enough potentially. Consider where the next threshold is and whether development needs to be focussed at all in this area.

Maximal – Threshold quadrant

- Because this is not Optimal, there is not a question necessarily about stopping development if above the threshold, so the question here is about chasing the next threshold and to balance the value against the cost. Qualifications would be a good example here; there is Maximal value in having more qualifications, but achieving it is a threshold – it may take me 5 years to complete a PhD but I only have a PhD at the end. Once the threshold is met.

Optimal – Incremental threshold quadrant

- Optimal – so good enough can be good enough, and it can be developed incrementally. In my example, Figure 7.11, I added "vlogging" as this is something that I don't yet do at all; I can publish videos one at a time (Incremental) and they need to be good enough for now. It may be in the future that I shift this into the Maximal/Incremental quadrant, but for now, I need to recognise that getting even one video out to promote the book would be good enough.
- The question to ask for items in this quadrant then is about the cadence and timing of development, and whether you are clear about what good enough looks like.

Maximal – Incremental threshold quadrant

- This is the closest to the idea of marginal gains. Something that can be developed a little bit (incrementally) and where any increase is beneficial (Maximal).

 The question though is to challenge whether it truly is Maximal and to balance the cost. Sales could be Maximal and Incremental, but what is my capacity to deliver those sales, do I have the resources, and what are the associated costs with generating the sales.

 Other questions

Threshold

- Do your organisational thresholds match individual thresholds? E.g. is there alignment with broader targets.
- Are you continuing to iterate? Once you've achieved optimum threshold, there is no need to develop further unless to the next threshold, so it could move to another quadrant. Optimal may become Maximal, but may not.

Summary of the process

Start with a blank OMIT template
Start to populate quadrants
Drill down to behaviours/smaller goals and put each of these into relevant
quadrants – remember that the smaller goals may not be in the same
quadrant as the "parent" goal.
Continue to iterate. Regularly challenge and re-write; goals will be achieved
and new goals and priorities need to emerge and take their place.

Development guides

It is likely that there are some common areas that will be in many people's
ATC or OMIT maps, and one of the aims of this book is to help make per-
formance shifts.

This section of the book will look at some of these common areas in
the hope that they will either specifically or generally be of use. Either you
have the exact same development area and this will specifically help, or by
looking at how we deal with some areas of development will help generally
with developing others.

The common areas are:

- Goals
- Reliability and conscientiousness
- Resilience
- Personal blocks
- Personal values (conceptual self)
- Optimism
- Self-efficacy

Goals

Goals are at the top of this list because it is highly likely that any perform-
ance improvements are focussed on the achievement of one or more goals.
How we set goals is linked to how likely we are to achieve them and there is
also a link to how motivated we are whilst in pursuit of these goals.

The theories of GST and Control Theory (CT) are covered in a previous
chapter. The aim of this section of the book is to shift from a theoretical
perspective to a practical one. Table 7.2 is a sample template to help focus
thinking on goals.

Table 7.2 Goals template

Clear	SMART: **Specific**, Measurable, Achievable, Realistic, **Timed**. Specific: In as much details as is needed to clearly outline the goal and the rewards. Consider team vs. individual goals. If there is a team goal, are there also individual goals?	
Difficult	The "Achievable" and "Realistic" of SMART The higher the goal, the higher the performance. How difficult is the goal you're setting? Aim for difficult over realistic	
Accepted	This is not the same as being assigned a goal. If the goal has been assigned, have you fully accepted it? What about rewards? Linked to Vroom's VIE, these also need to be measured and attractive How have you demonstrated your acceptance? Commitment is key. Have you considered communicating your acceptance of the goal, and to whom?	
Feedback	It is vital that you have an ongoing feedback mechanism Control Theory is about measuring progress against the goal. Make sure that the feedback is timely enough to be able to adjust behaviour and to maintain motivation. We are specifically looking here for feedback that enhances the opportunity of meeting the goal. Consider augmented feedback – that which would not otherwise be known to you. Who can provide this and how can you develop the relationship so that the feedback is helpful?	

If setting goals in a particular way helps with performance, then how does one go about setting goals in this way?

GST

The goals need to be Clear, Difficult, Accepted, with Feedback

Control Theory

This is about measuring present position against the goal/standard.

Reliability and conscientiousness

If we look at reliability, the likelihood is that to some degree everyone needs to be reliable. Others have expectations of us and we can make their lives easier or more difficult by meeting, or failing to meet, those expectations.

Reliability often has an amplification effect where others extrapolate situational and specific instances of reliability. Helpdesks that give specific times for call-back may have higher perceived **product** reliability because customers using the helpdesk attribute the helpdesk reliability to the entire organisation and their products.

It is possible therefore that reliability is also not just an individual aspect, but an organisational one and the ATC "leaves" that come from the Reliability branch could include shifts in organisational behaviour from call-backs that are offered as "as soon as possible" to being a specific time.

At an individual level, let's assume that I'm mapping my overall job performance. If my role has deadlines or other people are reliant on my reliability then it could be that I need to be aware of my level of reliability, or my reputation for reliability.

My role may also require me to be maximally reliable – so role critical, or it may be OK to just be reliable enough.

The worksheet here is for you to understand the extent to which you have made commitments and how you perceive your own reliability and that of others.

Conscientiousness is one of the so-called Big 5 personality traits and you may be interested in completing one of many online personality tests. The Big 5 is also known as OCEAN (Openness to experience, Conscientiousness, Extraversion, Agreeableness and Neuroticism). Whatever your score for conscientiousness, your reliability and reputation can still be increased should you wish to develop it.

Commitment process

With clients I have used the commitment process to underline and enhance not just reliability as a specific behaviour but the individual and organisational approach to commitments requested and given.

The process of giving or getting commitment is enhanced through negotiation and feedback, so that the parties can positively affect how commitments are given/got in future. The negotiation stage reduces the likelihood of a deadline of "as soon as possible" and increases the conversations to engage the customer (person requesting) in understanding what other commitments you already have (Figure 7.12).

Ask yourself what, right now, other people are expecting from you by way of commitments made. Have you agreed to meet someone, or deliver a piece of work? How confident are you that you will meet these commitments, and do you think the other person shares the same level of confidence, and of not are they more or less confident than you?

Now consider what you are currently expecting from others. Again, how confident are you that they will meet these commitments, and do you think they share the same level of confidence?

In all cases, the level of confidence that you have is probably a reflection of the history of the relationship. I have a colleague who will call precisely at 10.00 if that is the time we have agreed to speak. I know this so I raise my own level of reliability for this relationship.

Organisationally, what do your customers expect?

Figure 7.12 The commitment process.

Table 7.3 Commitments

Commitments to others	Your expectation/ confidence	Their expectation/ confidence
Describe the commitments that you have made to others.	Your expectation of meeting the commitment and your level of confidence.	Your estimate of their expectation and the confidence that they have in you.
Commitments BY others	Your expectation/ confidence	Their expectation/ confidence
Describe the commitments that others have made to you.	Your expectation of them meeting the commitment and your level of confidence.	Your estimate of their expectation and level of confidence.

I have taken one ATC leaf, that of Reliability and looked at it in the context of individual and team performance and there are potentially hundreds of leaves in anyone's ATC map.

Table 7.3 is a template for noting your commitments that you have made to others and that others have made to you.

It could be meeting socially as a given time/place, or it could be a deadline for a key project or part.

Resilience

I have grouped some of the key aspects of resilience; there are a few key models of resilience and a self-assessment questionnaire – the Nicholson McBride Resilience Questionnaire (NMRQ) that you can find online through Nicholson McBride's website (nicholsonmcbride.com).

Table 7.4 Resilience

Diagnosis	
Questionnaire	beyondmarginalgains.co.uk/resilience
Development areas	
Relationships	Asking for help Dealing with conflict Attachment to others
Goals	Solution orientation Visualising success Take action
Self-efficacy	Increase self-efficacy Taking control Boost self-esteem Conceptual self
Optimism	Learned optimism

As with other areas of this book there is a degree of overlap and many of the aspects that this book covers are integral to increasing resilience – Relationships, Goals, Self-efficacy, and Optimism.

For a practical guide to developing resilience, Table 7.4 highlights the questionnaire and development areas for focus.

Conceptual self and personal values

As we saw with Control Theory, self-regulation involves comparison with the conceptual self – or the idea of how we see ourselves. And how we see ourselves is in part influenced by our development journey, by our life path, and the individual and collective influential determinants along the way that are unique to each of us. Our life path is individually unique, but so is how we process and are shaped by these determinants. We don't all respond in the same way to the same event.

The practical aspect of this is to spend some time understanding what has shaped us, and what is important to us, for both of these will impact on our direction and achievement of goals.

Personal timeline

We all experience highs and lows in our lives, and those ups and downs shape us. Even others who experience the same events are not shaped

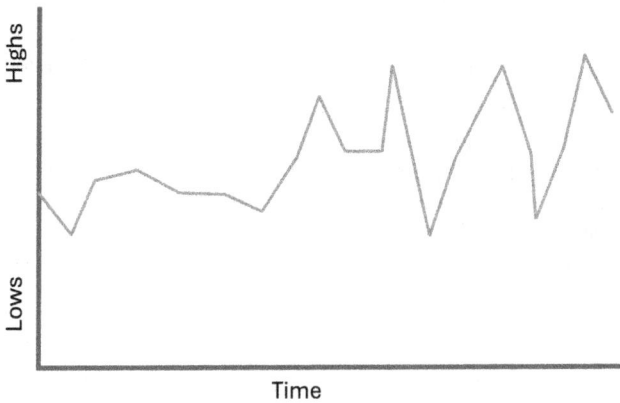

Figure 7.13 A personal timeline.

necessarily in the same way. It can be an interesting, useful, and thought-provoking process to draw a timeline with your highs and lows shown.

Start at birth and go through to the present day.

Figure 7.13 shows what mine looks like if I just put in the major life events; births, deaths, marriages, work highs, meeting key people, major events – that kind of thing. There's no right or wrong, but initially don't overthink it; it's interesting to see what emerges.

Personal values

The degree to which we strive to meet our goals depends in part on how those goals help us match the idea of who we are – our conceptual self. It's easy to see how goals that jar with our sense of identity would be difficult to strive for.

Sometimes, the goals can be changed to be more in line with our values.

At other times, maybe when the goals cannot be changed, we need to look hard to see how those goals can fit with our values.

In both cases, understanding what our core personal values are will be helpful. They help with motivation, and with direction and purpose.

Process:

Read through the 19 values statements in Table 7.5. If you think of a core value that's missing, add it in the final box

Then strike out or discard 11 that you could live without if you had to (or 12 if you've added 1). Leave 8

Next, find another three to strike out, to leave five

Then rank your final five.

Table 7.5 Personal values statements

Personal development	Wisdom	Community	Independence
I embrace challenges in life that help me grow and allow me to utilise my best talents and to mature as a human being	I grow in understanding of myself, my personal calling and life's real purpose	I am involved in a group with a larger purpose than myself. I am interested in humanitarian activities that improve the lives of others	I have freedom of thought and action. I live according to my own time schedules and I value my own space
Love	**Health**	**Family**	**Security**
I express love to myself and others	I am physically and mentally fit	I have time with my family	I have a steady income that fully meets my family's basic needs
Integrity	**Authenticity**	**Prestige**	**Expertise**
I live according to my own moral standards. I keep my word, promises, and agreements. I speak up for my personal beliefs	I live and speak according to my inner truth and am with others who do the same	I am seen by others as successful. I am well known. I have recognition and status in my chosen field	I am well informed, well known and respected as an authority in what I do
Enjoyment	**Power**	**Personal accomplishment**	**Leadership**
I enjoy the activities in my life and have fun doing them	I value being in charge. I have the authority to decide on a course of action in any given circumstance	I achieve goals that have significance for me personally. I am involved in activities that have significance to me whether or not they bring me recognition from others	I experience true empowerment by collaborating with others and enhancing the collective capacity of a group of individuals to create the results that matter
Creativity	**Wealth**	**Loyalty**	
I am innovative. I like to create new, original and better ways of doing things. This gives me energy and momentum	I earn amounts of money that allow me to live beyond my family's basic needs. I am financially independent	I have unwavering faithfulness to the people and practises in my life that I care deeply for	

Table 7.6 Building optimism

	Permanence	Pervasiveness	Personalisation
Good events	Stable (cause will last a long time),	Global (will affect other areas of my life)	Internal (it's down to me)
Bad events	Unstable (it won't last),	Specific (wrong place, wrong time)	External (it was just [bad] luck)

Optimism

Optimism, as we have seen is positively correlated with resilience, and resilience is a core part of what we bring psychologically to the table when listing our strengths.

Optimism also protects us, or maybe it is the protection that builds resilience.

Two aspects then are important from our perspective.

Firstly, to build optimism.

Secondly, to allow and encourage the right kind of pessimism. Create sufficient psychological safety that pessimism can help growth and build higher performance. Table 7.6 shows the optimistic mindset for both good and bad events for permanence, pervasiveness and personalisation.

There are many more exercises and ways to develop that are outlined in Seligman's book "Learned Optimism. How to change your mind and your life" (2006).

Learned optimism is about the way we process and understand the setbacks and victories. Write out an example of a bad event and see how you explain it from the perspectives of Permanence, Pervasiveness, and Personalisation.

Look for patterns, and see if it's a habit. You may already see some aspects in an optimistic way. Table 7.7 is a template for re-thinking a negative event in an optimistic way.

Building (the right kind of) pessimism

Under the right circumstances – with sufficient resilience for example – it is entirely appropriate to choose to look at things from what would be considered a pessimistic perspective.

It is different though, as it is a deliberate choice and not a pattern or explanatory style. Table 7.8 is a template for re-thinking a negative event focussing solely on the internal aspect of personalisation. This helps to build the right kind of pessimism by steering thinking towards what personal development can happen.

Table 7.7 Bad events worksheet

Bad events Think of a bad event that has happened recently, or a situation that didn't go as you'd hoped.		
How long-lasting	*How global*	*Internal or external*
Rewrite the event if you were to see it from an entirely optimistic perspective		
Unstable (won't last)	*Specific*	*External (not me)*

Table 7.8 Personalisation of bad events worksheet

Bad events Think of a bad event that has happened recently, or a situation that didn't go as you'd hoped.		
How long-lasting	*How global*	*Internal or external*
Rewrite the Personalisation (Internal or External) to focus on the internal only;		
Internal: What was my contribution to the event?	What development areas does it highlight for me?	How difficult is it for me to accept my part, and to commit to development?

Now, let's look at good events (Tables 7.9 and 7.10).

Building the right kind of Pessimism

Even though this is a good event, and the Optimistic explanatory style is to see the Personalisation aspect as Internal – i.e. the success was down to you, this does not lead naturally into development areas. So even for good events, I suggest taking a look at what you could have done differently (Table 7.11).

Table 7.9 Good events

	Permanence	**Pervasiveness**	**Personalisation**
Good events	Stable (cause will last a long time),	Global (will affect other areas of my life)	Internal (it's down to me)

Table 7.10 Good events worksheet

Good events Think of a good event that has happened recently, or a situation that went really well		
How long-lasting	*How global*	*Internal or external*
Rewrite the event if you were to see it from an entirely optimistic perspective		
Stable (will last)	Global	Internal (it was me)

Table 7.11 Personalisation of good events worksheet

Good events Think of a good event that has happened recently, or a situation that went really well.		
How long-lasting	*How global*	*Internal or external*
Rewrite the Personalisation (Internal or External) to focus on the internal only;		
Internal: What was it that I didn't do well enough?	What development areas does it highlight for me?	How difficult is it for me to accept my part, and to commit to development?

Self-efficacy

Raising expectations

Raising expectations for yourself, or for others, has tangible benefits, as discussed in the sections of this book for the Matthew/Galatea/Pygmalion effects.

It is important that these expectations are not raised deceptively, so evidence is important. Evidence can come from past and current performance (Table 7.12).

Superstars

If you're lucky enough to have a superstar in your team or around you, then you have a benchmark for high performance.

Teachers refer to this as WAGOLL (what a good one looks like). It is also close in concept to The inner game of tennis where W. Timothy Gallwey (2014, Macmillan) advocates demonstrating the motor skills as they are easier to emulate than to try and have them explained.

Table 7.12 Raising expectations

For yourself or for others	
What can you find that could lead to expectations being raised?	
Résumé/CV. A good place to start as generally it's written in order to give a good impression and raise expectations	
Past performance. Focus on Behaviours Characteristics	
Past or current poor performance. Focus on improvement rather than low performance Find the positives Find evidence of things being done well	

For superstars, there are two considerations though – firstly – your superstar is still capable of developing their performance further and such development should not be overlooked. It sometimes feels like there is greater potential gain from developing the weaker team members, thinking mainly of the value that they could add as they move closer to the performance of the Superstar.

Secondly – other team members may still be out-performing the superstar in some aspects, even if overall performance is higher for the Superstar. Don't assume that the Superstar excels at everything, and be prepared to not overlook so-called allowable weaknesses.

Aside from individual performance then, the Superstar can help raise performance of others by highlighting WAGOLL.

1. Ask the Superstar to help map their performance.
2. Get team buy-in to mapping performance against benchmarks; remember that the superstar is probably not setting all of the benchmarks (in fact they may be operating under "allowable weaknesses" which need exploring because they won't be allowable for everyone).
3. Note as many attributes of performance as you/they can think of. This is not an exhaustive list, keep adding to it. What you're looking for is ANYTHING that is part of the performance of the role, irrespective how small or ubiquitous for the role.

References

Connor, K., & Davidson, J. (2003). Development of a new Resilience Scale: The Connor-Davidson Resilience Scale (CD-RISC). *Depression and Anxiety, 18*, 76–82.

de Terte, I., Becker, J., & Stephens, C. (2009). An integrated model for understanding and developing resilience in the face of adverse events. *Journal of Pacific Rim Psychology, 3*(1), 20–26.

Gallwey, W. T. (2014). *The inner game of tennis: The classic guide to the mental side of peak performance.* Macmillan.

King, Z., & Scott, A. (2014). *Who is in your personal boardroom?: How to choose people, assign roles and have conversations with purpose.* Personal Boardroom Ltd.

Kobasa, S. C. (1979). Stressful life events, personality, and health: An inquiry into hardiness. *Journal of Personality and Social Psychology, 37*(1), 1.

Lyons, J. A. (1991). Strategies for assessing the potential for positive adjustment following trauma. *Journal of Traumatic Stress, 4*(1), 93–111.

Rutter, M. (1985). Resilience in the face of adversity: Protective factors and resistance to psychiatric disorder. *The British Journal of Psychiatry, 147*(6), 598–611.

Seligman, M. E. (2006). *Learned optimism: How to change your mind and your life.* Vintage.

Appendix
Research and data detail

Introduction

This appendix contains the findings from my 2017 research. One of the purposes of the book is to create awareness of the models and to encourage more research and to that end, publishing some details of the research could be useful. The title of the research was: "Topical sequencing and spaced practice – their impact on task performance, motivation and learning. Do quantifiable differences in spacing (front-loading, back-loading or linear) correlate with objective and subjective performance measures and allow for a cumulative advantage?".

As with much research, it may raise as many questions as it answers.

Research abstract

The purpose of the study was to determine and quantify the effects on practice efficacy of changes in the interval timing of training activities (simply quantified by measuring the area under a practice curve) and the correlations between objective and subjective performance measures. The concept of cumulative advantage has been applied to a number of scientific and sociological areas (success breeds success, the Matthew effect) but not specifically to learning and development. This study aims to show a cumulative advantage effect as a result of positively manipulating the pattern of spaced practice.

The study looked to determine the effect of tree-specific practice patterns, measuring performance improvement for a simple task (typing speed and

accuracy) as an objective performance measure, and measure perceived self-efficacy as a subjective measure. The research subjects were randomly assigned to one of three groups, where group membership determined the pattern of time spent learning over 5 weeks, whereas for all groups and subjects the total time spent practising was 5 hours.

In summary, the findings identified a clear objective performance advantage for the group that spent the majority of their practice at the start of the project (4 of their 5 hours in the first 2 weeks) and thus without any additional time spent over 5 weeks (relative to the other two practice pattern groups) the gain can only be attributed to the cumulative advantage as a result of the changes in the spacing of their practice.

Background and general introduction

Much of our lives is spent in periods of learning or development through practice. Whether as a simple by-product of repeating a task many times or through deliberate practice, we expect to improve over time. Organisations (UK alone in 2014–2015 spent £1048 per learner and average 16.2 hours per employee annually (Deloitte, 2016)) dedicate much of their time and resources to learning and development for several reasons. Firstly, higher individual performance leads to higher organisational performance (Ostroff, 1992). Secondly, individuals expect a career path with an upward trajectory that is in part a function of them continually learning (Lent & Brown, 1996). Thirdly, motivation theories such as goal setting theory (Locke & Latham, 1994) and Carver and Scheier's self-regulation theory (Carver & Scheier, 1982) show enhanced motivation as a result of moving towards a goal that is in some way stretching. Learning and development is often the method of closing the gap between the current and desired performance. Fourthly, organisations seek competitive advantage (Pfeffer, 1995) and their human capital is one of the largest resources available to an organisation and as such one of the most potentially effective means of delivering a competitive advantage.

Organisational learning and development therefore is a cost that is designed to deliver a benefit to the organisation, and can only be sustainable if the benefit outweighs the cost. It is therefore of critical importance to either reduce the cost, or increase the benefit of any learning and development as this is catalytic to competitive advantage. Meta-analyses of the effectiveness of training in organisations show mean effect sizes of 0.44 across all interventions (range 0.12–0.75) (Arthur et al., 2003) shows that there is great potential for the improvement in effectiveness of training.

Total development is often seen as a function of time spent; pilots log flying hours; most organisations measure man-days of development. Ericsson's work on deliberate practice (Ericsson et al., 1993) in the acquisition of expert performance cites the skill of Morse Code operators plateauing well below Maximal performance, but with extended effort could overcome the plateau. So, we have the initial concept of time being spent practising, then overlaying the deliberate nature of the practice in order to look for Maximal performance.

The research that I did looks further at the time spent and aimed to find if changing the pattern of spaced practice correlates with a quantifiable difference in performance. My research showed real outcome differences when just 5 hours of development time was focussed early, and if the average is 16.2 hours per employee training per year, then maximising the effectiveness of that time is important, and if we can show a consistent positive effect from how that 16 hours is spaced, then we can potentially increase the effectiveness of any training intervention without changing the content, the sequence or the total cumulative time spent.

A typical spacing of practice for a student can be imagined as a little time every week, followed by much greater time being spent towards the end with a spike of cramming before the exam or essay (Schmidt, 1983). This research looked to examine the effect if, for example, that timeline was to be reversed, with the cramming and spike at the start, plateauing afterwards. If the total time spent is identical, then the difference in the second scenario is that later practice is at a higher level. This may create a cumulative advantage, an effect most commonly applied to science and sociology (Allison et al., 1982; Merton, 1942) and which is generally seen as negative "the rich get richer and the poor get poorer" (Merton, 1968).

This research set out to see if the concept of cumulative advantage can be applied to learning and development and practice in such a way that it could be harnessed positively as a way of increasing practice efficacy.

Figure A.1 plots cumulative time spent on development against elapsed time. The points of convergence of the three plots are where cumulative time and elapsed time are the same for all three. Yet the area under each curve is different. Series 3, with the greatest area under, represents the curve (in the context of this study) most likely to demonstrate cumulative advantage. To simply differentiate between the three practice patterns, this study will use the area under the curve (AUC).

One of the key beliefs that underpins this book and the research, is that performance improvement as a result of deliberate practice is not just a function of time, but also a function of the pattern of time spent such that varying the pattern of cumulative time spent over elapsed time leads to

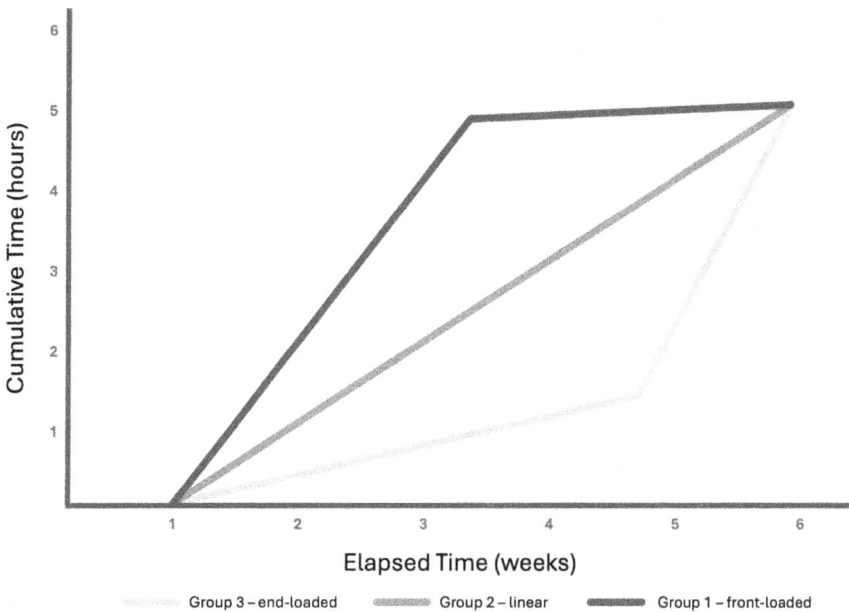

Figure A.1 Showing the three practice time patterns used in the research.

a quantifiable difference in performance gain; specifically for Group 1 in Figure A.1, where the time is front-loaded,

- Subjects experience a cumulative advantage from early development such that subsequent practice, though short, has a greater impact, and their total performance gain (measured by both speed and accuracy) exceeds other patterns of practice time.
- They subjectively experience greater self-efficacy as a result of making progress more quickly, and as such their perceived self-efficacy scores will be higher than subjects in other groups.
- Performance longevity is enhanced as a result of having spent more elapsed time practising at the higher level; we expect to see a smaller drop-off in performance between weeks 6 and 7 for Group 1 subjects.

Whilst the pattern of practice was different, when plotted it creates a different shape to the curve and I used the AUC as a measure of this "shape". So, one consideration of the research was to see if the total AUC correlated with the positive differences in performance improvement. If so, and if that correlation is consistent, then any shifts to increase the area under the learning curve would bring about positive performance improvements.

In other words, the AUC positively correlates with typing speed, typing accuracy, self-efficacy, and skill retention longevity.

Research method

The specific research design called for subjects to spend time practising a skill where their progress could be objectively measured, and where the practice alone was, as far as possible, the only factor leading to changes in skill. The design required a skill where individual capability and individual differences would have as little impact as possible. In summary, the design looked for a skill that was not too complex, where all subjects could reasonably practice and see improvements within the scope of a few hours so as to not make the study too longitudinal, and where their skill level had reached a plateau already, so that we could attribute the deliberate practice to any changes in skill. This plateau also meant that the need for a control group was negated in that the study sample had effectively already shown that they had stopped progressing.

Typing speed and accuracy were chosen after much deliberation. Other skills considered included Chess and Morse Code – the latter as a nod to Ericsson's early research in the Second World War. Morse Code would have been my preferred choice as it met more of the criteria but the decline in usage of Morse Code would have meant that subjects were unlikely to have any experience so would not have reached a plateau, nor would it have been in any way straightforward to recruit subjects to spend up to 10 hours practising a skill that would serve no other purpose than my research. Typing skills (speed and accuracy) are easy to measure and recruitment of subjects whilst still difficult principally because of the time commitment was made a little easier in that everyone (in all practice pattern groups) would expect to improve their typing speed and accuracy which would be of lasting benefit.

We worked from an assumption that typing is a skill that everyone has plateaued at. Ericsson proposes that even something that we spent many hours "doing" doesn't lead to improvement unless deliberate practice. The methodology that was used isolates the practice and negates other factors (such as individual differences and capability) by using a skill that is technically not difficult yet takes hours to master.

One weakness of using typing speed and accuracy though, is that typing and touch-typing could be seen as two entirely separate skills, not different levels of the same skill. This might explain why one subject saw a clear reduction in performance as they moved from their previous two-finger typing at which they were proficient, into touch-typing part way though at which they were unskilled.

The elapsed duration of the study (7 weeks, including 5 weeks practising) was optimum in meeting the study design, and the needs of the subjects. Longer duration would have been impractical for many subjects and would have restricted the possible sample size. The subjects were by voluntary application from client organisations.

Each person in the research completed 5 hours (total) of an online typing course over 5 weeks, and each week measured and recorded their speed and accuracy (having completed a short online typing speed and accuracy test) as an objective measure, and a self-efficacy questionnaire as a subjective measure. The GSE-10 (General Self-Efficacy Questionnaire) was chosen as a valid and reliable measure (Chow et al., 2001). The week before practising and the week after finishing the 5-weeks' practice were additional speed, accuracy and self-efficacy tests to check for evidence of skills plateau (at the start) and the degree of skill decline at the end.

For information, typingclub.com was the online training provider. This offered an identical learning experience for all subjects who also all followed the same sequence of training and practice, thus removing sequence as a variable.

Keyhero.com was the online speed and accuracy test medium because it offered a simple set of tests that quickly measure typing speed and accuracy.

Subjects were randomly assigned into one of three groups and each group allocated a practice pattern. One group spent one hour each week (linear pattern); another group spent 2 hours for each of the first 2 weeks, then 20 minutes for each of the final 3 weeks (front-loaded). The third group practised for 20 minutes for the first 3 weeks, then 2 hours for the final 2 weeks (back loaded). For all groups, the total practice time (5 hours), the elapsed time (5 weeks) and the sequence (all followed typingclub.com typing skills online course) were the same in order to measure differences caused only by the patterns of practice.

Data analysis

For those interested in the details, statistics package for social sciences (SPSS) was used for data analysis which then included AUC, mean, analysis of variance (ANOVA), and regression analysis.

The data were manipulated post-case in Excel in the following ways in order to reduce bias:

- Typing speed for each subject was related to their own baseline speed, as a percentage. This allowed for the research to measure the change in

typing speed and reduced possible bias by randomly assigning the fastest subjects into the same group for example.

- AUC calculations for practice time and for speed and accuracy. This allows for the shape of the improvement curve to be taken into account, and therefore makes use of the interim data, not just start and finish scores.
- Speed and accuracy were combined (Bruyer & Brysbaert, 2011) as a separate measure as it is often found that speed and accuracy can report in opposite directions as a result of a trade-off between the two variables.
- Data were removed for subjects who dropped-out (5 subjects only completed 1 week of the research and as such their results could not be used.
- For subjects with missing data, last observation carried forward (LOCF) was used for interim measures (Siddiqui et al., 2009).

Results and outcomes

To summarise,

Hypothesis 1

Practice time AUC positively influences typing speed performance gains.

Participants in Group 1 with front-loaded practice pattern and higher AUC than other groups, experienced a greater increase in typing speed over the duration of the 7 weeks.

However, between the linear group and the end-loaded group the results were not significant. So to achieve the best increase in typing speed over 7 weeks of practice, front-load the practice time pattern.

Hypothesis 2

Practice time AUC positively influences typing accuracy performance gains.

As a measure of performance, typing accuracy is not dependent to a degree that would be considered significant on the practice pattern followed for

typing skill training. As a result, a post hoc analysis was not required or relevant, and the hypothesis has not been confirmed.

Hypothesis 3

Practice time AUC positively influences self-efficacy.

An ANOVA showed that the effect of practice patterns on the change in typing speed was not significant.

Furthermore, the direction of the relationship is opposite to the hypothesis, with the front-loaded group recording the lowest mean self-esteem total (Figure A.2). However, the ANOVA shows that the effect size is not significant, and hence the hypothesis is not supported.

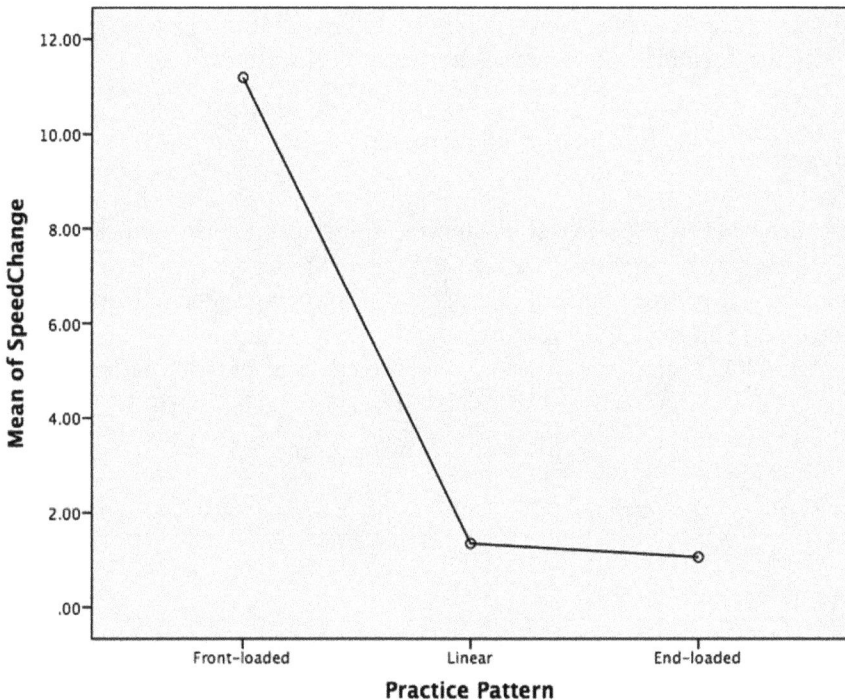

Figure A.2 Means of speed change by practice pattern group.

Hypothesis 4

Practice time AUC positively influences skill retention longevity (measured by the decline in performance between weeks 6 and 7).

The change in typing speed between weeks 6 and 7 as dependent on practice groups was not at a level deemed to be significant, and as such the hypothesis is not supported.

Results in more detail

The hypotheses for this research are as follows:

Practice time AUC positively influences typing speed performance gains
Practice time AUC positively influences typing accuracy performance gains
Practice time AUC positively influences self-efficacy
Practice time AUC positively influences skill retention longevity (measured by the decline in performance between weeks 6 and 7)

Hypothesis 1

Practice time AUC positively influences typing speed performance gains.
 A one-way between-groups ANOVA ($N = 16$) was conducted to compare the effect of practice pattern on the change in typing speed in front-loaded, linear and end-loaded conditions.
 An ANOVA showed (Table A.1) that the effect of practice pattern on the change in typing speed was significant, $F(2,13) = 4.94$, $p = 0.025$.

Table A.1 ANOVA comparing effect of practice pattern on change in typing speed

ANOVA
Speed change

	Sum of squares	df	Mean square	F	Sig.
Between groups	373.983	2	186.992	4.935	**0.025**
Within groups	492.623	13	37.894		
Total	866.607	15			

Table A.2 Post hoc analysis showing significance for change in speed

Multiple comparisons

Dependent variable: Speed change

Tukey HSD

(I) Practice pattern	(J) Practice pattern	Mean difference (I–J)	Std. error	Sig.	95% Confidence interval Lower bound	Upper bound
Front-loaded	Linear	9.83967	3.72753	**0.050**	−0.0027	19.6820
	End-loaded	10.12767*	3.72753	**0.044**	0.2853	19.9700
Linear	Front-loaded	−9.83967	3.72753	**0.050**	−19.6820	0.0027
	End-loaded	0.28800	3.89328	0.997	−9.9920	10.5680
End-loaded	Front-loaded	−10.12767*	3.72753	**0.044**	−19.9700	−0.2853
	Linear	−0.28800	3.89328	0.997	−10.5680	9.9920

This indicates that participants in Group 1 with front-loaded practice pattern and higher AUC than other groups, experienced a greater increase in typing speed over the duration of the 7 weeks.

A post-hoc analysis using the Tukey-Kramer (Tukey HSD) criterion for significance was performed to determine between which of the practice pattern groups levels, a significant difference exists. The Tukey–Kramer test (Table A.2) revealed that there is a significant mean difference between the front-loaded practice-pattern group ($M = 11.2$, $SD = 9.8$) and the linear group ($M = 1.4$, $SD = 0.8$) and the end-loaded group ($M = 1.1$, $SD = 1.1$), However, between the linear group and the end-loaded group the results were not significant. So to achieve the best increase in typing speed over 7 weeks of practice, front-load the practice time pattern.

The hypothesis is therefore partially supported, in that only front-loading the practice pattern to create the front-loading had significance – the small increase in AUC for the linear group over the end-loaded group did not achieve significant results.

Hypothesis 2

Practice time AUC positively influences typing accuracy performance gains. A one-way between-groups ANOVA ($N = 16$) was conducted to compare

Table A.3 ANOVA comparing effect of practice pattern on change in typing accuracy

ANOVA

Accuracy change

	Sum of squares	df	Mean square	F	Sig.
Between groups	6.526	2	3.263	1.522	0.255
Within groups	27.871	13	2.144		
Total	34.397	15			

effect of practice pattern on the change in typing accuracy in front-loaded, linear and end-loaded conditions.

An ANOVA showed (Table A.3) that the effect of practice pattern on the change in typing speed was not significant, $F(2,13) = 1.52$, $p = 0.255$. This means that as a measure of performance, typing accuracy is not dependent to a degree that would be considered significant on the practice pattern followed for typing skill training. As a result, a post hoc analysis was not required or relevant, and the hypothesis has not been confirmed.

Hypothesis 3

Practice time AUC positively influences self-efficacy. A one-way between-groups ANOVA ($N = 16$) was conducted to compare the effect of practice pattern on the change in self-efficacy in front-loaded, linear, and end-loaded conditions.

An ANOVA showed ($N = 16$) (Table A.4) that the effect of practice pattern on the change in typing speed was not significant, $F(2,13) = 0.112$, $p = 0.895$.

Table A.4 ANOVA comparing effect of practice pattern on total self-efficacy scores

ANOVA

SE total

	Sum of squares	df	Mean square	F	Sig.
Between groups	161.467	2	80.733	0.112	0.895
Within groups	9396.533	13	722.810		
Total	9558.000	15			

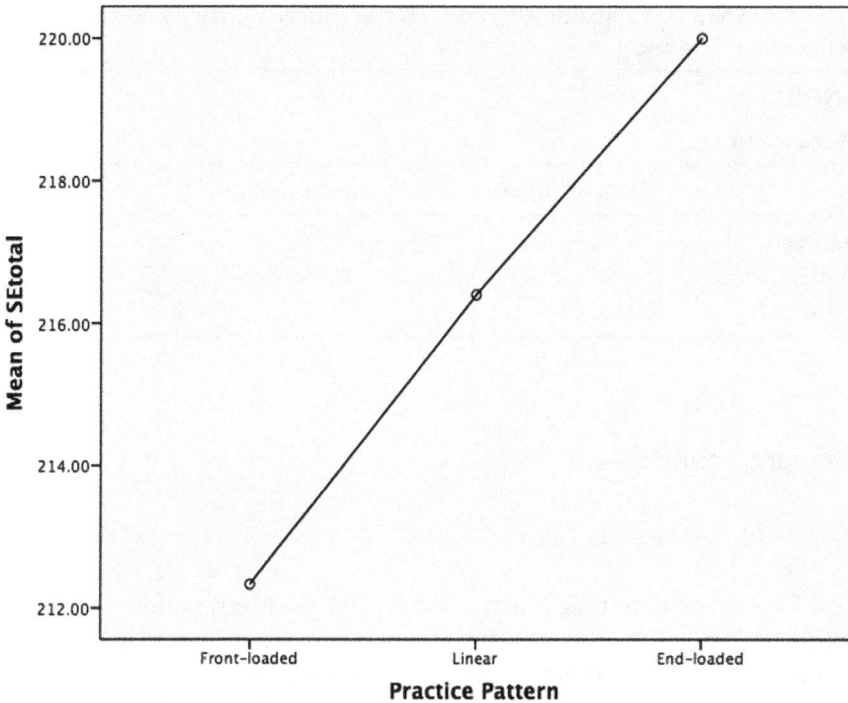

Figure A.3 Means of self-efficacy total by practice pattern group.

Furthermore, the direction of the relationship is opposite to the hypothesis, with the front-loaded group recording the lowest mean self-esteem total (Figure A.3). However, the ANOVA shows that the effect size is not significant, and hence the hypothesis is not supported.

Hypothesis 4

Practice time AUC positively influences skill retention longevity (measured by the decline in performance between weeks 6 and 7).

A one-way between-groups ANOVA ($N = 16$) was conducted to compare effect of practice pattern on the change in typing speed between weeks 6 and 7 in front-loaded, linear, and end-loaded conditions.

An ANOVA showed ($N = 16$) (Table A.5) that the effect of practice pattern on the change in typing speed was not significant, $F(2,13) = 1.651, p = 0.230$. Again, the change in typing speed between weeks 6 and 7 as dependent on practice groups was not at a level deemed to be significant, and as such the hypothesis is not supported.

Table A.5 ANOVA comparing effect of practice pattern on typing speed change between weeks 6 and 7

ANOVA

Week 6 and 7

	Sum of squares	df	Mean square	F	Sig.
Between groups	233.989	2	116.994	1.651	0.230
Within groups	921.042	13	70.849		
Total	1155.031	15			

Research conclusions

What do the results mean?

The first hypothesis that practice time AUC positively influences typing speed performance gains was supported. We have shown that the front-loaded practice curve leads to increased performance

That's about the extent of the really good news, but it still underpins the accelerate the curve (ATC) approach. What we had hoped for was the result that increases in the AUC correlate with increases in performance.

As we look for more nuanced positive results, we are left with questions more than answers, but I have started to answer the questions and I hope that others may be inspired to carry out further research in this area.

What about the other hypotheses?

Hypothesis 2: Practice time AUC positively influences typing accuracy performance gains.

The data supported the hypothesis in the direction of the relationship between practice time AUC and typing accuracy. The ANOVA means plot is similar to the plot for typing speed; however, the statistical significance is above $p = 0.05$.

Let's look at this from the other angle then – that the statistics have informed the research that typing accuracy is not positively influenced by the practice time pattern. This may be explained by the more complex relationship that accuracy has with speed; in cognitive psychology, the inverse efficiency score (IES) has been proposed (Townsend & Ashby, 1978, 1983) as a better independent variable, where IES is calculated from both speed and accuracy. Whilst IES was proposed for combining accuracy (as

PE – proportion of errors) and speed (RT – reaction time) it is not possible to create the IES from changes in typing speed and accuracy; however, it informs us that there is a relationship between speed and accuracy that is a trade-off.

Given that this research elapsed time did not continue until subjects reached a new plateau, we can explain the rejection of the accuracy hypothesis because of not having reached maximal typing accuracy.

Hypothesis 3: Practice time AUC positively influences self-efficacy.

Research data showed that the direction of the relationship is opposite to the hypothesis, and that the relationship is not statistically significant. The a priori hypothesis reasoning is that the learner makes better progress early on, and as such their subjective performance increases which would be reflected in the GSE-10 Self Efficacy scores. That the group with the highest speed improvement also reported the lowest mean self-efficacy scores is therefore unexpected.

Self-efficacy was chosen as the subjective measure because of Bandura's Social Cognitive Theory's (Bandura, 1986, 1997) definition as "beliefs in one's capabilities to mobilize the motivation, cognitive resources, and courses of action needed to meet given situational demands" (Wood & Bandura, 1989) but more specifically the definition as applied to tasks – level of task difficulty, certainty of performing at a certain level and the generality of these factors across tasks and situations. It may therefore be a case of the subjective measure being overly general, instead of a specific subjective measure for performance.

In summary, the hypothesis has been rejected based on the subjective measure GSE-10, and a more specific measure, or hypothesis, would be required.

Hypothesis 4: Practice time AUC positively influences skill retention longevity (measured by the decline in performance between weeks 6 and 7).

Longevity, as measured by only 1 week looks to have been insufficient and further speed and accuracy tests over longer elapsed time may give different results.

However, there are students the world over who are testament to the power of last-minute cramming being effective.

Conclusions

This research was designed to test the a priori hypotheses around the timing and practice patterns of spaced practice, specifically that objective and subjective performance measures would be influenced by the practice

pattern when all other factors are unvaried (total practice time, elapsed time, syllabus, scope for improvement and sequence of training interventions).

The research findings are that for one performance measure (typing speed) the hypothesis was supported by the data and that the group with the front-loaded practice pattern objectively reported a significantly greater increase in typing speed over the duration of the research. That this significant and sizeable increase was achieved without any more time spent practising over 5 weeks than the other two groups is an exciting development as the concept has now practical proof.

To a large degree, this front-loaded practice pattern is seen in many aspects of organisational life – occupational learning generally happens in the early stages of a career (especially careers that require formal qualification). Many professional careers – doctors, lawyers, accountants – have several years of intense training at the start followed by a career that spans decades with incremental learning as a continuous part.

For longer-term learning then, we absolutely apply the principle of front-loading practice.

What has not been explored before is the concept of applying this in a short-term scenario and this chapter goes some way to demonstrating that even over as little time as 7 weeks a significant difference is seen.

If maximal increases in performance or learning are sought, then organisations and individuals would be wise to apply the principles in this chapter and to increase the area under the practice curve.

Whilst we have shown that the particular front-loaded practice curve that was used in this study did lead to increased performance, what we cannot yet know is whether the practice pattern (as measured by the AUC) has an optimal or maximal design, or indeed if it is linear or curvilinear in relation to the objective performance outcomes.

References

Allison, P. D., Long, J. S., & Krauze, T. K. (1982). Cumulative advantage and inequality in science. *American Sociological Review*, 47 (5), 615–625.

Arthur, W., Jr., Bennett, W., Jr., Edens, P. S., & Bell, S. T. (2003). Effectiveness of training in organizations: A meta-analysis of design and evaluation features. *Journal of Applied Psychology*, 88(2), 234–45.

Bandura, A. (1986). *Social foundations of thought and action: A social cognitive theory.* Prentice-Hall.

Bandura, A. (1997). *Self-efficacy: The exercise of control.* Freeman.

Bruyer, R., & Brysbaert, M. (2011). Combining speed and accuracy in cognitive psychology: Is the inverse efficiency score (IES) a better dependent variable than

the mean reaction time (RT) and the percentage of errors (PE)? *Psychologica Belgica, 51*(1), 5–13.

Carver, C. S., & Scheier, M. F. (1982). Control theory: A useful conceptual framework for personality – Social, clinical, and health psychology. *Psychological Bulletin, 92*(1), 111.

Chow, J. Y., Davids, K., Button, C., & Renshaw, I. (2021). *Nonlinear pedagogy in skill acquisition: An introduction*. Routledge.

Deloitte LLP. (2016). *Benchmarks, trends and analysis of the UK training market.* https://www.bersin.com/Practice/Detail.aspx?id=19463

Ericsson, K. A., Krampe, R. T., & Tesch-Römer, C. (1993). The role of deliberate practice in the acquisition of expert performance. *Psychological Review, 100*(3), 363.

Lent, R. W., & Brown, S. D. (1996). Social cognitive approach to career development: An overview. *The Career Development Quarterly, 44*(4), 310–321.

Locke, E. A., and Latham, G. P. (Eds). (1994). Goal setting theory. Motivation: Theory and Research, 332. http://doi.org/10.4324/9780203082744

Merton, R. K. (1942). A note on science and democracy. *Journal of Law and Social Policy, 1*, 115.

Merton, R. K. (1968). The Matthew Effect in Science. *Science, 159*, 56–63. http://doi.org/10.1126/science.159.3810.56

Ostroff, C. (1992). The relationship between satisfaction, attitudes, and performance: An organizational level analysis. *Journal of Applied Psychology, 77*(6), 963–974. https://doi.org/10.1037/0021-9010.77.6.963

Pfeffer, J. (1995). Producing sustainable competitive advantage through the effective management of people. *The Academy of Management Executive, 9*(1), 55–69.

Schmidt, R. M. (1983). Who maximizes what? A study in student time allocation. *The American Economic Review, 73*(2), 23–28.

Siddiqui, O., Hung, H. J., & O'Neill, R. (2009). MMRM vs. LOCF: A comprehensive comparison based on simulation study and 25 NDA datasets. *Journal of Biopharmaceutical Statistics, 19*(2), 227–246.

Townsend, J. T., & Ashby, F. G. (1978). Methods of modeling capacity in simple processing systems. *Cognitive Theory, 3*. https://doi.org/10.1163/_q3_SIM_00374

Townsend, J.T., & Ashby, F.G. (1983). *Stochastic modeling of elementary psychological processes*. Cambridge University Press.

Wood, R., & Bandura, A. (1989). Impact of conceptions of ability on self-regulatory mechanisms and complex decision making. *Journal of Personality and Social Psychology, 56*(3), 407.

Index

Note: *Italicized* and **bold** page numbers refer to figures and tables.

www.ingramcontent.com/pod-product-compliance
Lightning Source LLC
Chambersburg PA
CBHW070332270326
41926CB00017B/3852

9 781032 613857